Crowdsourcing for Filmmakers

Whether you're a producer, screenwriter, filmmaker or other creative, you probably have a project that needs constant exposure, or a product to promote. But how do you rise above the noise?

In *Crowdsourcing for Filmmakers: Indie Film and the Power of the Crowd*, Richard Botto explains how to put crowdsourcing to use for your creative project, using social media, networking, branding, crowdfunding and an understanding of your audience to build effective crowdsourcing campaigns, sourcing everything from film equipment to shooting locations.

Botto covers all aspects of crowdsourcing: how to create the message of your brand, project, or initiative how to mold, shape and adjust it based on mass response; how to broadcast a message to a targeted group and engage those with similar likes, beliefs or interests; and finally, how to cultivate those relationships to the point where the message is no longer put forth solely by you, but carried and broadcasted by those who have responded to it. Using a wealth of case studies and practical know-how based on his years of experience in the industry and as founder of Stage 32—the largest crowdsourced platform for film creatives—Richard Botto presents a comprehensive and hands-on guide to crowdsourcing creatively and expertly putting your audience to work on your behalf.

Richard "RB" Botto is the founder & CEO of Stage 32 (stage32.com), the world's largest online platform for connecting and educating film creatives. Called "LinkedIn for film creatives" by *Forbes*, Stage 32 boasts a half million members and over 1,000 hours of education. Prior to Stage 32, Botto was the founder, publisher and editor of *Razor Magazine*, a national men's lifestyle magazine, which had a readership of 1.5 million at its peak. Botto is also an actor, producer and screenwriter. His latest screenplay, *The End Game*, is in production at Covert Media. Botto is a much sought-after speaker, teaching and mentoring around the world. He has also appeared on such networks as Fox News, CNBC, CBS News, MSNBC and Bloomberg, speaking on the subjects of social media, networking, crowdsourcing, crowdfunding, screenwriting, business, entrepreneurial practices, and more.

Praise for *Crowdsourcing for Filmmakers*

"As a subject matter expert as well as someone who has lived it, RB has a massive amount of wisdom to impart throughout *Crowdsourcing for Filmmakers* that enables entertainment industry participants to build and take advantage of their personal and social media networks to reach their goals."
—**Paul Hanson**, CEO, Covert Media

"Comparing the power of moving your existing contacts to crowdsourcing a targeted audience is like comparing the power of mobilizing a small village to the power of potentially moving the universe. Rich Botto's *Crowdsourcing for Filmmakers* shows how hard work and planning will greatly help today's filmmaker take part in what is a new revolution. RB shows clearly that the power is in you, and that power can be harnessed by learning the lessons in this amazing book."
—**Michel Merkt**, Golden Globe winner and Creative Producer of over 50 films

"Filmmaking has changed dramatically since I started Raindance in 1992. Film funding has completely changed. Some would argue for the worse. Not Richard Botto and his essential *Crowdsourcing for Filmmakers* which clearly and completely outlines the social media (and other) strategies used by successful crowdsourcers to make their movies happen. Richard writes in a matter-of-fact tone that his hundreds of thousands of followers will instantly recognize for its warmth, wit and wisdom. This book is like having Richard Botto and his years of experience in your back pocket 24/7. Indispensable."
—**Elliot Grove**, Founder, Raindance Film Festival, British Independent Film Awards

"Sourcing and moving a crowd has never been a bigger factor in the life of an indie filmmaker. With *Crowdsourcing for Filmmakers*, RB has written a next-level and engaging discourse on the subject that will help so many achieve their artistic endeavors."
—**Michael Polish**, Director, Writer, Producer (*Twin Falls Idaho, The Astronaut Farmer, Big Sur*)

"I learned so much from *Crowdsourcing for Filmmakers*. Rich Botto has crafted an easy to grasp resource with definitive steps on how to best access a community and get your films made. This is essential reading."
—**David Greenblatt**, Manager/Producer

"No one is more dedicated to educating filmmakers to learn and prosper in today's rapidly changing landscape than Richard Botto. He is successfully helping filmmakers move towards a newer, more global and digital era of filmmaking. In *Crowdsourcing for Filmmakers* he has introduced an important tool for filmmakers to help achieve maximum engagement—not just on their films, but on themselves. Read this book!"

—**Jason Roberts**, DGA AD (*Jurassic World*,
Transformers: The Last Knight, *Almost Famous*, *Empire*)

"*Crowdsourcing for Filmmakers* is a must in the new era of filmmaking as the traditional models have begun to die out. And there is no one who understands the future of the business and where it is headed more than RB."

—**Elissa Friedman**, Entertainment Executive, Covert Media

"The independent film landscape continues to change at a rapid rate. It is no longer good enough simply to be a filmmaker, you have to know the brand of your film and the brand of you. With *Crowdsourcing for Filmmakers*, Rich Botto provides a clear road map, using both time tested and innovative techniques designed to help you build an army of support for your project from conception to distribution and beyond."

—**Jon Reiss**, Filmmaker, Author, Film Strategist, Hybrid Cinema

"Given the hundreds of thousands of creatives on Stage 32, Rich Botto certainly knows how to source a crowd. In *Crowdsourcing for Filmmakers*, RB takes his wealth of knowledge and lessons learned and passes them on to the independent filmmaker. This could not be a more book for the now and should be essential reading for anyone making films in today's environment."

—**Bradley Gallo**, Producer (*The Call*, *Mr. Right*),
Chief Creative Officer, Amasia Entertainment

"It's almost impossible to crowdfund without the crowd. You've gotta crowdsource FIRST. Before you can convert strangers into motivated fans to champion your artrepreneurial dreams, you've gotta start by authentically engaging friends, family and acquaintances to create tipping point momentum. No one is better at identifying and charismatically catalyzing aspirants into a branded community than RB. If you're an independent filmmaker or content creator looking to make your creative and career dreams come true, RB's insights will help you blueprint your plan. It's up to you to put it into action and make it happen."

—**Heather Hale**, Author (*How to Work the Film & TV Markets and
Story$elling: How to Develop, Market and Pitch Film & TV Projects*)

"Richard Botto is my favorite sort of guy: The type of guy who went out and figured it out for himself, unearthing information wherever he could, and making good use of it at every turn. In *Crowdsourcing for Filmmakers*, RB shares the priceless knowledge he has gathered along the path to becoming an industry trailblazer, generously imparting on the reader with the sort of fundraising and crowdsourcing information on the shoulders of which projects can get made and careers will be built."

—**Lee Jessup**, Screenwriting Career Coach, International Speaker and Author (*Breaking In: Tales From the Screenwriting Trenches*)

"What sets great filmmakers apart is their understanding that they need an army of support. With *Crowdsourcing for Filmmakers*, RB has written the definitive guide on how to drum up support and get your audience to engage in you and your project."

—**Agustine Calderon**, Development Executive & Producer (*In the Company of Lies*)

Crowdsourcing for Filmmakers

Indie Film and the Power of the Crowd

Richard Botto

Routledge
Taylor & Francis Group

NEW YORK AND LONDON

First published 2018
by Routledge
711 Third Avenue, New York, NY 10017

and by Routledge
2 Park Square, Milton Park, Abingdon, Oxon OX14 4RN

Routledge is an imprint of the Taylor & Francis Group, an informa business

© 2018 Richard Botto

Library of Congress Cataloging in Publication Data
A catalog record for this book has been requested

ISBN: 978-1-138-10713-7 (hbk)
ISBN: 978-1-138-84989-1 (pbk)
ISBN: 978-1-315-72513-0 (ebk)

Typeset in Warnock Pro
by Apex CoVantage, LLC

For my mom, Joan Fedi, and my dad, Robert Botto, Sr.
I can never repay you for all you've given me, but now, at least, you know how to crowdsource a film.

Contents

Foreword

I first met Richard "RB" Botto at the 2013 American Film Market Marketing summit, where I was invited to give a keynote address on "Crowdsourcing Your Audience." At that point, about two-thirds of the room considered crowdsourcing a fleeting fad. But the remainder had already recognized that it was quickly becoming an essential element in the alchemy of content production, distribution and marketing. And even among those more farsighted attendees, RB was alone in his recognition of the need for a truly authoritative resource to help filmmakers understand just what crowdsourcing is and how it can become one of their most effective tools.

I am convinced that RB is precisely the right person to have written the first book on crowdsourcing for filmmakers: Founder and CEO of Stage 32—the world's largest online platform for film and theater creatives—RB has over the years not only developed and applied best practices in crowdsourcing, but facilitated in-depth discussions among industry leaders about the power and possibilities of professional networking. The result is a book whose economy of thought is equal parts informative, inspiring and actionable.

As you turn these pages, I encourage you to read them not as an instruction book, but as a guide to help chart your own path and strategies. Crowdsourcing is not just an initiative or a campaign, but a state of mind and proclamation that visionaries will become exponentially more powerful when they can harness the forces of mass collaboration and community. Having devoted much of my professional life to improving the reach and efficacy of crowdsourcing for filmmakers, I can attest that this practice is essential to building or enhancing a career on the bedrock of what you stand for and believe in.

Since the term "crowdsourcing" has become trendy over the past decade, many people regard this practice to be new or emerging. The reality is that crowdsourcing has been around long before we humans ever walked this planet. As the late great microbiologist Lynn Margulis said, "Life did not

take over the globe by combat, but by networking."¹ The natural world, which has survived for epochs, contains multiple examples of this. For instance, a bee might seem like a creature that could easily fall prey to other animals, insects and natural forces. It has very little to protect itself from predators or the violent natural conditions it faces. However, by forming a community and working together through a well-organized division of labor that is based on the capability of each bee to conduct all the needs of the hive, bees have achieved a greater level of well-being and safety than any isolated creature ever could—no matter how strong, smart or cunning that creature might be.

As synergistic as bees are in this regard, they are not the only examples in nature of vulnerable individuals collaborating to form mighty and indestructible communities. Symbiosis, collaboration and mutual aid—the primary ingredients of what we call "crowdsourcing"—have acted as the catalyst for essentially all life that has evolved. We are the lucky ones who live at a time when, thanks to the impact of technology, our ability to network and collaborate on a massive scale has grown as rapidly as the transformation from horse-and-buggy to drone. Today, a message can connect with an audience to create a borderless community that multiplies by orders of magnitude into a movement. The act of marketing is no longer just about how loud and ubiquitous you can be, but rather about how engaging and meaningful you are. A new order of Darwin's concept of "survival of the fittest" has emerged in the virtual world: Only the most useful, relatable and/or engaging ideas survive. This book helps us understand the advantages of crowdsourcing, how others have effectively put them to work and how we can expect to see these techniques applied in the years to come.

Over the past several years, I've helped to create and grow Tugg, the crowdsourcing platform that lets people choose the films that come to their local cinemas. I've often been asked, "What problem does this solve?" The answer to that question is true not only of Tugg but of nearly all film-centric crowdsourcing platforms: They are designed to help filmmakers achieve their best work and reach their widest audiences. By helping lower the barriers to entry when seeking capital and a market, crowdsourcing creates bridges between creators and their fanbase. The closer these two cohorts become, the more successful and prolific filmmakers will be. The case studies and analyses in this book showcase the ways in which crowdsourcing is empowering filmmakers to connect directly with their audiences, while removing many of the legacy middlemen that have eroded the potential for filmmakers to build

a commercially viable infrastructure around their work—middlemen who have often obstructed filmmakers' core messages from reaching their audience as well.

Even in our current media landscape, when a good idea is executed into a great film, a community of core fans is still needed to help lift the film above the cluttered marketplace and into the consciousness of a broader audience. While the efficacy of advertisements and reviews continues to decline, the impact of word-of-mouth marketing among peers within their own social networks continues to rise at an exponential rate. Crowdsourcing is one of your best instruments for cutting through the noise of today's media environment and establishing a direct relationship with a core audience (who will not only be the first in line to see your film, but will bring along their friends, families and followers). After all, while the ways we can reach our audiences are more abundant than ever before, every ounce of your audience's attention is being diverted by competing interests. Filmmakers and marketers are faced with the increasing challenge of securing a place in the public consciousness. Today it's easy to be everywhere, but more difficult than ever to be somewhere. Crowdsourcing acts as a means to establish meaningful relationships with people who would otherwise be strangers, and enables those strangers to become advocates of your work and to reinforce your message.

That kind of lasting bond with your backers and evangelizers requires first and foremost a shared set of values and mission—and that, in turn, demands that you launch your crowdsourcing campaign with absolute clarity about both. As you consider the examples and anecdotes included here, I urge you to ask yourself fundamental questions about your own project: Who is your film for and why are you making it? Once you clearly identify your vision, message and target audience, it will become inestimably easier to locate audiences who share your passion for that vision and who can help amplify your message. Without this clarity, your crowdsourcing efforts will be rudderless; however, with a firm understanding of your project's identity and mission, you will be amazed by how many share your affinity and want to help you achieve your goals.

Those lasting and influential relationships turn out to be among the most valuable outcomes of any successful crowdsourcing campaign. Without exception, when I speak with people who have completed a campaign, they marvel at the relationships they have developed with people worldwide

who have shared interests and meaningful resources. For instance, some of the most successful initiatives we've had at Tugg have been executed by those who previously conducted crowdfunding campaigns on platforms like Seed & Spark, Kickstarter and Indiegogo. As a result of their crowdfunding campaigns, these creators learned to treat their backers not as metrics but as partners. When kept informed throughout the journey from production to distribution, backers evolve from supporters to sellers. The social capital these filmmakers sustained during the lifecycle of their film also now follows them as their journey continues, enabling eager participants to support their next venture. Their crowdsourcing campaigns acted as open calls-to-action to become involved in not just their content, but in their community—and not just as observers, but as contributors.

While the rewards of a successful crowdsourcing campaign are abundant, pulling one off is no easy feat. I cannot count the number of times I have been in a meeting with a creator or marketer who laments the difficulty of crowdsourcing. I cringe when I hear executives from crowdsourcing platforms try to sell their platform or the practice of crowdsourcing as "easy." That attitude might get a lot of campaigns launched, but it will also lead to many frustrations and failures. As Benjamin Franklin said, "By failing to prepare, you are preparing to fail." Anyone who fails to appreciate the scope of crowdsourcing is failing to prepare for the challenges of executing a successful campaign.

Instead, I encourage you to think of a crowdsourcing campaign as similar to a film production. Like a film project, you will need to set daily goals that build on one another, and, as with the highly organized division of labor on a film set, you will need to put together a core team of collaborators who will be able to shoulder the weight of the challenge. Together you can achieve what would have been impossible to do alone.

In other words, before you can collaborate with the masses, you will need to collaborate with your core team. You will need to lead its members to become the beehive that can collectively achieve what the individual could only imagine. Take it from me—someone who has devoted the majority of his adult life to evolving the practice of crowdsourcing: It may be incredibly hard, but the payoff will stay with you, growing and ultimately becoming a primary catalyst toward reaching the next level of your career. After all, the basis of crowdsourcing is that communities are infinitely stronger than

individuals, and that collaboration is the most effective means to achieving what might otherwise be out of reach.

This book should simply be the beginning of your exploration of the potential and power of crowdsourcing. For while there are many great case studies and best practices to learn from, there are few boundaries to inhibit the ways crowdsourcing can pave the way for the most successful version of your filmmaking career. I suspect that in the years to come, those who have read RB's insights with an open and creative mindset, those who find synergy in collaboration and those who innovatively integrate these practices into their work, will be the people in the position to write the next installment.

As John Lennon said, "A dream you dream alone is a dream. A dream you dream together is a reality." With that in head and heart, I encourage you to keep reading with a curious mind.

Nicolas Gonda, Producer
April 2017

NOTE

1 http://www.newworldencyclopedia.org/entry/Lynn_Margulis

Acknowledgments

This book would not be possible without the support, insights, musings and experience of some of the brightest minds I'm lucky enough to have in my orbit.

Right off the bat, I have to thank my dad, Robert Botto, Sr., and the Managing Director of Stage 32, Amanda Toney, for being my first line of defense in the editing process. Both read this book more times than anyone should be forced to read anything, and did so with patience and boundless energy. You provided me with a wealth of helpful advice, positive mojo and support. All love to you both.

Providing a different kind of support, my mom, Joan Fedi, and stepdad, Arnie Fedi. Simply by lovingly asking, "How's the book coming along?" every time we spoke over the last couple of years supplied enough energy (and guilt . . . in a good way) to keep me going.

At Focal Press, my thanks to Emily McClosky, who convinced me over a beer at the Loews Hotel pool at AFM to write this book in the most Seinfeld-esque way (Her: "That's the book!" Me: "What's the book?" Her: "That! Everything you just said!"). Thank you for the guidance, the passion and the gentle nudging. I hope the Oregon life is treating you well and sparking your creativity.

Also at Focal, my appreciation to John Makowski, who listened to my rantings, ravings and pushbacks with calm and carefully crafted his responses like a seasoned diplomat. Simon Jacobs, your support at the most recent AFM gave me a much-needed jolt of confidence at just the right time.

To Jonathan Wolf, Head Honcho of AFM, my thanks to you for your unwavering support and open-mindedness through the years. It's an honor to have this book published under the "AFM Presents" banner. All respect to you, my friend.

Without the love, encouragement and persistence of Heather Hale, I would not have been presented the opportunity to speak on crowdsourcing at AFM, and, therefore, this book would simply not exist. We talked much about selflessness throughout our journey together. Well, there isn't a more giving human being on this planet, and I couldn't be more blessed to know you and call you friend.

To my canine writing partner of over 15 years, Penny Lane (the beagle), thanks for the welcome distractions.

All of the following people contributed their time, insight, knowledge, stories, passion and support to the cause: Kia Kiso, Jason Fitzpatrick, Ric Serena, Jen Serena, Durand Trench, Paul Bessenbacher, Zee Hatley, Dean Silvers, Tyler Silvers, Bernard Chadwick, Mara Tasker, Lee Jessup, John T. Trigonis, Timon Birkhofer, Jessica Sitomer, Mitchell Peck, Michel Merkt, Suzanne Lyons, Elliot Grove, Marty Lang, Gary Ploski, Michael Polish, Tomasz Mieczkowski, Dara Taylor, Julie Zhou, Erik Grossman, Greg Piccionelli, Anna Vradenburgh, Agustine Calderon, Jason Roberts, Jon Reiss, Bradley Gallo, Jason Scoggins, Elissa Friedman, Paul Hanson, David Greenblatt, Nicolas Gonda. I'm grateful to you all.

And I'd be remiss if I didn't thank my staff and the entire Stage 32 community. So many of you have checked in asking about the progress of this book and offered encouragement. Those gestures were never lost on me or taken for granted, I can assure you. You have been my army, my boots on the ground, and I am forever thankful.

1

Allow Myself to Introduce ... Myself

As it states on the cover, my name is Richard Botto. My friends, however, call me RB, and since you've spent your hard earned money to buy this book and will now invest your invaluable time reading it, and seeing how we're going to be spending the next 300 pages together, I consider you a friend. So . . . I'm RB, and it's a pleasure to meet you.

I am a screenwriter, producer, actor and voice actor. I'm also an entrepreneur. The combination of these pursuits led me to create Stage 32 (www.stage32.com), the world's largest online networking and educational platform for creatives working in film, television and theater. More on that down the road.

My interest in film started at a very young age. No one in my family is exactly sure where this passion originated. Though my parents and grandparents enjoyed movies as a source of entertainment, none of them would qualify as avid students of the medium. For them, like most filmgoers, movies represented entertainment and escapism. And in my earliest years, that's what they represented to me as well. I remember all too well rushing down the stairs on a cold, East Coast winter morning, opening our front door and braving the blast of frigid Staten Island wind, anxiously retrieving our copy

of the *Daily News* and fervently flipping pages until I landed in the section with the movie advertisements. What films were opening this weekend? Were they playing near us? Where? What time?

As I approached my teenage years, I found myself not only compiling a list of favorite films, but favorite actors and directors as well. Eventually those lists included cinematographers and producers. I was a passionate baseball card collector at the time and trust me when I tell you, if they would have printed cards for film directors, I would have had 2,000 Scorseses and Spielbergs (I might have unloaded a few of those Spielbergs for some Coens and P.T. Andersons today, but I digress).

Early on, I could find merit in just about any film—"I have to tell ya, I think the narrative arc in *Revenge of the Nerds III* certainly surpasses that of *Nerds II*"—but over time, my tastes sharpened and my senses honed. I became aware of the classics. But more importantly, I awakened to the art and the craft of filmmaking. While people formed lines around the corner at my local video shop, anxiously awaiting to shell out three bucks or more for the latest hit movie release, I was slipping in and paying one slim dollar to rent the VHS tapes gathering dust in the corner: genius works by Welles, Kurosawa, Fellini, Hitchcock, Chaplin and Hawks. Slowly, my passion for all things cinema morphed into an obsession. I craved backstories, histories, on-set tales—anything that would add color to what formed the creative process of a particular artist or how a particular film came together. This was pre-internet, of course, so information was at a premium. There were no director's commentaries or bonus content on VHS tapes. Instead I used my allowance to head to my local Borders, where I would buy every book and biography related to film I could get my hands on. If I happened to find myself in Manhattan, I would beg to be taken to the nearest newsstand so I could grab a copy of *Variety* or *The Hollywood Reporter*.

I can remember sitting at a Mets game with a friend of mine and during a lull in the action offering, "You know . . . I'm a little concerned that Francis Ford Coppola is losing his passion for cinema."

I was 13.

My overarching desire was to be a director. I studied the greats of the past and those who had captured the imaginations of millions during my childhood. In photos they always looked so reflective, learned and creative. They commanded

respect. They had the ear of all involved. On a semi-related note, I also swore that if I became a director, I would revolutionize director's sartorial sensibilities by wearing something besides khaki pants, safari jackets and bad hats. But, that's a story for another book or perhaps over a cocktail or ten.

Directors, to me, seemed to have it all. I loved that the best of the best were called "auteurs." So regal. So perfectly pompous. I was obsessed with framing, lighting, camera angles and editing choices. Even then, it wasn't beyond me to watch a film twice in a row, once as a fan and once as a student.

Since I didn't have a camera (camcorders were ridiculously expensive and weighed roughly the same amount as a '74 Buick Skylark back in those days), I began writing short scripts, with no idea of format, I should add, and visualizing the scenes in my head. And then a funny thing happened—I discovered I not only enjoyed the writing process, but I had a knack for it. It came fairly easy. The tales flowed, the suspense built, the characters arced. In no time, I was pumping out short stories, novellas, plays and more short (still brutally formatted) screenplays.

I would gather some open minded kids (no small task) from the neighborhood to act out my scenes. Having attended an acting camp one summer, sometimes I would insert myself as the lead, defending my choice with a mighty "Hell, Welles did it!", which, of course, endeared me to just about everyone (he said with a healthy dose of sarcasm). I came to realize that I enjoyed acting almost as much as I enjoyed creating the characters. Soon, I started putting on plays for the neighborhood, serving as actor, writer and director (move over, Orson!). I was a true triple threat. Occasionally, I would even put my ego aside and magnanimously act in *someone else's* play or student film. I was gaining confidence. Each effort garnered more attention and accolades. My star, as they say, was rising. And then I did what any aspiring and thriving actor, screenwriter and filmmaker would do . . .

I went to pharmacy school.

Yep.

My preference, as you might imagine, was to go to film school. I applied to a few and was accepted by a couple. But my dad made some compelling arguments why pharmacy school would be a more logical choice. For starters, he and my brother were pharmacists, so I was around pills my entire life.

Wait, that doesn't sound right. Let me try again.

I had exposure to pharmaceuticals, since I was a kid.

Hold on.

Let's just say by virtue of being a son and brother to two pharmacists, I knew my stuff. Plus, I was already working in a pharmacy, filling prescriptions as a tech three years before I was legally of age to do so. Don't worry, everyone lived. Then there was the fact that, while a senior in high school, I sat in on my brother's 5th year pharmacology final and scored an 86.

The logic became this: Pharmacy school would be a walk for me. The five years would fly by. I would all but be guaranteed a job when I graduated, and a high paying job at that. The world needed more pharmacists. Plus, and finally, if I went to film school, I would most likely party my ever-loving ass off.

I couldn't argue any of these points, especially the last one.

So, it came to pass that a few short months later at 7am on a bright and sunny fall morning, I found myself in a lab at the Fulton Street Campus of Long Island University Pharmacy School in downtown Brooklyn with half a buttered poppy seed bagel clenched between my teeth while I surgically extracted the kidneys of a fetal pig. Was my mind still on film? I'll let the fact that I had created an elaborate backstory for the mother of this fetal pig (damn you, creators of *Babe*) serve as an answer. At the midpoint of semester one, I had a 4.0 average. None of it had been earned with a lick of passion.

Clarity, rescue and salvation came in the form of a diminutive English Composition teacher whose visage was a cross of Mr. Magoo and George Carlin. This was a man for whom being called cantankerous would serve as the highest of compliments to him and an understatement to anyone who had ever served time in his class. This was a man who introduced himself on the first day of class not by mentioning his name and welcoming us, but by sitting down and staring at us for seven solid minutes before stating, "Let's get one thing clear. You're pharmacy students. This is an English class. I know you chose this as an elective because you think you're gonna coast. Well, let me tell you geniuses something, I've been teaching here for 25 years and I've given 3 As. Chew on that. I'll give you some time to digest." He then

proceeded to kick his feet up on his desk and eat an egg salad sandwich while thumbing through *The Sun Also Rises*.

Sixty percent of the class did not return for day two.

But I did. There was something about the guy. He had a mad creative genius sort of vibe. When it came to dissecting great literature and a passion for inspired writing, he suffered no fools. He didn't pity them either. In fact, I would say the word pity only existed in his vocabulary as a vehicle to spray spittle on the ignorant. His insults were so creative—*"I'm sorry I've been so hard on you, Mr. Johnson. I didn't realize until this moment that English is clearly your second language. I have no idea what your first is, but clearly English is your second." "Miss Clark, I was wondering if I could take you out for a drink this weekend and introduce you to my dear friend, The Comma."*— I imagined he spent time working the material in his bathroom vanity mirror the night before. Slowly, I had to come to terms with the fact that I might just have a masochistic side, or at the very least should seek professional help, as I found myself actually *looking forward* to his class.

There were even fleeting moments where I thought I was winning him over or, at the very least, had crossed a pinkie toe over to his good side. But, even when you did something right, he left room for doubt.

> **Me:** I believe the explanation of the rich man passing the poor man on the stairs in the bar is Joyce's way of saying that as quickly as one can rise in stature or standing in a job or within a community, that's as quickly as one can fall. Today can bring fortune and friends, tomorrow destitution and loneliness.

> **Him:** An interesting take that I'm compelled to agree with.

> **Me:** (smiles)

> **Him:** I suppose you want a cookie now?

Toward the mid-term break, we were tasked with writing a 30-page story on something that had a profound impact on our lives: An event that had rattled our cages, to be written in non-linear fashion. I had been an altar boy when I was younger (a fact that, to the people who know me well, elicits much gut-rolling laughter). During this time, there was a priest, Father Hicks, who

became a very good friend of my family. Outwardly, he was a progressive, sometimes brash soul. Although he certainly took his vows seriously, much of his outward bravado was just an act. He loved the theatrics for which his position allowed. His Sunday sermons were not just fire and brimstone, but accompanied by booming acoustics and dramatic lighting.

Once, prior to a High Mass ceremony, he asked me to show him how much charcoal I had put in the thurible, a metal censer designed to burn incense. At a certain point during the ceremony, I would present the thurible to him and he would add the incense, take the thurible from me and swing it to and from, blessing the altar and the parishioners.

Minutes before Mass was to begin, he did some quality control—bass, lights, thurible. His nod the cue, I opened the thurible, revealing three small round pieces of charcoal. It should be noted, most priests required only one. But I knew Father Hicks liked a lot of smoke. Three was more than enough to do the job.

He glanced at the three pieces of charcoal with disdain and began to slowly, menacingly fold at the waist, tilting his head until he was inches from my face. He then gazed down his nose at me, and in a voice that would have made Darth Vader shiver said, "More fire."

I added three more charcoals.

When the time came to present the thurible to him, the metal chain attached to it was scalding to the touch. I had to use rubber padding to handle the vessel. I opened the top and Father Hicks and he proceeded to drop a heaping spoon of incense inside, resulting in a "whoosh" sound so loud, it reverberated through the church. Although I couldn't make out anything an inch in front of me, I'm pretty sure I saw my eyelashes tumble through the instant and enveloping mushroom cloud.

He took the thurible from me and began swinging it. At the altar, around the altar and toward the congregation. Then he proceeded down the steps of the altar and walked around the entire church until the smoke was so thick, I expected to hear a foghorn.

I just stood in place. Eventually, he emerged from the thick cloud like a magician who just nailed his signature trick. He handed me back the thurible, smiled the most devious smile and whispered, "Big fire." Then he gave me a wink.

That was him. Serious with a wink and a smile. Underneath it all, and the people who knew him best were well aware of it, he had a heart of pure gold. When tragedy struck the family of my best friend, he was there. When I struggled in school, he was there. In fact, when anyone suffered difficult times, he was always there. In short, he was a great man, cut from a cloth you don't see much of any longer.

Days before I was to begin writing the paper, I learned that he had passed. Although I hadn't seen him in well over a decade, his death had a profound impact on me. Whether it was the sudden removal of a significant part of my life that was so profoundly formative, the soft amber glow of nostalgia or something else entirely, I don't know. But I knew one thing. I had to write about him. And so I did. And I kept writing, the words flowing so naturally and effortlessly. Forty-two pages later, I was done. I had no idea if it was any good, I just knew it had poured out of me and contained everything I needed to say. I submitted it without any edits.

About a week later, I was summoned to my professor's office. As I sat in the outside lobby, awaiting my fate and making note of the emergency exits, one of my fellow classmates emerged, the blood flushed from his face.

"What happened?" I asked.

"He asked if I thought it might be possible for me to suck less."

I noticed him clutching his paper in his hand.

"What did you get?"

"A four."

"What do you mean, a four? He only gives out letter grades."

"He said there was no appropriate letter."

At that point, the receptionist informed me that "the hangman" would see me now. My classmate gave me a nice-knowing-you pat on the shoulder and a soulful nod. I trudged on.

I entered my professor's office, a cramped space with thousands of books, papers, magazines and other paper materials stacked perilously on top of

one another. I found him at his desk, clutching a thick tipped red marker, furiously swiping and scribbling through some poor sap's work. Without looking up, he waved for me to sit down. Without picking up his head, he said, "Why the fuck are you in pharmacy school?"

"Excuse me, sir?"

Now he stopped. He craned his neck, nudged his thick framed eyeglasses down to the tip of his nose and said, "Oh God, don't tell me you've been deaf this entire time." He began pantomiming sign language to me with his hands while saying with measure, "Why. The. Fuck. Are. You. In. Pharmacy. School?"

"Well, sir, you see, my father was a pharmacist and my brother was a . . ."

He began to violently shuffle through papers on his desk. Finally, he found what he was looking for and tossed it at me. It was my story. There was a big black "A" on top. He had used something beside the red marker!

"That's the best paper I've read in 25 years," he said. "I'll take it one step further. You're the best writer I've had in 25 years."

I don't think it would surprise you to learn I was stunned. I managed to stammer, "Thank you, sir."

"Yeah, well, don't get too big a head. After all, I teach nothing but fucking pharmacy students."

And then the biggest surprise of all—he smiled. Well, more likely, his lips shifted to an angle which could be interpreted as a smirk or it could very well have been gas, but, I'm telling this story and I say his smile rivaled that of the Cheshire Cat.

"Listen," he said, his voice now softer, "you're wasting your life. A guy with your talents shouldn't be taking pills from a big bottle and transferring them to a smaller bottle for a living. You need to go create. You're good enough that maybe you'll even be one of the few to make money doing it someday. Then you can *buy* your father and brother a pharmacy."

Two weeks later, I transferred out of the school, but not before visiting with my professor and thanking him for the impact he had on my

life. We promised to keep in touch, and we did for a short while. And then life being life, those occurrences happened less and less until they happened no more. Recently, I looked him up again and thanks to the magic of the internet, I found him. And guess what? I learned something new. Not only is he a former International Table Tennis Federation Vice-President, a former three-term President of the United States Table Tennis Association (now USA Table Tennis), and a former Secretary of the Association, but he also was a member of the 1971 US "Ping-Pong Diplomacy" Team that opened the door to China. Since then, he has attended, as an official or journalist, more than 25 World and International Championships. In 1975 he captained the US Team to the World Table Tennis Championships in Calcutta. He's also been a US World Singles and Doubles table tennis champion at some point in every decade from his 40s through his 70s.[1]

This man changed the course of my life. I will remain grateful to the day I die. All creatives need champions, and he was one of my earliest.

Over the next few years, I took every acting, writing and filmmaking course I could fit into the schedule. I acted in student films and plays, my passion for the discipline growing. I wrote some articles as a freelance journalist and even banged out the obligatory, unpublished Great American Novel. I worked to creating my own opportunities, and I embraced every single one that came my way.

In my early 20s, I decided I was going to move to Hollywood to pursue being a filmmaker. I was going to grab that fleeting entity, Life, by the throat. But then Life slowly and kindly removed my hand from his windpipe, sat me down for a beer and reminded me in no uncertain terms that I had no money and no contacts.

So, I got a part-time job. And that job led to my first full time job. And that job led me to working at an office in a skyscraper on Wall Street, doing the ol' 9 to 5. And that job made me realize that I didn't like being a number and not having my opinions heard. Also, quite candidly, I didn't like answering to a boss. So, I started my own business. I promised myself I would commit to finding time to learning about filmmaking, writing and continuing to hone my acting. I would get up early or stay up late. A half hour here, an hour there, a weekend sacrifice when possible. Discipline and commitment would be the name of the game.

Didn't happen.

In fact, nothing on the non-business creative side of things moved forward until I began publishing and editing a national men's lifestyle magazine called *RAZOR*. Instantly, I was propelled into the Hollywood scene, hanging with actors, screenwriters, producers and directors. I found myself hanging on the sets of top television shows and major motion pictures. During set up, which could last for hours, I would sit in the trailers of A-List stars listening to their remarkable journeys from no one to someone (hanging with James Caan on the day of Marlon Brando's funeral a definite highlight). I became friends with many accomplished people in the business and, over dinner, drinks or both, would be regaled with the tales of their latest meeting, audition, job, success or failure. Further, I was giving assignments to and then shaping and editing the works of top-level journalists and authors. Every day I was surrounded and enveloped by creativity. It was all wonderful, amazing and exhilarating except for one thing . . .

None of this creativity was being born by my hand.

When *RAZOR* was no longer, I took some time to collect myself and recalibrate my dreams and desires. I decided I wanted to learn more about the business side of putting a film together, so I looked for a project to produce. Additionally, I knew I wanted to try my hand at screenwriting, so I read a couple of articles, some highly regarded screenplays, and bought myself a copy of *Final Draft*. Finally, although producing and writing appealed to me more, I wanted to revive the dead nerves of my acting instincts, so I sought out some reputable teachers and revived my studies.

Now, mere years later, I've worked as a producer on an award winning Sundance film, a number of shorts and a documentary we're planning to take to the major festivals. I've also managed to wrangle a top Hollywood literary manager, sold a screenplay and have a number of projects in various stages of development. I continue to take acting classes and have begun once again receiving offers for roles. And, as a result of committing to learning the business side of the film industry along with the relationships I've made on the creative side, I was able to live the experiences that would ultimately place me in a position to create Stage 32 and be asked to write this book.

COOL STORY, RB, BUT WHAT DOES IT HAVE TO DO WITH CROWDSOURCING?

Why, I'm glad you asked. Thank you.

Well, for starters, we're going to be spending a bunch of time together and, unfortunately, when it comes to books, the author/reader relationship is one-sided (even with an audiobook!), so you can't tell me all about you, but I can tell you all about me. Still, I assure you, taking advantage of you as a captive audience member to tell my story wasn't an exercise in narcissism. Quite the opposite. This was actually the first lesson toward understanding the concept of crowdsourcing.

Allow me to explain.

Since you're reading this book, it only stands to reason you have an interest in either filmmaking, work within the filmmaking realm or that you ply your trade in a craft associated with filmmaking and are interested in furthering your pursuits by learning about crowdsourcing. This means that somewhere along the path of your life you had a dream and chose to chase it. This also means that you probably have had periods of insane and intense drive and desire contrasted against periods of deep procrastination. You've had moments where you thought you were brilliant and moments when you were filled with doubt. You've been on the path to glory only to be knocked off by seen or unforeseen circumstances. You've had champions, doubters and enablers. Hell, I bet you picked up some scars along the way and have the well worn bar stories about how you got 'em.

Now think about my story. Is it relatable to you? Did you connect with it? Maybe even see yourself in some of it?

You'll notice that my trip down Memory Lane doesn't include my childhood love of playing sports, my time during my teenage years singing in a rock band or how I pried a tooth out of my mouth attempting to play the "Star Spangled Banner" on my guitar, Hendrix-style.

Further, my story also doesn't begin on the first day I was born, but at the birth of my creative genesis—the moments that informed and shaped my decision to pursue an artistic life. You surely have had similar moments and each and every one of them led you to this book.

But I had other motives for telling you this story, all geared toward the same end.

I wanted get the point across that I'm not simply some business dude who, by virtue of starting a social network partially for film creatives, was commissioned to write this book. I'm also a creative. Just like you. I get it. The *need* to do what we do.

I spoke to my entrepreneurial pursuits because I firmly believe that in this DIY (Do It Yourself) world, a world of social media, crowdfunding, an endless array of distribution channels, films being recorded and edited on phones and so forth, it's not enough to just be competent at your chosen path. You need to be an entrepreneur, proficient at business, marketing and, yes, crowdsourcing.

Indeed, the tale above was told with two objectives in mind:

1 To present myself as an engaging and empathetic figure.

2 To present myself as a reliable narrator.

Believe it or not, at this point in the process, the second objective is more important than the first. But the first is extremely important as well. It's my hope that I've accomplished both, but in no way would I be presumptuous enough to assume I've accomplished either . . . Yet.

I'm well aware I need to gain your trust, build up some social currency and get you to believe in me as an expert in the field. I realize I need to do everything possible to hold your attention. After all, you're, no doubt, busy. In the last five minutes, you've received a dozen push notifications for all your social media accounts. You also have 40 emails to answer, 10 voicemails you haven't listened to and your DVR is bursting at 99% full. That new season of *Orange is the New Black* isn't going to binge watch itself! Oh, and I forgot, the kids need to be fed and Bonkers just peed on the rug.

Further, man, you want to learn, but holy crap isn't there just a five minute YouTube video you could watch instead of reading this freakin' 300 page book? I mean, who the hell has the time?

I hear ya and I feel ya.

And it's why it's so important that I continue to pursue these two objectives as we continue our journey together. Why is this so important to me? Well, I'd like you to keep reading and enjoy the ride with the comfort that I'm a peer, but also with the confidence and security that the information and knowledge you'll receive is coming from someone who has earned the right to disseminate it. I certainly realize I may not have convinced you of all or any of this at this early juncture. As mentioned, I perfectly understand that we're talking about you getting to know me and me earning your trust and respect. That takes time. That's a process. But I have a game plan, a strategy and the will that by the end of this book, you will know me, and you will find me to be the most reliable of narrators.

And then, I'm going to present the "Ask."

You see, there's a method to my madness.

While you're learning about crowdsourcing, I'm going to be crowdsourcing you.

Confused? That's OK. That's why we're here.

We're going to discuss film crowdsourcing in the most fun, non-stuffy way possible. There will be no end of chapter assignments, callbacks or puzzles. What there will be is a wealth of useful, applicable information and real examples to back it up.

We'll get into the origins, the meanings, the designs. We'll explore social media strategies as well as the advantages of getting out from behind the computer (gasp) and interacting in the "real world." We'll discuss crowd-funding and how crowdsourcing fits into every successful campaign. We'll take a look at a slew of successful film crowdsourcing case studies including short, feature and documentary films. All this and much more.

While this may seem a great deal to digest, I'm making a promise to you here and now that my objective is to not complicate matters, but to simplify.

And although, as mentioned, the writer/reader relationship is a one-sided one, I want you to know I feel a kinship to you. We both love to learn, we share common creative interests and we're progressive minded enough to be open to a subject that is only now coming into vogue as it relates to film.

You've shown me an initial vote of support by virtue of purchasing this book. Now, like any good relationship, and, by the way, any good crowdsourcing campaign, my goal is to build on this goodwill organically and selflessly.

So put on some comfy clothes. Brew yourself a cup of coffee or pour yourself your favorite libation. Relax yourself and let me be your guide. You need do nothing more than enjoy the journey. We're exploring a new frontier here. Something that's evolving before our very eyes. And I plan to provide you with information and strategies that will separate you from the pack.

But remember, at the end of our journey together there will be an "Ask."

Oh yes, there will . . .

NOTE

1 https://docs.google.com/document/d/1ELrUgZc7YOUH4A1J0zQ8I6sPm5IEEppWH
4rnNCwiSeo/edit

2

Let's Get One Thing Out of the Way, Shall We?

As I mentioned in the previous chapter, my intention with this book is to provide you with all the tools you need to understand and master the tenets and strategies associated with crowdsourcing. My goal is to get you to the point where putting those tools into practice becomes as natural as breathing. We have much ground to cover, and, as you'll shortly see, much of that terra-not-so-firma has shifted over the last decade plus. As we will soon discover and explore, this is because crowdsourcing is a relatively new term and, as such, has no tried and true definition attached to it. That may sound a bit scary or even might make you concerned that this journey will be fraught with ambiguity. You may even be thinking that I might leave you with more questions than when I found you. Let me assure you right here and right now that the opposite is true. While the definition of crowdsourcing is seemingly shape-shifting before our very eyes, it's because the intelligentsia, in their own well intended but erudite way has, with all due respect, overcomplicated the situation. And what did I tell you one of my jobs would be? What did I promise you?

Simplification.

And that you will have.

What we must first come to understand, however, is that the evolution of how crowdsourcing works or, perhaps better yet, how it's perceived to work, is in a constant state of flux. That, too, is OK. For you'll also come to understand that if we can get the basic theories, philosophies and, perhaps most importantly, psychologies down, adapting to the changing tide and thriving in an evolving environment will not only be a snap, it will become second nature. So, fear not. We will get to a clear and simple end point of how we will define crowdsourcing going forward. First, we have some work to do.

Since this is the very first book on film crowdsourcing, we'll be covering a ton of unexplored territory and virgin lands as well. Sounds exciting and exotic, no? Think of yourself as Magellan, Drake, Cousteau and Armstrong all rolled into one. You are going to be pelted with hailstorms of information. But, I promise you that in the end, you'll look back with the warm glow of nostalgia that only the mind's eye can provide and remember those hailstones landing on your skin as gently as powdery, cotton ball shaped snowflakes.

Have I made this romantic enough for you yet?

So, again, don't let the shifting shapes of the so-called "known" and the anxieties of the "unknown" intimidate you. To the contrary, the mere prospect of this journey should be met head on with anticipation and excitement, and with the knowledge that, simply by virtue of having completed the journey, you will have a competitive advantage over others looking to gain attention or traction for their film projects.

I am going to demystify, clarify and, yes, simplify the crowdsourcing process and everything that goes into designing a successful crowdsourcing strategy and running a successful crowdsourcing campaign.

Consider me your Zen-minded Sherpa.

I promise you safe passage.

UNPACK YOUR BAGGAGE

What's that you say, RB? I thought you just told me we were going on an exciting and exotic journey. And now you want me to unpack?

Yes. Yes, I do.

Here's why.

A ton of research was put into the plotting, planning and writing of this book. Polls and focus groups were commissioned not only by Focal Press, the fine publisher of this tome, but by yours truly. We posed a myriad of questions to film creatives of varying age and experience regarding varying aspects of film crowdsourcing. We sought not only answers, but also to measure the level of conviction within the answers—in short, how certain or assured people were in their responses.

At first, we did this on a micro level. We drilled down to various aspects of launching and sustaining a crowdsourcing campaign. What became immediately obvious was that a large swath of those polled and those in the focus groups were confused by many of our questions. We took a step back and examined our queries. On the surface, they not only seemed to be rational, but (and believe me, we checked every one of them) they were also written in perfect English. So we tried again, and again, and again. And then the problem finally dawned upon us. We were asking questions on a micro level when we should have been asking them on a macro level. In other words, we were asking about methods and strategies about crowdsourcing without recognizing this issue:

A majority had no idea what crowdsourcing truly was.

And that should have been the first (the macro) question.

So, again, we stepped back and refocused our efforts, finally settling on two basic questions . . .

WHAT IS YOUR DEFINITION OF CROWDSOURCING? AND HOW CONFIDENT ARE YOU IN YOUR ANSWER?

Yeah, I know . . . Pretty obvious, huh? And what did I just say about the intelligentsia and their erudite ways?

Listen, I'm good intentioned. I was cutting caffeine out of my diet at the time. I was a little slow on the draw. But we're here now and I have some really interesting results to share, so cut me some slack, would ya?

Thanks.

Now, we could have gone in with "Do you know what crowdsourcing is?" with "Yes" and "No" checkboxes. But because there are many aspects to crowdsourcing and to the methodologies and strategies of running a campaign, we believed by asking for only a positive or negative response, we were leaving ourselves open to the potential of a large number of false positives.

By having those polled and those in the focus groups provide a detailed answer, we would be able to see not only the variance in the responses, but the accuracy of the responses as well.

Further, by asking them to answer the second question, we would be able to understand if there was a correlation between a particular answer *and* the respondent's confidence level.

Let's look at those two questions again for reference.

1 What is your definition of crowdsourcing?

2 How confident are you in your answer?

Here's a taste of what we discovered (see Figure 2.1):

▶ **Nine percent** of all responders were not in the ballpark when it came to their definition of crowdsourcing or when attempting to explain what they believed went into a crowdsourcing campaign. Whether it was speaking to an offline or online approach, there was a complete misunderstanding as to either the definition of the term or the strategies one takes in the running of a campaign.

Of this group, 61% were extremely confident in their responses.

▶ **Seventeen percent** of all responders were in the ballpark when it came to their definition of crowdsourcing or when attempting to explain what they believed went into a crowdsourcing campaign. But they were sitting in the cheap seats. Some connected crowdsourcing with driving an audience to a film. Others thought it involved building a fanbase on social media. Others still thought it had to do with rallying a crowd—leading

an actual (live) rally—in an effort to drive donations for a film or cause associated with a film and so on. (I'm happy to report that there are small truths in the thoughts above, but they're parts of the whole: tiny, fragmented pieces of the puzzle.)

Of this group, 74% were extremely confident in their responses.

▶ **Two percent** of all responders were not only in the ballpark, they were on the pitcher's mound, having a very comprehensive and accurate answer when it came to their definition of crowdsourcing or when attempting to explain what they believed went into a crowdsourcing campaign. Those fitting into this group combined various strategies and identified numerous initiatives in pre-campaign, campaign and post-campaign areas.

Of this group, 83% were extremely confident in their responses.

I know what you're thinking: 9% not in the ballpark, 17% in the ballpark, 2% on the pitcher's mound. That's 28% of the responders? What happened to the other 72%?

Patience, my dear Padawan.

Let's first take a look at that 28% and overstate the obvious: Only an infinitesimal amount (2%) of those polled and those from the focus groups had a well rounded picture as to the definition of crowdsourcing, as well as a broad worldview of what a crowdsourcing campaign entails. Taken as a group above, this was not all that surprising. Again, crowdsourcing is a relatively new term and concept for many. To illustrate further, we asked some follow up questions, one of which was: When did you first hear of the term "crowdsourcing"? A whopping 67% answered: Within the last 12 months. So, again, we were not all that surprised that the answers as to the definition of crowdsourcing were askew.

However.

What *was* more than a bit surprising was the confidence level of all those polled. You'll notice that as the accuracy of the definition of crowdsourcing and the strategies associated with running a crowdsourcing campaign grew within each subsection, confidence in the answers grew as well—from 61%

in the fully incorrect responses to 74% in the partially correct responses to 83% in the completely correct responses.

All of us working on the polling and focus groups expected confidence levels in the 20–30% range. That's pretty standard for targeted polled and focus group people who are interested in a subject that has such a high unfamiliarity factor. Yet, here we were showing results ranging much higher. I was so blown away by this, I had no choice but to go searching for an explanation to the anomaly.

I found my answer in the group representing the 72% unaccounted for.

This group believed crowdsourcing to have a cut and dry definition. They shared a commonality (however, a very broad commonality given the various moving parts of what they were defining) of what planning and strategies were involved in the process of carrying out their definition. Many responses were of the puffed chest, "I-Know-Better-Than-Most" variety. Nearly half of the people representing this subsection said they had put their strategies into practice in the form of a campaign. However, less than one in five claimed to be successful at it (many others offered a wide variety of excuses as to why they hadn't been successful). Over half of the people in this group said they

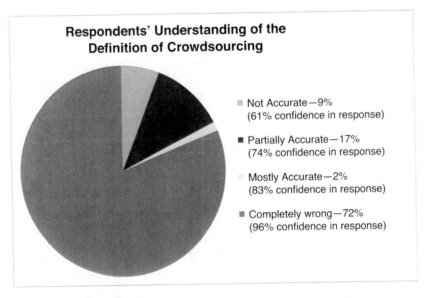

Respondents' Understanding of the Definition of Crowdsourcing

- Not Accurate—9%
 (61% confidence in response)

- Partially Accurate—17%
 (74% confidence in response)

- Mostly Accurate—2%
 (83% confidence in response)

- Completely wrong—72%
 (96% confidence in response)

FIGURE 2.1 Respondents' Understanding of the Definition of Crowdsourcing.

planned to put their strategies into practice within the next six months and were overwhelmingly confident that they would succeed.

Now here's the kicker . . .

96% of the people polled from this group were extremely confident in their responses.

One hundred percent of them were dead wrong.

And here's why . . .

Crowd*sourcing* is not the same as crowd*funding*.

CLEARING UP A COMMON MISTAKE

In November of 2013, I was leading a panel on film crowdsourcing at the American Film Market (AFM) in Santa Monica titled *Crowdsourcing Your Audience*. As you might imagine, I was a bit nervous, not because I get nervous in front of crowds (well, maybe partially), but simply because this was a very new subject and the first panel of its kind at the market. I had spent the eight weeks since being selected to run this panel (an honor and responsibility I took extremely seriously) doing phone interviews and taking coffee and dinner meetings with anyone who I felt might lend some insight into confusion within the industry regarding the subject of film crowdsourcing, as well as soliciting potential questions I might ask the panelists. What I discovered was that the more people I spoke with, the broader and longer my potential question list became. Many times, I had to explain to the person I was interviewing or meeting with that I was asking about crowd*sourcing*—not crowd*funding*—thoughts and strategies. This both scared the living hell out of me and enthralled me at the same time. On the one hand, the unfamiliarity of the subject allowed me the freedom to believe I would have a wide berth as to what questions I could ask. On the other hand, there seemed to be no hard and true facts or tenets regarding film crowdsourcing to build a base upon and expand outward (as is the goal of any qualified and aware moderator). I couldn't help but feel I was heading into choppy seas in a rickety boat without a life preserver.

Fortunately, for me, my nerves were somewhat tempered by the fact that a who's who of panelists had been recruited from the powers that be at the

conference, including Rikk Galvin, Principal at RGM Global; Susan John-ston, Founder and Director of the New Media Film Festival; Christian McGuigan of Participant Media (a production company extremely active with crowdsourcing); and Jonathan Reiss, who had just been named one of *Daily Variety*'s Top 10 Digital Directors to watch. This was one accomplished and knowledgeable group. And one I would lean on with the full weight of my insecurities.

By the end of our first strategy meeting, and even though they had wide and varying thoughts on the subject themselves, I had whittled over 200 potential questions down to 50. After speaking with them and soliciting some thoughts, I narrowed the list to the ten I believed would not only cover the most ground without being too broad, but would also inspire further questions from the crowd. AFM likes their panels to be extremely interactive, and with an estimated 1,000 people planned to be in attendance, I wanted to make certain that there were enough triggers in my queries to guarantee maximum interest, curiosity and, ultimately, participation.

Before we hit the stage for our 90-minute session, I was handed an iPad. Instead of the usual hand raising or people lining up at a microphone and waiting their turn, the crowd had received instructions on how to submit their questions electronically. I would have a dedicated screen on which I would be able to view queries from the audience in the order they were submitted. From there, I could peruse the list and pick the questions I felt were most beneficial to keeping the conversation flowing. My plan was to go to the audience early, very early, as soon as all the panelists introduced themselves and made their opening remarks. I wanted the room into it and engaged from the jump.

Assisting in warming up and priming the crowd was Nicolas Gonda, producer on a number of Terrence Malick films, CEO of the theatrical event crowdsourcing platform Tugg (www.tugg.com) and also the guy kind and magnanimous enough to write the foreword of this book. Nick had just enthralled the masses with a 15-minute keynote on crowdsourcing (which we will read, review and examine a few chapters ahead). He had the room on a string; completely engaged, laughing, clapping and wide-eyed with interest the whole way. I could feel my pulse steadying. This was going to be a walk in the park after all.

We take the stage and I ask the panelists to introduce themselves, explain what they do for work and how that work relates to or involves crowdsourcing.

Everyone rises to the occasion, giving clear examples of how crowdsourcing either impacts their work or projects they have developed. While they address the crowd, including pertinent details related to why they are qualified to speak on the subject of crowdsourcing, I steal glances at my iPad and see that I already have over 20 questions in the queue. Awesome.

Then I start scrolling.

"How do I raise money for a crowdfunding campaign?"

"What's the best crowdfunding platform?"

"With so many people running crowdfunding campaigns, how do I stand out?"

And my favorite:

"What the hell are you guys babbling on about? This has nothing to do with running a crowdfunding campaign. How do I get a refund?"

A cold chill hits the back of my neck. I peek at my watch. A mere 81 minutes to go.

Let me fast forward to May of 2015. Stage 32 had been invited to present at the NEXT Pavilion at the 2015 Cannes Film Festival Marche du Film. The NEXT Pavilion highlights companies bridging the gap between tech and entertainment. Naturally, all of us at the company were quite thrilled to be offered such a prestigious honor, even more so when we discovered we would be presenting in the same program as such well regarded and established companies as Netflix, Amazon and Indiegogo.

Part of our two-week responsibilities at the fest included giving a talk on the subjects of social media and crowdsourcing for filmmakers. Amanda Toney, the Managing Director of Stage 32, and I had prepared a roughly 70-minute talk leaving open the last 20 minutes for a question and answer session.

The NEXT pavilion is located right along the marina—as beautiful and serene a setting as one can imagine. And because the pavilion is a half closed, half open-air structure, on a normal French Riviera day in May, the warm air flowing off the water creates a comfortable and relaxing setting.

On a *normal* French Riviera day in May.

On the afternoon of our talk, temperatures soared into the 90s. Further, Mother Nature had decided to power down the warm flowing air. The pavilion was muggy and the crowd, packed shoulder to shoulder, was immediately restless. Wanting to make sure we engaged the audience early and often, Amanda and I decided to change course.

We began our presentation by giving an overview of what crowdsourcing means, along with a firm and clear definition of the term. We then discussed some basic strategies of how social media ties into a crowdsourcing campaign, and how I used crowdsourcing strategies to build the community of Stage 32 from 100 of my closest industry friends to over half a million people within four years. This all took about 15 minutes. We were certain, however, that we had presented enough information and ideas that would generate a myriad of questions. So we opened up the floor to the crowd and waited for our first inquiry.

Instead, we received a statement from a very cocksure and sweaty filmmaker from Prague.

"None of this has anything to do with crowdfunding."

He was right . . .

And oh so wrong.

Since the panel at AFM, I've had the honor and pleasure of speaking all over the world on crowdsourcing and film crowdsourcing. I can say with total accuracy that there hasn't been one occasion where someone or some group hasn't confused crowdsourcing with crowdfunding.

Further still, almost inevitably over these last ten months or so, when I've mentioned that I am writing a book on film crowdsourcing, I've been hit with questions and statements such as:

"Is it going to go into detail on how to run a Kickstarter campaign?"

"Don't you think crowdfunding is just a fad?"

"Oh good, I'm planning on raising money for my feature this year."

So when I discovered that 72% of the people from the polling and focus groups had mistaken the definition and strategies for crowdsourcing with those associated with crowdfunding, let's just say my eyebrows didn't arch all that much. But when I saw that 96% of the people in this group were extremely confident in their responses—a full 13% more than those who had the *correct* definition and strategies—my eyebrows arched so high, they scraped paint off the ceiling.

Which brings me back to the gentleman at Cannes who so bluntly told me that my talk regarding social media and crowdsourcing has nothing to do with crowdfunding. I said that he was right, but oh so wrong. I'll explain that conflicting thought in just a second, but first let me give you some good news and bad news. Let's get the bad news out of the way first.

The bad news is if you thought this book was strictly going to be about information, strategies, tips and tricks on how to raise money for your film project through running a crowdfunding campaign, I'm afraid that will not be the case.

Wait! Don't close the book! I said there was good news too, right?!

The good news is that within every single successful (key word) crowdfunding campaign—pre-campaign, during the campaign and post-campaign—there exists elements of crowdsourcing.

Every. Single. Campaign.

Additionally, the methods through which you will promote your campaign, be it social media, chat boards, blogs, offline efforts and the like, also will contain elements of crowdsourcing.

Now here's the really, really good news. Not only are we going to cover all the methods I mentioned above, not only am I going to present multiple case studies where funding for the project at hand was raised through successfully crowdsourced crowdfunding efforts, but I also have two extremely detailed chapters dedicated strictly to the subject of crowdfunding.

Am I still on the positive side of your graces? We all good?

Disco.

Now, lest you think I was cruel enough to leave those audience members who didn't know the difference between crowdsourcing and crowdfunding hanging, I certainly did not. I try to educate and enlighten wherever I go and, of course, here is no different. So . . .

Crowdfunding, simply put, is the practice of funding a project or venture by raising small amounts of money from a larger number of people (the crowd) via online or offline efforts.

What's crowdsourcing you ask?

Sensei says, in time, grasshopper.

As Plato said, "He who rushes headlong into love will fare far worse than if he cast himself from a precipice."[1]

That has absolutely nothing to do with crowdsourcing, but I like the quote. If you happen to be considering rushing headlong into love, consider this a bonus lesson.

Now . . .

I SAID, UNPACK YOUR $@&*#@ BAGS!

As my fifth grade math teacher, my high school baseball coach and my bookie used to preach, the numbers don't lie. Taking what we learned from the polls and the focus groups, 98% of you have zero to limited knowledge as to what defines and constitutes crowdsourcing or instituting and conducting a crowdsourcing campaign. So I'm asking you to wipe your mind clean of all the preconceived notions and ideas you had about this subject when you first cracked open this book. I mean scrub your mind as if you were a spy awake with the knowledge that you're ten minutes from being captured. I want you traveling light and picking up trinkets of knowledge along the way.

For the other 2% who have a good grip on crowdsourcing basics, congratulations on not only educating yourself and putting the information you've learned into practice, but for buying this book. This means you believe there is more to be gained on the subject. And as someone who believes in

learning something new every day and preaches self-education everywhere he goes, I salute you. I also promise you I will not let you down. I can tell you with certainty that I came to the writing of this book thinking I had all my bases covered. Man, did I learn a hell of a lot along the way.

So . . . for better or worse, we're in this together.

What do you say we start our journey, OK? Now that we've cleared up what crowdsourcing *is not*, let's start exploring what it actually *is* and how we can put the aforementioned tenets and strategies into practice so that we can rise above the noise and stand out from the competition.

Let's ride.

NOTE

1 http://www.picturequotes.com/precipice-quotes/2

3

So What the Hell Is Crowdsourcing Anyway?

Damned if I know.

Trip over.

I kid, I kid!

But it is a valid and vital question and, as we're about to discover, one to which the answer is quite fluid. It's also certainly one we need to explore as a first marker on our journey. Now, don't worry, this is not going to be one of those dry as sand history textbook lessons that is going to make you want to line Fluffy's litter box with pages from this chapter while cursing me under, or perhaps above, your breath. I promised you fun. I also assured you that my goals were to present myself as a reliable and empathetic figure as well as a reliable narrator. You don't think I want to blow my chances to woo and win you over this early in the game, do you? Of course not.

To the contrary, my goal here is to not only give you a comprehensive overview of crowdsourcing, but to illustrate that the basic tenets and strategies associated with and involving crowdsourcing have been practiced for eons, long before the word ever escaped man's lips.

Further, having spoken and mentored for a number of years now on the subject, I know that many of you reading this book, particularly those new to the principles of crowdsourcing, find it to be confusing at best and overwhelming at worst. Allow me to take your anxieties away by stating that what you're feeling is completely understandable. There simply isn't a wealth of information out there as to what crowdsourcing truly embodies (and even less as it relates to film crowdsourcing). Further still, much of the information that's out there is either vague or contradictory. The simple explanation for this is that the term is hardly a decade old and, when initially introduced, was strictly tied to the internet. And if you've been around the World Wide Web long enough, you know that any online innovation that is defined as something today will surely carry an altered or completely different definition tomorrow. So, as I asked you in the last chapter, now is the time to wipe your mind clear, *Total Recall* style, of everything you think you know about crowdsourcing. Now, like any good meditation session, open your mind, feel your shoulders releasing free of stress and maybe even chant a few Oms. I'll wait.

There . . . Doesn't that feel amazing?

For those of you who are new to the subject of crowdsourcing, again, based on my experiences, you may not be clouded by fuzzy research. But, odds are, you've come to this book with some preconceived notions on the subject. I'm going to ask you to leave those preconceived notions at the door. You are free to do some more Oms. Again, I'll wait.

You look relieved already.

That's why I'm here, not only to give your central nervous system relief and unclog your synapses, but to take this plethora of information and jumbled messages and distill it down to what you will need to successfully run a crowdsourcing campaign.

Again, I'm here to *simplify*.

Remember, this is the first book ever on *film* crowdsourcing, so we're blazing a new trail here. That's not to say that we can't learn from what's come before or that we shouldn't explore the origins of the subject at hand. In fact, I believe it's imperative that we do so in an effort to understand how we arrived at this very moment. There's an undeniable evolution at play.

Based on everything I've spelled out thus far, this might not surprise you. What may surprise you, however, especially given the World Wide Web (as we know it) is barely a couple of decades old, is just how long this evolution has been in progress.

I promised you this would not be a dry lesson, and it won't be! But just in case you have doubts, I'm throwing in a drinking game. Pour yourself your favorite libation and get ready.

Got it? Good.

Let's dig in.

A BRIEF, IF NOT SOMEWHAT COMPREHENSIVE, HISTORY OF CROWDSOURCING

Consider that in the 11 months I did research for this book, the first two paragraphs defining crowdsourcing on the Wikipedia (www.wikipedia.com) page dedicated to the subject have changed (in some capacity) no less than *15* times by my count. That's more than one alteration to the definition and explanation of crowdsourcing per month. Even the world's best and more capable (cough) Wikipedia editors can't get it right! And since Wikipedia is considered to be a crowdsourced platform itself, what hope do we have?! It's madness, I tell you, madness! We might as well just wrap this whole thing up. Throw in the towel. Call it a day.

What's that? You want to soldier on? I dig your style. Let's solve what Wikipedia can't on our terms, shall we? In fact, let's go against everything your mother told you about making assumptions and make some of our own.

Given the sheer number of tweaks and outright changes on the Crowdsourcing page of Wikipedia, and in an attempt to narrow the scope of what crowdsourcing truly embodies, I believe we can posit two things:

1 Crowdsourcing is a fairly new term with no universally accepted definition.

2 There is no hard and steady accepted criteria to crowdsourcing.

I've posited. Let's explore.

If there is one thing the masses (even the crowdsourced masses of Wikipedia) can agree upon, it's that the term crowdsourcing is, indeed, fairly new. The origins of the word can be traced back to 2005, when Jeff Howe and Mark Robinson, both editors at *Wired* magazine at the time, introduced the word during conversations on how businesses were using the internet to outsource work to individuals. I'll come back to that notion in just a bit. But first, since this is one area of the Crowdsourcing page on Wikipedia that hasn't changed a bit since the launch of my research, allow me to post the rest of that section from the site:

> Howe and Robinson came to the conclusion that what was happening was like "outsourcing to the crowd," which quickly led to the portmanteau "crowdsourcing." Howe first published a definition for the term "crowdsourcing" in a companion blog post to his June 2006 *Wired* magazine article, "The Rise of Crowdsourcing," which came out in print just days later:
>
> > "Simply defined, crowdsourcing represents the act of a company or institution taking a function once performed by employees and outsourcing it to an undefined (and generally large) network of people in the form of an open call. This can take the form of peer-production (when the job is performed collaboratively), but is also often undertaken by sole individuals. The crucial prerequisite is the use of the open call format and the large network of potential laborers."[1]

So that was crowdsourcing "simply defined" in 2006. In summary, we have a new term coined by a couple of very intelligent (they used the word portmanteau!), dare I say visionary, men, which, at this moment in time, is more or less tied to employers moving individuals and/or a crowd for the purposes of eventually finding a collaborative labor force to outsource functions normally undertaken by employees.

As we'll discover, based on evolution, this is now considered to be an embryonic and somewhat myopic viewpoint. But that doesn't mean the notion and definition wasn't revolutionary (or even correct) at the time. In fact, this concept of an open call system as a method to increase workflow was so widely accepted as a new norm that companies rushed to institute aspects of open call crowdsourcing into their businesses. A major and lasting example of this was Amazon introducing and launching Mechanical Turk,

a crowdsourced internet marketplace (and one of Amazon's Web Services sites) in 2005. The Mechanical Turk platform was launched to enable individuals and businesses to coordinate the use of human intelligence to perform tasks (such as choosing alluring photos for an internet landing page, filling out a survey, categorizing and cataloging a website's image database) that computers were unable to handle. Within the internet marketplace, employers would be able to post jobs, also known as Human Intelligent Tasks (or HITs), and workers (affectionately known as Turkers within the marketplace) would then be able to browse those jobs and complete them for a monetary payment set by the employer.

As I sit here typing this sentence, Mechanical Turk is considered to be the world's largest and most heavily used crowdsourcing platform (although one could argue that more people use one or many of the broad based social media platforms strictly for their crowdsourcing needs and purposes. But I digress). However, as I've outlined and explained Mechanical Turk to you, does it sound anything different than a common job/outsourcing/freelancer board or site where people offer services for pay? I certainly don't think so.

So here in 2005/2006, we have this new term which is tied to labor and, seemingly, has more to do with *individual* sourcing (my creation, not an actual word, but I'll be lobbying Oxford and Webster's) than crowdsourcing. Still, the mere fact that Howe connected the idea of "taking a function . . . and outsourcing it to an undefined (and generally large) network of people in the form of an open call" is enough to back pocket. What we have here are some seeds planted in extremely dry soil.

Let's move on by going back to Wikipedia and see what we can cull from the next listed piece of information:

> In a February 1, 2008 article, Daren C. Brabham, "the first [person] to publish scholarly research using the word crowdsourcing" and writer of the 2013 book, *Crowdsourcing*, defined it as an "online, distributed problem-solving and production model."[2]

At first blush, this definition might seem a little, one might say . . . slight? Vague, perhaps? However, Brabham's book, *Crowdsourcing*, was published by MIT Press' Essential Knowledge Series.[3] So, not only do I have no inclination to match wits with him *Good Will Hunting* style (and, yes, I know

that was Harvard, but a joke is a joke), but I'm going to give him the benefit of the doubt that he knew exactly where he was going, and that his brevity of style and substance was intended. But I still believe there is a point to be made here. To illustrate that point, I'm going to omit the word "online" from the Brabham definition. The reason: In 2008 (and, as we'll see shortly, beyond), we were still associating all things crowdsourcing with online audiences and platforms. As we move along, we'll examine why, especially as it relates to film crowdsourcing, specifying and limiting these methods and actions associated with the term to online activity and action is simply and plainly incorrect.

So let's concentrate on the remainder of Brabham's 2008 definition of crowdsourcing: "distributed problem-solving and production model."[4] Now we're getting somewhere. The idea of taking a problem (beyond the scope of labor issues), disseminating the information causing the problem and asking a group of unknown individuals to come together to solve the problem is an evolutionary baby step from Howe's 2006 definition. For starters, in its brevity, Brabham's definition is infinitely more inclusive. He's not limiting himself to speaking only about labor or workforce problems that need to be solved. Further, while Howe suggests that crowdsourcing can take the form of "peer-production," he also makes it quite clear that the solving of a particular problem is "often undertaken by sole individuals"[5] (I've heard that three's a crowd, but one? Perhaps, I guess, if you have voices in your head. If that's the case, please tell them to pipe down . . . I'm trying to make a point here). I think it's entirely valid to argue that Brabham's use of the word "distributed" alone suggests that he believes that the problem-solving to be performed would be handled more efficiently and effectively by the masses. This is important to note. While the root of any crowdsourcing effort or campaign can certainly begin with one individual, it's those individuals coming together as one to form the crowd that causes a message to resonate. In this instance, it truly does take a village, um, crowd.

Still, even though we are now beginning to get a more rounded view of the definition and purpose of crowdsourcing, we still do not have complete delineation of the whos, hows and whys.

So let's fast forward to 2012 and check in with Enrique Estellés-Arolas and Fernando González Ladrón-de-Guevara, who not only have killer dime store romance novel names, but are also researchers at the Technical University

of Valencia. They, too, are mentioned on Wikipedia's page as a trusted voice in putting forth a definitive definition for crowdsourcing. But instead of copying what's listed on Wikipedia, I've pulled this more comprehensive overview of their findings from *Advances in Crowdsourcing* written by Fernando J. Garrigos-Simon and Ignacio Gil-Pechuán:[6]

> In 2012, Estellés-Arolas and Fernando González Ladrón-de-Guevara sought through a literature review different crowdsourcing definitions. The purpose of their research was to extract all the elements which would allow distinguishing between crowdsourcing and any other internet initiative.
>
> After analyzing more than 200 documents, they found more than 40 different definitions. The authors identified within these definitions eight fundamental elements that any crowdsourcing initiative must contain. These elements are as follows:
>
> 1 There is a clearly defined crowd.
>
> 2 There exists a task with a clear goal.
>
> 3 The recompense received by the crowd is clear.
>
> 4 The crowdsourcer is clearly identified.
>
> 5 The compensation received by the crowdsourcer is clearly defined.
>
> 6 It is an online assigned process of participative type.
>
> 7 It uses an open call of variable extent.
>
> 8 It uses the internet.

As a result of this research, its authors developed a definition of crowdsourcing, which although being wordy, defines in detail the concept. The definition is as follows: "Crowdsourcing is a type of participative online activity in which an individual, an institution, a nonprofit organization, or company proposes to a group of individuals of varying knowledge, heterogeneity, and number, via a flexible open call, the voluntary undertaking of a task. The undertaking of the task, of variable complexity and

modularity, and in which the crowd should participate in bringing their work, money, knowledge, and/or experience, always entails mutual benefit. The user will receive the satisfaction of a given type of need, be it economic, social recognition, self-esteem, or the development of individual skills, while the crowdsourcer will obtain and utilize to their advantage that what the user has brought to the venture, whose form will depend on the type of activity undertaken."

Whew! Much to review here, but before we do . . . The secret magic word makes its first appearance . . . HETEROGENEITY! Everyone drinks!

See, this is fun so far, right?

Terrific! Let's move on.

So, this definition is a little more, how shall we say . . . involved? Unlike Brabham, Estellés-Arolas and González Ladrón-de-Guevara are really covering all their bases here. But my fear is that while navigating this virtual minefield of erudite observation, the lead has been buried. Let's raise it above the dirt.

Estellés-Arolas and González Ladrón-de-Guevara analyzed *200 documents* and found more than *40 definitions*! In case the italics, the bold type and the exclamation point didn't provide enough emphasis, allow me to repeat.

200 documents.

40 definitions.

Holy, doesn't anyone know what the hell they're talking about here, Batman?!

I do.

Stay with me.

Looking at the eight elements (numbered 1–8 in bold above) that a crowdsourcing initiative must contain, as laid out by Estellés-Arolas and González Ladrón-de-Guevara, we see a few repetitive concepts, a couple of familiar, yet evolutionary concepts and three revolutionary, game changing concepts. Let's break them down.

Repetitive Concepts

1 The Crowdsourcer Is Clearly Identified

The most basic of concepts as it relates to the term. To source a crowd, one must do the sourcing. This notion is first introduced by Howe in his 2005 definition by identifying (however limiting) "a company or institution" and expanded upon here with Estellés-Arolas and González Ladrón-de-Guevara adding "an individual" and "a nonprofit organization."

2 It Is an Online Assigned Process of Participative Type

This element falls in line with all previous definitions in the belief that all crowdsourcing initiatives occur online. The entire statement, specifically that crowdsourcing entails an "assigned process of participative type," can be tied neatly to the part of Brabham's definition speaking to crowdsourcing being a "distributed problem-solving and production model."[7]

3 It Uses the Internet

Still a prevailing thought in 2012 and a constant in all definitions we've reviewed thus far.

Familiar, Yet Evolutionary Concepts

1 There Exists a Task with a Clear Goal

Sure, you can read the Howe definition and make a strong argument that this element should appear in the Repetitive Concepts section above. We've already discussed the fact that Howe's definition of crowdsourcing is tied to labor and that it is a company or institution that is doing the crowdsourcing in an effort to outsource a "function" through an open call. Presumably the crowdsourcer and the individual or crowd being sourced has a clear idea of what the task at hand encompasses and that the goal or identifiers associated with completing the task have been delineated. But I think the argument falls apart with this line from the Estellés-Arolas and González Ladrón-de-Guevara definition:

> The undertaking of the task, of variable complexity and modularity, and in which the crowd should participate in bringing their work, money, knowledge, and/or experience always entails mutual benefit.

The adding of parameters and qualifiers, to me, signals an evolution in what constitutes a clear goal. That's enough to see it as progressive. Further, if we can color outside the lines for a moment (go ahead, it's fine!), we'll discover as we move along that sometimes there is more than one goal to be achieved within a crowdsourcing initiative, furthering the need for clear, concise tasks and goals. And although that concept isn't quite raised here, I believe the spirit exists in embryonic form.

2 It Uses an Open Call of Variable Extent

The idea of an open call can be traced back to Howe's *Wired* article, where he called the open call format a "crucial prerequisite" and stated that the task to be outsourced should be brought to a "network of people in the form of an open call."[8]

Estellés-Arolas and González Ladrón-de-Guevara carry this notion forward with one slight, but remarkably important, difference:

> Crowdsourcing is a type of participative online activity in which an individual, an institution, a nonprofit organization, or company proposes to a group of individuals of varying knowledge, heterogeneity, and number, via a flexible open call, the voluntary undertaking of a task.[9]

Hey-Yo! . . . HETEROGENEITY . . . Everyone drinks again!

Blink and you might miss it, but the word "flexible" before "open call" allows for a more targeted and, if need be, adjustable approach. I even like the word "variable" in the element title above, which suggests that more than one open call, and, therefore, more than one task or goal, may need to be performed. But the impact of this subtle change is far more reaching and important. It also serves as a perfect segue into our . . .

Revolutionary, Game Changing Concepts

1 There Is a Clearly Defined Crowd

Now things are getting really interesting. So, we've gone from Howe's open call to Estellés-Arolas and González Ladrón-de-Guevara's flexible open call, which, as we discussed above, has an impact on what tasks and goals need

to be attacked. But what about who is going to be doing the attacking of said tasks and goals?

In previous definitions the idea of who was to be targeted via an open call was open-ended or, at the very least, ambiguous. Here we have Estellés-Arolas and González Ladrón-de-Guevara referencing focus of the crowdsourcer's aim as "a group of individuals of *varying knowledge, heterogeneity* (drink again!), *and number . . ."*[10]

In essence, what we have here is Estellés-Arolas and González Ladrón-de-Guevara speaking in what I like to call "general absolutes," meaning that to launch a successful crowdsourcing task (or campaign, if you will), one must, with absolute certainty, identify a clearly defined crowd to be targeted and, eventually, enlisted.

Although their qualifiers of what a clearly defined crowd entails are a bit fuzzy, I believe the spirit of their intention, and the evolutionary step forward in thinking, particularly given the name of the element alone, is quite clear.

2 *The recompense received by the crowd is clear*

 AND

3 *The compensation received by the crowdsourcer is clearly defined*

Color me intrigued. Howe and, in the spirit of Howe's definition, Mechanical Turk, had tied crowdsourcing to labor, specifically to a company or institution taking tasks or functions normally and specifically performed by employees of said company or institution and outsourcing them to an unidentified individual or network of people in the hopes of getting that task or function completed in exchange for *monetary* compensation. So the recompense received from the crowd was, without question, clear. And it could be easily (I believe) argued that the compensation received by the crowdsourcer is equally defined in that they receive a completed project or service in return. Again, isn't this a basic, common concept? Haven't we been trading money for services rendered since the beginning of time? Surely that can't be all there is to crowdsourcing, could it?

Even as a rhetorical question, it's a weak one.

Let's dig deeper.

Brabham's definition mentions nothing about compensation, defined or otherwise, in relation to the crowd or the crowdsourcer. Yet, again, through omission comes inclusion or, at the least, open interpretation. By not tying crowdsourcing to labor and by not tying compensation to money, Brabham leaves open the possibility that crowdsourcing is indeed a more vast and inclusive concept, where the possibilities of what is to be crowdsourced are boundless and where the rewards to both crowdsourcer and crowdsourcee are equally limitless.

Estellés-Arolas and González Ladrón-de-Guevara take this notion one important step further. Let's take this section of the Estellés-Arolas and González Ladrón-de-Guevara definition:

> Crowdsourcing is a type of participative online activity in which an individual, an institution, a nonprofit organization, or company proposes to a group of individuals . . .

You'll recall that Howe's definition from the 2006 *Wired* article specifically stated that crowdsourcing was something undertaken by a "company or institution." Here, with the Estellés-Arolas and González Ladrón-de-Guevara definition, we have the addition of "an individual" and, of lesser concern for us at the moment, "a nonprofit organization." To me, the addition of "an individual" in conjunction with two specific statements speaking to the clear recompense to be received by the crowd and the clear compensation to be received by the crowdsourcer is groundbreaking to the continual evolution of what constitutes crowdsourcing. For starters, prior to this definition, the only time we saw an individual mentioned was on the side of the crowd back in Howe's definition when he suggested that the job or task at hand was "often undertaken by sole individuals."[11] So basically we had a crowd, defined as a company or institution, trying to move an individual to do something for them. Now, even though we're speaking of *crowd*sourcing, it's not entirely incorrect to say that the movement of a crowd cannot begin with the movement of an individual. But, as we've certainly learned through the advent of crowd*funding*, social media and other initiatives and platforms that involve a crowdsourcing aspect, many crowdsourcing campaigns are started and molded by individuals, not companies or institutions.

Further, by not specifically stating that the recompense to be received by the crowd or the compensation received by the crowdsourcer be tied to money,

but be clearly defined, Estellés-Arolas and González Ladrón-de-Guevara are definitively stating the rewards to both the crowdsourcing party or parties and the individual or crowd being sourced is, indeed, infinite.

But there is something much more exciting and revolutionary at play here.

As we've illustrated, up until this point, recompense for the crowd had been tied to money—remuneration for work or a service. Conversely, compensation for the crowdsourcer had been tied to the reception of a completed project. This was true of the Howe definition. It was (and remains) true of Mechanical Turk. But the Estellés-Arolas and González Ladrón-de-Guevara definition changes the game. Let's look at how, first by examining this section:

> The undertaking of the task, of variable complexity and modularity, and in which the crowd should participate in bringing their work, money, knowledge, and/or experience, always entails mutual benefit.[12]

I love the use of "mutual benefit" in this part of the definition. Not to hop on a soapbox (excuse me while I do just that), but this is a notion that is lost on so many when using various strategies—social media for example—toward their crowdsourcing efforts. Often times, the crowdsourcing campaign itself is imbalanced unfairly toward the crowdsourcer. We're going to touch upon this idea quite often as we travel forth. But it's worth bringing up here. Estellés-Arolas and González Ladrón-de-Guevara clearly saw the importance of including those very important two words, which on the surface may seem like an obvious notion, but in reality is not only lost on so many, but speaks to the philosophy and, more important, the psychology involved in running a campaign. That alone is progressive as hell, and I salute them for the inclusion.

Now help me down off this soapbox. Thanks.

OK. So, we have Estellés-Arolas and González Ladrón-de-Guevara saying here that the crowd "should participate in bringing their work, money, knowledge, and/or experience."[13] Based on everything that came before, what do you say we play a game of *Which of These Is Not Like the Other*?

If we examine previous definitions and everything else we've discussed this far, it stands to reason that the crowd, if sourced to perform a job or task, would bring their work, knowledge and experience, wouldn't you agree?

Especially if, as we already know, their purpose for picking up and carrying the torch on a particular project was to get paid.

But did Estellés-Arolas and González Ladrón-de-Guevara just say that the crowd should participate by bringing their *money*? Are they suggesting that the crowd should pay the crowdsourcer to do a job?

Not at all. What Estellés-Arolas and González Ladrón-de-Guevara have done here, quite intelligently, I might add, is lay down the notion that the crowd may be moved to finance the crowdsourcer's project, initiative or cause.

And how, pray tell, in the middle of the second decade of the 21st century, can a crowd be moved to finance a crowdsourcer's project, initiative or cause?

You got it . . . through crowd*funding.*

Our first connection between crowd*funding* and crowd*sourcing.*

And, if we want to take it one step further and tie it into what we talked about in the last chapter, our first piece of evidence that within every crowd-funding campaign there is an element of crowdsourcing.

The worm turns.

As Vincent Gambini asks Mona Lisa Vito when she's on the stand in *My Cousin Vinny*, "Is that it?"

And her response, "No, there's more!"[14]

And so there is here as well. And it's the ultimate game changing concept, in my opinion.

Besides this new thought that the crowd could bring their money as a method of compensation for the crowdsourcer, Estellés-Arolas and González Ladrón-de-Guevara further destroy the idea that the standard idea between the two parties is work for compensation with this:

> The user will receive the satisfaction of a given type of need, be it eco-nomic, social recognition, self-esteem, or the development of individual

skills, while the crowdsourcer will obtain and utilize to their advantage that what the user has brought to the venture, whose form will depend on the type of activity undertaken.[15]

Let's get the obvious out of the way. Estellés-Arolas and González Ladrón-de-Guevara still state that the user can receive economic satisfaction or development of skills. That speaks to money and, of course, the experience that comes from taking on a task or job. In this respect, they're not denying anything that came before. BUT, and it's a big but, the satisfaction, and therefore the recompense, can also be in the form of "social recognition" or "self-esteem."

Psychology 101, anyone?

So the crowd can be moved to act on behalf of the crowdsourcer due to the desire for a more significant place of standing within the community or a feeling of higher worth for oneself.

And where, pray tell, in the middle of the second decade of the 21st century, do the masses go to satiate their desire for a more significant place of standing within the community or a feeling of higher worth for oneself?

Anyone? Anyone? Bueller? Bueller?

You got it . . . on social media.

Our first connection between crowdsourcing and social media.

The worm turns once more.

And, finally, we have what the crowdsourcer, according to Estellés-Arolas and González Ladrón-de-Guevara, can get out of this exchange. Due to the efforts put forth by the crowd, they will not receive simply a completed job or task, but will "obtain and utilize" that which "the user has brought to the venture," which will provide them with an "advantage."

I love this line as well, particularly the use of the word "advantage."

Let me state this clearly. As the person who is doing the crowdsourcing, *everything you do is designed to give you an advantage within the marketplace and, therefore, over the competition.*

By appropriately and directly moving a crowd with a definitive initiative and goal (or initiatives and goals, as the case may be) and executing your plan to perfection, the crowd will deliver you the advantage you seek. It's that simple.

To date, the spirit of the Estellés-Arolas and González Ladrón-de-Guevara definition of crowdsourcing, for me, remains the most whole. It takes the original thoughts passed forth by Howe and Robinson as well as the broad implications of Brabham's interpretation and liberates them from restriction and speculation. By expanding the scope of what constitutes a clear task beyond that of just labor, Estellés-Arolas and González Ladrón-de-Guevara identified crowdsourcing as something not exclusive, but inclusive. By changing the parameters of an open call to a flexible/variable open call, they introduced the idea and importance of targeted crowdsourcing. By opening the landscape as it relates to the identity of a clearly defined goal, it reinforced the importance of targeted sourcing. And, by detaching the idea of recompense and compensation to that of labor and money, and linking it to the philosophical and psychological, they identified that, for many, the thing that moves them to act is to improve themselves as humans and to feel good about themselves.

Further and finally, with more vision than what preceded it, the Estellés-Arolas and González Ladrón-de-Guevara definition presents a worldview that captures the heart and essence of what a crowdsourcing campaign should entail, particularly the fact that any initiative should be mutually beneficial to the person doing the crowdsourcing as well as to the actual crowd being sourced.

So all good, right? We can move on?

Not so fast, my dear Padawan.

Both as written, and with a heavy dose of generosity toward interpreting the spirit of the thing, the Estellés-Arolas and González Ladrón-de-Guevara definition is also inaccurate or, to be favorable, off target in some respects, and simply incorrect in others. The most egregious of these transgressions (so much for being favorable) can be found in regard to the following elements: "It is an online assigned process of participative type" and "It uses the internet."[16] These points are simply untrue. We know that crowdsourcing, and for our specific purposes, film crowdsourcing, can occur online and in, as we'll call it throughout this book, the real world.

But how do we know this, RB?

Because crowdsourcing is hundreds, if not thousands, of years old.

Say what?

Allow me to explain and to take you on a most excellent crowdsourcing adventure.

But first . . .

HETEROGENEITY!

Everyone drinks!

NOTES

1 Wikipedia, s.v. "Crowdsourcing," last modified August 14, 2017, https://en.wikipedia.org/wiki/Crowdsourcing
2 https://en.wikipedia.org/wiki/Crowdsourcing
3 https://www.amazon.com/Crowdsourcing-MIT-Press-Essential-Knowledge/dp/0262518473/ref=asap_bc?ie=UTF8
4 https://en.wikipedia.org/wiki/Crowdsourcing
5 https://en.wikipedia.org/wiki/Crowdsourcing
6 http://www.springer.com/us/book/9783319183404
7 https://en.wikipedia.org/wiki/Crowdsourcing
8 https://www.wired.com/2006/06/crowds/
9 https://en.wikipedia.org/wiki/Crowdsourcing
10 https://en.wikipedia.org/wiki/Crowdsourcing
11 https://www.wired.com/2006/06/crowds/
12 https://en.wikipedia.org/wiki/Crowdsourcing
13 https://en.wikipedia.org/wiki/Crowdsourcing
14 http://www.imdb.com/title/tt0104952/quotes
15 https://en.wikipedia.org/wiki/Crowdsourcing
16 https://en.wikipedia.org/wiki/Crowdsourcing

4

A Most Excellent Crowdsourcing Adventure

Yes, much like our dear friends Bill and Ted, we're going to go on a most excellent adventure back in time so that we can further understand just where and when crowdsourcing began. And, also like our loveable compadres, our goal for taking this trip is to return enlightened and inspired upon our most triumphant return. Unfortunately, we will not be bringing any historical figures back with us, nor will we be giving a presentation at San Dimas High at the end of our tour through history, but we're going to have a blast all the same, I assure you.

Before we commence on our journey, let me clarify what I meant at the end of the last chapter about crowdsourcing being centuries, if not millennia, old. While it's true (at least from most published accounts) that Jeff Howe and Mark Robinson coined the term "crowdsourcing" in 2005, the reality is they just gave a name to what they saw occurring online, particularly as it related to laborers securing work through the use of an open call. But the basic tenets and strategies that govern a successful crowdsourcing campaign have been known to, and executed by, we humanoids for eons.

So let's step into the time travel phone booth that Bill and Ted kindly left behind in the parking lot of the local convenience store ("Strange things are afoot at the Circle K").[1]

Ready, dudes?

Excellent.

Our first stop is ancient Greece in the year 450 BC, where we find ourselves sitting at the foot of the famous historian, Herodotus, also known by the supercool moniker, "The Father of History." Herodotus claims that the ancient Babylonians actually crowdsourced their solutions for the unwell. As we glare into his mesmerizing blue eyes, he proclaims,

> The Babylonians have no physicians, but when a man is ill, they lay him in the public square, and the passers-by come up to him, and if they have ever had his disease themselves or have known any one who has suffered from it, they give him advice, recommending him to do whatever they found good in their own case, or in the case known to them; and no one is allowed to pass the sick man in silence without asking him what his ailment is.

As Herodotus pauses for effect and we adjust our togas, a thought passes—sourcing a crowd to find a solution to various illnesses. In ancient times. Pretty cool. Revolutionary, yet awfully familiar.

CrowdMed, anyone?

2,500 years earlier.

Hmmm . . . Let's move on.

Our next stop is Britain in the year 1714. At the moment, Britain's Navy is considered to be one of the most, if not the most, formidable in the world. And they intend to keep it that way. There's only one problem. Measuring latitude is a piece of cake—simply measure the rise and fall of the sun against a timetable. Measuring longitude on the other hand, well . . . not so easy. Without any accurate measure, let's just say complications have ensued. Britain's Navy has suffered a number of accidents, culminating with a horrific crash off the Isle of Sicily in 1707 when over 1,400 sailors perished. In response to this unspeakable tragedy, yet still at a loss to solve the longitude issue, the British government has turned to the public in the hopes of finding a solution. Anyone who can provide a practical method into discovering how to measure "true longitude" will receive a cash prize from the

Board of Longitude ranging from 10,000 to 20,000 pounds (equivalent to 1.29 to 2.58 million pounds today).

Some of the brightest minds in Britain have come together to solve this problem. The solutions are not only complicated, but evolve over decades. In the end, the 20,000 pound top prize is not issued to one person, but 11 cash rewards are issued by the Board of Longitude, including the biggest, 23,065 pounds, to John Harrison for his H4 Sea Watch, an item which took him 45 years and the help of countless others to perfect.

One other takeaway from this crowdsourced venture, perhaps my favorite, comes from Leonhard Euler and Tobias Mayer, who both received cash awards for their work on Mayer's lunar distance tables. When their prizes are announced, Euler and Mayer both go public to make it extremely clear that they weren't motivated or moved by the potential of receiving money for their efforts, but because they wanted to contribute to the progress and improvements toward navigation and cartography.

This sounds familiar, no? People picking up the torch on behalf of a crowdsourced project not for money, but for the common good? And feeling enriched and fulfilled simply by virtue of their contributions? Where have we heard that before?

That's right: it sounds much like the Estellés-Arolas and González Ladrón-de-Guevara definition of crowdsourcing.

300 years earlier.

Interesting . . . Let's move on . . .

Staying relatively close, but jumping forward a century or so, it's time to visit Oxford, England, in the year 1844. An archbishop (and poet) and two philologists walk into a bar (my note: The bar part is unverified, but that's how I like to imagine it). Over a few mugs of mead they decide that they've had it up to their ascots with the state of current English Dictionaries. Thirteen years later (I guess perhaps they weren't *urgently* pissed off), they act on their frustrations by forming an "Unregistered Words Committee" to search for words that either do not exist or are defined weakly in other dictionaries. They find this task to be, as you might imagine, overwhelming. So, they turn to the public and source a crowd of like-minded participants.

Ultimately, tens of thousands of people are sourced. The reward? Knowing that they are making a contribution and playing a part in something revolutionary. Nothing more. The crowd works together to collate the definitions and origins of every word in the English language.

The project takes 70 years to complete.

The *Oxford Dictionary* is born.

Man, this reminds me of something else as well. A site that was and remains completely crowdsourced and has become the unofficial site of record for finding information on a plethora of subjects?

Ah, I got it!

Wikipedia, anyone?

150 years or so earlier.

Intriguing.

Back into the phone booth!

Hey, it's a New York City dinner party in the year 1979. Wow, take a gander at that gorgeous skyline. On a night like this, you can see forever. And, oh wow, look at those shiny silk shirts! And that hair . . . chest and other! And is that freakin' *We Are Family* by Sister Sledge playing on the stereo over there?

Wait, is that . . . It is! Why it's Nina and Tim Zagat! Holy cow, they look great, don't they? Well, I mean, her more than him. Love her dress. You think it's Gucci? Look at all the people around them. Let's move closer and see if we can hear what they're talking about.

Sounds as if the Zagats are looking to collect and correlate restaurant ratings based on food, décor, service and cost. Who is going to collect and correlate this mass of information? Amateur critics? And what's the end game? To aggregate this information in a book for people to purchase to guide them where to dine? Am I hearing this right?

Look at all the other guests scoffing, trying desperately not to choke on the duck pâté.

I mean, who would want to contribute to that?

How about over 250,000 people across 70 cities at the height of its success?

Yelp, Urbanspoon, Trip Advisor, Airbnb, anyone?

30 years or so earlier.

Fascinating, no?

Well, that was fun, wasn't it? I do think it's time we head back. I think we have had enough for one day. Also, we certainly don't want to take advantage of Bill and Ted's generosity. That would be most heinous.

ALL THE PEOPLE TELL ME SO, BUT WHAT DO ALL THE PEOPLE KNOW?

So what have we learned, dudes? Well, for starters, we have a term that is just over a decade old associated with a premise that's thousands of years old. Yet, this newly minted term is still going through an evolutionary discovery process as it relates to the definition of said term. In fact, going back to where we started, the Definitions section on the Wikipedia page for Crowdsourcing, after listing the Howe and Robinson information and references to the *Wired* article, moving past the Brabham definition, skating down over the Estellés-Arolas and González Ladrón-de-Guevara breakdown, skipping past an opinion by college lecturer Henek Van Hess which we didn't touch on, and moving beyond a sort of back to the future summary from a returning Howe (also from the 2005 *Wired* article), we find this orphan sentence:

> Another consequence of the multiple definitions (of crowdsourcing) is the controversy surrounding what kinds of activities can be considered crowdsourcing.

Come again? What's that now?

Dog, meet tail. Tail, meet dog.

Still, in spite of all these opaque and non-committal readings and interpretations, there are some extreme lessons to be learned from the extensive

breakdown of the definition of crowdsourcing and the historic examples outlined above.

For starters, I think it's very clear that what's tripping everyone up in the modern technology driven era is the commitment to fact stating that crowdsourcing is tied to the internet. Let's throw that out the window. It's an incorrect notion, particularly as it relates to film crowdsourcing, and one we will debunk repeatedly as we continue.

 So let's pull out the important and pertinent facts.

To run a crowdsourcing campaign, you need the following:

► A definable mission and goal (or mission and goals, depending on the initiative).

► A crowd which can be reached by a variable open call, via either online or offline methods, to which you can bring the mission and goal.

► To clearly design and understand what is to be gained (compensation and recompense) by you as the crowdsourcer as well as the crowd being sourced. These goals must be mutually beneficial to both parties.

Let's use these points as a basis for what's to come. In the next chapter, I'm going to do what I've promised: namely, I'm going to expand on the above by simplifying and distilling it down to three concepts (my definition) that will allow you to plan a crowdsourcing campaign with an easy to navigate, compartmentalized approach. Further, we'll see how others have put those three concepts into practice through a variety of case studies.

NOTE

1 http://www.imdb.com/title/tt0096928/quotes

5

The Moment of Truth—My Definition of Crowdsourcing

So here we are. The moment we've all been waiting for—my definition of crowdsourcing. A little melodramatic, I know, but I like to build some momentum and anticipation toward the big moment. I'm a storyteller, after all.

Now, look, I understand that I've thrown a great deal of information at you thus far. Some of it might have seemed a bit dense. Maybe you felt some of it was overkill. I promise you that any misgivings or ill feelings you have toward me will be remedied by the end of our time together and that all the definitions, data and other minutiae presented thus far are not only pertinent, but will serve as support, reinforcement and encouragement as you embark on your film crowdsourcing campaigns. I'm a believer in the notion that to blaze a trail forward, we must look at what came before. In this case, we must understand the roots and evolution of crowdsourcing to fully grasp the concepts and strategies that lie ahead.

Additionally, since my intent is to keep this journey fun and interesting, I have chosen a signpost approach as it relates to the layout of this book. What I mean by this is that I am purposely trying to draw through lines in my narrative. Likely (and hopefully), you'll be digesting this book as a straight narrative, and there's at least a possibility that you will begin reading

it cover to cover again once through. But, over time, you will most likely be thumbing through this book to reread certain sections and hitting certain reference points depending on where you are in the progression of your film crowdsourcing campaign. My intent is to make it easy for you to do so.

This is also why I've chosen not to end each chapter with a homework assignment or worksheets. Yes, there are many individual moving parts to a crowdsourcing campaign. Yes, you will inevitably hit some bumps along the way. And that's OK. But my belief is that a robotic approach to crowdsourcing is a failed approach. While the overall strategies and philosophies can be defined distinctively, within those strategies and philosophies must exist an individuality—your voice, your narrative, your words and actions. And that's not something any homework assignment or worksheet is going to provide you. Quite the opposite: it may just rob you of said individuality. Further, as mentioned, my intention with the narrative here is to keep the flow going, not have stops and starts by bringing each chapter to a crashing halt by forcing you through a checklist of some sort or making you sharpen a pencil to assure me that you've been paying attention

So remember, if properly planned, a crowdsourcing campaign should run smoothly. The individual facets should stream into one another seamlessly and, eventually, without thought—lyrics and music becoming one. This will allow you to react to any challenges or pivots you might have to make along the way with clarity and alacrity. Reaching this level of assuredness will only occur with practice, repetition and trial and error.

Another reason behind my choice of presenting a straight flowing narrative pertains to a mindset I want you to embrace: When you run a film crowdsourcing campaign (once you have your target audience involved and invested), you become a storyteller. You're telling the story of you, your campaign and, perhaps most importantly, your army. And that story should flow as naturally as if you were sitting in a café chatting with your best friend about something terrific that happened to you recently, or perhaps just chilling in a saloon, regaling the masses with your best bar story.

As for the rest of our time together, allow *me* to be a storyteller in an effort to provide you with the necessary tools and confidence *you* need to be a storyteller. The goal is to have you approach your next (or first) crowdsourcing campaign with the ease, likability and charm of a crowd-pleasing raconteur.

With some of the heavy lifting already out of the way, we're going to continue forward not only with an examination as to the best practices of running a successful crowdsourcing campaign, but with a myriad of case studies that will illustrate some of these best practices in action. You will see some common themes over and over, and you will see some unique and innovative strategies—original voices, narratives, words and actions within structured plans and philosophies. You will hear me repeat myself in some cases in an effort to drive a point home. This is by design. As they say, practice makes perfect and repetition makes an expert. Again, the goal is to make the strategies seem obvious and the practices for execution second nature. I want those "A-ha" moments of discovery to become "Of course!" moments of recognition.

And they will . . . I promise you that.

What's that you say? Oh yeah, I'm supposed to give you my definition of crowdsourcing. No, I didn't forget . . .

I'm simply ratcheting up the anticipation.

After all, I'm just a storyteller . . .

A HALF STEP BACK TO MOVE 100 STEPS FORWARD

As I mentioned above, to blaze a trail forward, we must look at what came before. And I realize we've done that already. But, for the purposes of driving toward my definition of crowdsourcing, let's summarize the discoveries we've made thus far.

We've discovered that a majority of the public not only has a somewhat confused or muddled idea as to the definition of crowdsourcing, but also how to go about launching and sustaining a successful crowdsourcing campaign.

We've learned that crowdsourcing is definitively, and without question, not crowdfunding, but that there is (or should be) an element of crowdsourcing within each crowdfunding campaign.

We've read, examined, dissected and compared and contrasted the Jeff Howe/Mark Robinson, David D. Brabham and Enrique Estellés-Arolas

and Fernando González Ladrón-de-Guevara definitions of crowdsourcing, extracting the extremely pertinent nuggets of information we'll use going forward.

We discovered that psychology plays a significant part in all crowdsourcing efforts.

We've learned that Wikipedia can, at times, offer some incomplete or contradictory information (certainly, however, not for lack of effort), and that investigative and research efforts should not begin and end with one source!

We took a trip back in time and discovered that the basic tenets of crowdsourcing have been around for eons.

And, finally, we got quite buzzed playing the HETEROGENEITY drinking game.

Not bad, right?

And, really, not all that dense when simplified and laundry listed, is it?

Yet, if you've forgotten or are still fuzzy on any of the information that we've covered thus far, that's OK. Your inclination might be to go back and reread a certain section of a chapter or an entire chapter altogether. I'm going to kindly suggest that you resist that urge. Again, I would love for you to consume this book as a straight narrative first and use it for reference and to delve deeper into certain touchpoints later. There's a method to my madness here. You may remember at the beginning of our journey together that I said I'm here to *simplify*. I promise to remain true to my word. And here's the evidence . . .

MY DEFINITION OF CROWDSOURCING (AND THE CROWD SAYS, "AMEN")

At the end of the "So What the Hell is Crowdsourcing Anyway?" chapter, we compiled a mashup of the Jeff Howe/Mark Robinson, David D. Brabham and Enrique Estellés-Arolas and Fernando González Ladrón-de-Guevara definitions of crowdsourcing and made some conclusions of what was right, at the very least, spiritually, within. We talked about open calls, the benefits

to the crowd and so on. There's no need to memorize it all. When you do revisit that chapter, either during a second reading or perusing it for reference, you will see that all of our conclusions were indeed evident within the case studies which will follow.

It's now time to simplify these terms in a manner that will make the process less daunting and infinitely easier to manage.

You probably have a reason (or a number of reasons) as to why you would like to run a film crowdsourcing campaign for your project. Perhaps it's simply to build recognition for you and your talents (your brand). Perhaps it's to shine a light on what you believe is a worthy project. Or perhaps you're looking to run a crowdsourcing campaign in an effort to raise funds through traditional avenues or through crowdfunding. Your logic is smart. But as a wise man once said, ideas are as common as air. Execution of ideas is another story.

And this is where most crowdsourcing campaigns fail: In the execution.

Running a crowdsourcing campaign is a journey. It's about curation and cultivation. It's about curiosity. It's about listening. It's about inclusion. It's about an active, yet selfless voice.

It's about patience.

And that's where the failure in execution begins.

This might surprise you, but most people have little patience. With all respect to Queen, we want it all, and we want it now.

Crowdsourcing is a classic walk before you run prospect.

Surely you remember the iconic street running scenes in *Rocky*. The Italian Stallion rises before the break of dawn, treats himself to a tasty breakfast of a glass of raw eggs, stretches out the tight hammies and takes to the streets of Philadelphia to get his road work in. The city is just beginning to wake up, and as he passes through the working class citizens going about their day, Rocky is an unknown and unnoticed commodity—a face in the crowd. Even when he takes his first run at climbing the stairs of the Philadelphia Museum of Art, he's just another sweaty, out of shape jogger in ratty

sweatpants blending into the backdrop. As he was the day before and the day before that, he's invisible to the world at large.

But then something magical happens. As Rocky's narrative becomes public knowledge, more and more people from this blue-collar city begin paying attention. Rocky's a classic underdog story. A club fighter from the neighborhood. He works out in an old school, run down, no frills gym. He trains in a meat packing plant, bludgeoning large slabs of beef as part of his training regimen. At the televised press conferences, he's self-deprecating, generous and humble—a lovable lug. He's egoless, doesn't speak about winning and actually goes out of his way to praise his challenger, Apollo Creed, who does his menacing best to intimidate and bully Rocky. He's portrayed, and, as important, carries himself, as an everyman. Minus these extraordinary circumstances, he's just another guy from the neighborhood. Like the majority of the working class Philadelphians, he's simply trying to get by, live a day-to-day proposition. In short, he's a relatable entity; a reflection of the city and the people within. This isn't an act or some media angle trumped up by a prestigious marketing and PR firm. This is exactly who he is.

This is his story.

This is his brand.

The next time that Rocky goes for his morning run, he begins to get recognized. The people on the street shout his name, root him on. Soon, a few kids begin to run along with him. A few people become a group. A group becomes a crowd. Before long, it seems like the entire city is running with him. When they hit the top of the steps, they celebrate with him. He represents them. They *are* him. They feel ownership and pride in his pursuit. A piece of them is going into the ring with him. The nobody has become a somebody. The message of one has become a mission of many.

On the night of the fight, when that bell rings for the 15th round, it's Rocky's name their chanting, not Creed's. This is a man representing a crowd, a city of people, who know a thing or two about getting off the mat and fighting with every last bit of their being to go the distance. As a result, even in defeat, there is victory. He and his army have won this day together. And that army will continue on with him with complete and absolute loyalty as his journey continues.

When you start your first film crowdsourcing campaign, you are Rocky on that initial run through the quiet streets of Philadelphia. You're an unknown. An unproven commodity. You're just another face in the crowd, trying to make a name for yourself. Most likely, you won't have the power of the media to help establish your brand and spread your message and mission like Rocky did. But what you'll have is a wealth of avenues to curate and cultivate relationships and, eventually, get your story to the masses. If handled right, those masses will carry the message of your story forward and you'll more than go the distance.

[handwritten: what? Avenues?]

But to reach that end, to bask in the glory, you must embrace the fact that all winning crowdsourcing campaigns are rooted in patience and execution.

Given the fact that you've made it this far in our journey and you haven't thought about turning back, I'm going to assume patience isn't an issue. Therefore, I'm not going to make *you* impatient talking about why you need to have enormous patience. Instead, let's begin to talk about execution.

Crowdsourcing is a people game. It's a relationship game. It's a trust game. It's about commonality. It's about loyalty.

But, at its most base, crowdsourcing is simply this:

Identifying, engaging and moving an audience.

[handwritten: - How do you identify the audience?]

Say it with me again.

Crowdsourcing is identifying, engaging and moving an audience.

That's it. That's the definition. The one I want you to keep in pocket.

What's that you say? That's easy! Let's go!

Not so fast, I say.

Just look at how many more pages remain in this tome. We still have far to travel and much to explore.

The strategies of running a successful crowdsourcing campaign are vast and can be complex. But they can be simplified by remembering this definition,

these three easy to remember words. For everything about running a successful crowdsourcing campaign begins and ends with identifying, engaging and moving the crowd.

So let's start at the top . . .

IDENTIFYING YOUR CROWD

I realize that the big bold words above read "Identifying Your Crowd," but I'm actually going to start this section speaking about engaging.

I thought you said you were going to *simplify* things, RB?

Patience, my dear Padawan.

You may find this hard to believe, but we live in, how should I put this, a slightly, well, narcissistic world. No, really, it's true. I can pause while you digest this.

Good?

Good.

Narcissism is especially evident in the world of social media. Yep, I know . . . also hard to believe. There's this thing where people take pictures of themselves. I think they call them selfers or selfies, something like that. Probably a fad.

Now, I'm being glib, but I'm also being very serious.

Ego, hubris, a higher sense of worth or talent, causes people looking to create a brand for themselves to lose the war before they ever have a chance to spit shine their boots and fight a single battle. It also, whether mindfully or not, causes them to skip the first and most integral aspect of the crowdsourcing strategy: identifying your audience. They come with an attitude that all they have to do is show up and the masses will flock to them.

Wrong.

Every. Single. Time. Wrong.

So while we'll talk about engagement in the next section, let me point out two things. One, to run a successful crowdsourcing campaign, you must check your ego at the door. And don't confuse ego with confidence, which is absolutely acceptable in doses. Two, if you check your ego at the door, you will immediately give yourself a greater chance of success on social media and other online avenues. This is also true of your offline crowdsourcing pursuits.

The reason for this is quite simple. We're cultivating relationships here, remember? Ask yourself, when was the last time you were approached by a stranger who immediately launched into a long winded story about themselves and their magnificence and thought to yourself, *Man, I need more of this person in my life.*

Answer? Never.

Don't be that dude or dudette.

Now, I just said we're cultivating relationships, right? But you'll remember that earlier I paired the word curating with cultivating. And curating a potential crowd is an art. A painstaking art. It requires research. It requires work. It requires a serious investment of time, patience and commitment.

So, in addition to putting aside ego, hubris and a higher sense of worth, the first step in running a successful crowdsourcing campaign also involves acquiring and honing a certain skill set, a willingness to roll up the sleeves, grab the lunch pail and put in the long hours.

Are you surprised so many skip this part?

But not you. No way. You're in it to win it.

Identifying your crowd comes down to asking yourself two simple questions:

1 Who is the audience for this film?

2 What individuals, groups or organizations might have a vested interest in this project?

Now, along the way, based on the subject matter or other specific touchpoints within your script, you may find yourself asking some other questions

in an effort to identify your crowd. But these are the two initial and most important questions you can ask and which will yield immediate results.

Let's play a little game. We're going to take the first step toward crowdsourcing a movie together.

This is a coming of age story about a kid named Tom from Hershey, Pennsylvania. Tom has been a social outcast for most of his 11 years. He keeps to himself at school, doesn't have a girlfriend, and spends most of his time with his Labrador retriever, Max. Max is more than a friend. The old rascal actually saved Tom's life when he was five years old and had an epileptic seizure while swimming in a lake. Epilepsy is something that has plagued Tom his entire life, and the prospect of a seizure occurring at any time has further led to his introverted behavior.

On the surface, there's nothing special about Tom. But he does have one gift—he can throw a baseball like nobody's business. I mean, this kid can bring the heat. And although his mom has begged him to join the local Little League in an effort to get him into a more social setting and to put his evident talent on display, Tom has quietly declined. Now, however, the state has decided to run a Summer Championship Series. Each little league throughout the state will form an all-star team with the most talented kids from their respective district. The manager from Tom's district comes to recruit Tom . . . Hard.

Let's stop there. What I have above is a simple two-paragraph synopsis of our movie. You'll notice, outside of some implied drama, I haven't really introduced the stakes or what Tom's arc is going to be. I've just outlined the basics. Because right now, the basics are all we need.

Now let's ask those questions again.

Who is the audience for our film?

Well, right off the bat (pun intended), we can say with absolute certainty anyone who loves the game of baseball. We can also say that fans of baseball and sports movies will likely be interested in our story. Anyone who loves a good underdog story would be most interested as well.

Let's cast a wider net by asking the next question: What individuals, groups or organizations might have a vested interest in this project? Let's brainstorm.

How about the people of Hershey and the surrounding areas, including Williamsport, the town which hosts the Little League World Series every year? Anyone who plays baseball? All Little League organizations around the world? If we're to aim higher, perhaps even Major League Baseball? How about individuals who suffer or have suffered from epileptic seizures? Organizations dealing with epilepsy? People with social disorders? Organizations dealing with social disorders? Dog lovers, especially Labrador retriever owners?

As you can see, the possibilities are only limited by our creativity and willingness to do research. As we move along, you'll also discover that our options are quite moldable depending on who shows interest. This will be especially evident in some of the case studies we'll be examining shortly.

In a very small period of time, we've been able to recognize who our audience is and who might be interested in supporting and contributing to our project in a general sense. Now we must begin to drill down and identify these individuals and groups through rigorous research.

In this case, Google is your friend. Finding a list of Little Leagues around the world is a few keystrokes away. The same holds true for discovering groups and organizations dedicated to epilepsy and social disorders. Chat boards and forums dedicated to baseball and baseball films? Tap, tap, tap . . . Enter. And fugghedabout how easy it is to find legions of dog lovers, particularly lovers of Labrador retrievers, on the web.

By virtue of putting in this research and spending time on the chat boards and forums, we will also be able to identify passionate individuals with whom we will eventually want to engage, develop a relationship with and, ultimately, move on behalf of us and/or the project. But we'll also want to utilize social media as well. There are many things you can say about social media and the impact, good and bad, it has had on our society. You need to put whatever notions you have aside and recognize the fact that social media, when wielded properly, is an incredibly valuable tool. Wielded correctly, it gives you the ability to reach a global audience instantly. It gives you the ability to turn an audience of one into an army of many without leaving your home. If handled correctly, it gives you a powerful and meaningful voice. It cannot and should not be underestimated. So take all your negative feelings about social media and park them in the dark recesses of your mind. You need to be open minded, beginning right now.

I so believe that social media will become one of the most powerful weapons in your film crowdsourcing arsenal, I've dedicated an entire chapter to the subject later in this book. For now, I'll just say that putting in the time on social media to identify individuals who will help your cause will be time well spent.

So now we have identified the people we feel might be interested in our humble little project. Now let's spend some time talking about approach (that word again).

ENGAGING YOUR CROWD

Look, almost anyone with a computer and an internet connection can figure out how to use a search engine or a search feature within a social media platform. Hell, even if you live a low-tech life (something we will have to change), just about anyone can flip through a phone book (they still print these! I use one as a doorstop!) and find the phone number and address of a desired contact.

Finding information is not the problem. What to do with that information, that's where many fail.

You've heard me mention a few of times already (and will hear again and again) that approach is everything. This is an absolute, undeniable and unforgettable fact.

Allow me to illustrate.

Let's say you decide to crash a party. Cool people, open bar, hundreds upon hundreds of people. You slip through security with no problem. You beeline to the bartender, order an Appletini (shame on you, by the way) and take in the crowd. Across the dance floor, you see a group of people in a circle, deep in conversation. They all seem to know one another and are genuinely enjoying each other's company. You swagger over, full of your own importance, ready to grace them with your magnificence. You shoulder one or two out of the way, plant yourself in the middle of the circle, extend your arms and without so much as even introducing yourself, proclaim "Yo! I'm making a movie!" You pull some cards with the poster of your film from your back pocket and add, "Check it out!"

The group doesn't look at you . . . they look through you. And then they move around you, form their circle again and continue their conversation as if you were never there to begin with.

"Hey!" you shout. "Hey, did you hear what I said? I'm making a movie!" But you're getting nothing. Crickets. You glance around for support. There's none to be had. Save for a couple of people who have their arms extended in "Talk to the hand" fashion.

Now in this scenario, the reprehensible behavior may seem like an obvious and egregious faux pas. In fact, you might find that drawing a negative example so obviously blatant is simply a gross exaggeration on my part to hammer home a point. I assure you it's not. The truth is, this scenario will play itself out on social media dozens, if not hundreds, of times in the length it takes you to read this sentence. And that's not hyperbole.

You sign up for a social media account and immediately begin blasting people, or, to be more direct, complete strangers, with information about your project. These are people who potentially have zero interest in your project and almost absolutely have no interest in you. You've built up no social currency, no good will and no respect. You've asked no questions. You've made no effort to cultivate a relationship. You've given no value whatsoever. But simply by blasting out your message, you are soliciting a response. In essence, you are asking for value in return when none was given.

As it relates to social media, I call this being a broadcaster. And if you have attempted this tactic in the past, trust me, you're not alone. According to more than one published report on the subject, 2 billion people were using social media in 2015. *Two billion*. That means 2 billion microphones were turned on ready to amplify 2 billion voices. Yet, many people believe when they sign up for a social media account that they've been granted the only microphone on this (or any other) planet and immediately begin by broadcasting their wants, needs and desires selfishly, recklessly and at will. This is a huge mistake. Not only will the people you are demanding time and attention from turn a deaf ear to you forever, but those witnessing the behavior will as well. We'll discuss this in much greater detail in the social media chapter ahead, but for the purposes of this section, let's focus on an equally important issue: By approaching strangers and having no data or information as to what individuals, groups or organizations might be interested in your project, you're robbing yourself not only of time, but of energy.

You aren't cultivating, you're excavating.

And, make no mistake, you're going to get called out, ignored or blocked. Either way, you've turned a potential winning situation into a losing one before you've barely left the starting blocks.

But, hey. We live and we learn, right? Let's go to another party, shall we?

This party, you've been invited to. The invite came from an old friend you reconnected with on Facebook. You haven't seen her in years, but based on that one picture you invested the time to look at, the one with her and her baby at the waterpark, she seems happy. You immediately catch sight of her standing at the bar. You approach. She's thrilled to see you. After a quick hug, she asks quite innocently, "How have you been?" "Great!" you reply with such gusto it rocks her back on her flats. You then launch into a 20-minute synopsis of your film, complete with commentary on why it is going to revolutionize cinema as she, and the rest of all man and woman-kind, knows it. You're so caught up in your own insane excellence that you fail to notice that her eyes haven't only glazed over, there's a good chance she's out on her feet. When you finally finish, she says, "Sounds terrific, but I just realized I have to be somewhere else," then adding with obvious half-heartedness, "but let me know when your film comes out! I can't wait to see it!!" before sprinting like Jesse Owens on 60 Red Bulls for the door.

You think to yourself: I don't think she was all that honest about wanting to see my movie. And, brother, you couldn't be more right. But it's even worse than that. She's not going to be a champion of you and your film. If she tells anyone about her experience with you at all, it will come from a place of pure negativity. You've lost a potential ally as a champion *and* all her allies as well.

Little did you know that she was going through a divorce and simply needed a friend to talk with. Little did you do to truly reconnect and begin culti-vating that relationship once again. Little did you know that she actually loves the type of movie you were making and would have told all her friends and colleagues. Little did you know. Because you made it all about you. You broke the first rule of cultivating relationships: You didn't ask any questions.

This is networking 101 when it comes to the online world. You must take an interest in the people you want to take an interest in you. How do you do that? The same way you do it in the "real world," by being gracious, generous

and most of all *selfless*. You do it by showing concern, empathy and by *asking questions*. You take the time to respect people's time.

Let me say that again.

You take the time to respect people's time.

Everyone on social media has a goal. But we're not worried about everyone, right? We've already identified the individuals we hope will help form our crowd. Therefore, we have already identified a common interest. It's now our job to tap into that common interest in a selfless, gracious and giving manner.

So let's go back to our movie. We've identified a number of individuals and groups we believe might have an interest in our project. We've identified @PhilLovesBaseball (fake name, fake person, don't go searching) on Twitter. Phil's account is dedicated to The Most Famous Underdog Baseball Movie of All Time. Phil has over 75,000 followers on Twitter. Our eyes go wide. With a little further digging, we discover that Phil also runs a very popular chat board dedicated to The Most Famous Underdog Movie of All Time. Everyone tweeting with (you'll notice I said *with* and not *at*) Phil is talking about their passion for baseball. On his chat board, there's even a forum for "Other Underdog Sports Films We Love." Holy hell, this is the motherload. The *perfect* audience for our film. We wipe the drool from our jowls, crack our knuckles and bang out "Hey @PhilLovesBaseball. I have an underdog baseball movie! Follow me!"

Radio. Silence.

And you've earned it.

Quickly. Definitively. Absolutely.

Now let's say there's a parallel universe. In that world, you type: "Hello @PhilLovesBaseball—I love your Tweets! Great job! What do you love most about baseball?"

Phil responds with: "I've had a love for it since I was a kid! My dad used to take me to games every weekend."

You now have Phil's attention. You respond with: "So did my dad! Amazing how special those times were, right?"

And now you have found common ground and you've done so selflessly. The seeds of a relationship have been planted.

It can't really be that simple, can it, RB?

Yes, it can . . . and it is.

But you can't be asking me to literally communicate with every single person I've identified as someone I'd like to be a supporter of me and my project, can you?

Yes and no.

Your job, and this is true of your online and offline crowdsourcing pursuits, is not only to be a curious and magnanimous human being. Your job is also to present your passion and knowledge. You don't want to come off as if you have *all* the answers, but that you can speak intelligently on the subject at hand and come from an informed place. At the same time, you need to be humble, open minded and receptive to debate, opinion and the fact that you may not know everything.

So, yes, you want to engage those influencers who have legions of followers and whose opinions are respected. You want to make sure you make initial contact with them. And sure, it doesn't hurt to thank people for following or liking you or your posts. But, of course, there are only so many hours in the day and as your list of followers and fans grows, the ability to be the one to initiate every single individual conversation becomes a bit tougher.

This is where sharing content as a tool for engagement comes into play. Whether you write this content yourself or share content produced by others (always recommended, but make sure they are absolutely qualified and have their facts straight), providing your followers with material that you know they will find interesting (remember, you've identified them and their interests already) will go a long way. Attaching a simple question to that content (Do you agree? What do you think about _____?) goes even further to driving engagement.

Now, let's say you write a sweet blog post about the times your dad took you to baseball games on the weekend and how it stoked the flames for your lifelong passion for the sport. You share this post on social media. It connects with so many of your followers that you get 30 responses ranging

from "Nice job!" to "You made me call my father today." Do you respond to those 30 people?

Yes, you do.

All day, every day.

Again, engagement online is no different than engagement offline.

Imagine the same scenario. This time, the piece regarding you and your dad is published in the local paper along with a photo of the two of you. You're standing in line at a local deli when a guy approaches and says, "Hey, I read your piece in the *Gazette*! Really moved me." Would you pick up your half pound of pastrami, turn away and walk out without saying a word?

Of course you wouldn't.

Don't do it on social media.

Once again, I have a whole chapter on this subject still to come, as well as one regarding networking offline, so don't sweat the small stuff at this point. But always remember (assuming you've done your job identifying), engaging an individual or a group doesn't work without a distinct strategy. And while that strategy may vary depending on how the individual or group may eventually evolve and change as the relationship develops, the constants are being selfless and curious. Your first move (and truly, your second and third move as well) should always be to make it about the other person before you.

MOVING YOUR CROWD

OK, so now for the moment of truth. We've spent a great deal of time identifying those who might have a vested interest in our little film. We have covered all of our bases (pun once again intended) by identifying the audience for our movie as well. We then dedicated a decent amount of time every day to engaging these individuals and groups through online and offline methods. We've been almost entirely selfless by asking questions, sharing content and assisting in any and every way humanly possible. We've responded to every single post, returned every phone call, kept every meeting and promise. We've been informative about our overall mission without being

suffocating, annoying or irritating. We've kept our composure and cool when being challenged, made debate fun and not combative and entered every encounter with an open mind and heart. We've been thoughtful, analytical, practical and, well, nice as hell.

We have, haven't we?

Be sure.

Be honest.

Because if you have any doubts that you've been lacking in any single area, you still have work to do.

What's that you say? I'm solid, RB?

OK, then. Congratulations are in order.

You have curated, cultivated and engaged your crowd.

Now it's time to move it.

Before we move on, let's go back to being sure and being honest one more time. You may try to convince yourself that you're ready to move your audience. Hell, you may have just fooled me. But there's one group you won't fool no matter how hard you try or how conniving you think you are: The crowd. The crowd is all knowing, all seeing and all hearing. And if you haven't done your job with them, the sound you'll hear when you go to move them will be the most deafening silence in the history of mankind. So again . . .

Be sure.

Be honest.

But, you know what? We've built up one heck of a rapport in a short period of time, so I completely trust that you're ready to push the "Move" button. How do we go about that?

Well, for starters, we're still going to maintain a level of discipline usually reserved for top martial arts practitioners and Jedi masters. We are not going

to carpet bomb the hillside, *Apocalypse Now* style, with our message. What we're going to do is go to those people and organizations who have been most supportive and loyal and present our "Ask." Now it doesn't matter what the "Ask" is. It could be equity investment or crowdfunding donation dollars. It could be a request for a location to shoot scenes for your film. It could be to make an introduction to someone who could benefit the production.

The "Ask" is immaterial.

It's the approach that's material.

Say it with me again.

The approach is everything.

Remember, up to this point, all the talk about our baseball project has been inclusive. By doing the research and putting the time into identifying our crowd, we've given the members a feeling of pride. They're part of a club. Our club. But then, by engaging them and asking questions about the project, we gave them a voice, a say, a feeling of being part of the team. This approach now has them ready to run through fire for us and, more importantly, for the project. They believe. They feel ownership. They're invested.

The last thing we want to do is ruin that with demands.

An "Ask" is not a demand.

"Would you be willing to . . . ?"

"Do you think you could please . . . ?

"It would mean so much to me and the project if you could . . ."

"Your support means so much to me; I would be eternally grateful if you would . . ."

Approach is everything.

I always say that when you're in doubt about how to communicate with someone, reverse the situation and ask yourself how you would like to be

communicated with. Now, I think you would agree, what tickles you might not tickle everyone else. I'm sure the way you talk with one friend, family member or colleague might be different from the next. But, if you're a decent human being, and I know you are all that and more, you'll at least have a basis, a standard, for how you believe most people like to be treated. Still, this can't be a fall back and failsafe position. There is a certain amount of nuance to communicating a similar message to a wide swath of people and still maintaining a feeling of intimacy. But this is why you've spent so much of your valuable time identifying your audience, cultivating these relationships and responding to each person you've engaged. You should be able to personalize and tailor your "Ask" to the individual or group you're looking to move.

If you think this sounds a bit like mirroring in sales, you're absolutely right. Although remember, we're not going in for a sell here. Most sales initiatives and practices are devoid of intimacy. The seller and the sellee (usually) have not cultivated a relationship. It's trust building from a cold start over a very truncated period of time. And if the seller and the sellee have built a relationship over a period of time—think a car salesman selling you your fourth car over 20 years—there really isn't any selling at all, is there? No. Because there's a relationship that's been cultivated over time. There's intimacy. There's trust.

So don't think of this as mirroring as much as understanding your audience. You've used your time engaging to learn the ins and outs of the individuals within your crowd. You know what makes them tick. What turns them off. What caused them to be engaged in the first place. Use that information to further build your relationship by tailoring a message that will complement their sensibilities.

Be human. Be humble. Be relatable. Be real.

MOVING ON

Well that was pretty painless, wasn't it? And pretty simple to grasp, wouldn't you agree?

Look, I'm not trying to persuade you into thinking that running a film crowdsourcing campaign will be easy. I'm not a cliché guy, but I do believe

that nothing worth doing comes easy. And, building relationships isn't easy. But I'll be damned if it isn't rewarding as hell and a gift that keeps on giving when done right. So while there is much more to learn as we continue along, remember, no matter how complex your campaign or how big a crowd you are trying to source, if you get lost along the way, you can always come back to this definition of crowdsourcing to take a 10,000 foot view of where things might have gone awry.

In the next chapter, in an exercise intended to crystalize all that came before, let's take a look at Nicolas Gonda's keynote speech from AFM. And then, in the following chapter, let's break that speech down and see how Nick structured his wonderful talk to identify, engage and move his crowd.

6

Why Should We Crowdsource? (Will You Whistle for Me?)

Below is a transcript of Nicolas Gonda's (film producer and CEO of Tugg) keynote address, Why Should We Crowdsource?, *which was presented to over 1,000 American Film Market attendees ahead of the Crowdsourcing Your Audience panel which I moderated on November 11th, 2013.*

Thank you very much for having me today. It's a huge honor to speak in front this audience. Thank you also, John, for the kind introduction.

Today I want to spend some time defining what I consider crowdsourcing to mean, and how I am using it in the context of growing our audiences. Then, I'd like to discuss how we can use it by looking at recent successes, and how we can apply those learnings to inform future frameworks. But before I do that, I want to play a game.

I'd like to ask the audience to whistle if they feel compelled to.

Ready?

OK. Whistle.

(RB note: Approximately 25% of the audience offered a weak, disjointed whistle) Thanks, we'll come back to that, at which point I promise it will make more sense.

This morning, I'm going to spend some time talking with you about the buzzword, crowdsourcing. I was specifically invited here today to speak about the role of crowdsourcing in marketing.

My only instructions were to not promote my company Tugg with too heavy a hand. Sidenote: Tugg is an ingenious distribution platform that gives audiences the power of choice in moviegoing by bringing an on-demand experience to local theaters. And in no way am I promoting that you go to Tugg. com (that's with two g's) or go to our Facebook page.

See? I kept my promise.

So what is crowdsourcing? And why is it worth 15 minutes of your morning?

Quite simply: Crowdsourcing is going to be a feature of your marketing efforts that is going to be as commonplace as an ad in a magazine. And it's going to cost a hell of a lot less. Why should you care about it? Because it can help you get more butts in seats and eyes on screens than you can without it.

I want to start by raising a question that I think everyone here has faced, possibly even this morning. It's one of the first questions we ask ourselves when we encounter a new project

It goes something like: "Why will people see this film?"

Is it because famous people are in it?

Because there are blue aliens?

Because you get to be trapped in space with George Clooney?

Maybe.

In the past, we used marketing vehicles to manufacture an impetus to get and grow audiences. We've tried to amplify our messages as loud and as

long as possible, hoping through sheer force we could convince people our content was worthy of their time and money. The thinking has long been that how much we spend directly relates to how much we earn.

At best, these mediums convince the consumer exposed to them to see or buy our films, and perhaps bring some of their friends along the way. But we've rarely made it *theirs*.

According to generally accepted market research, one word of mouth recommendation has the impact on an individual of over 200 television ads. To be clear, that sort of recommendation usually sounds something like: "There's something *I* really think you should see." And the statistic—1:200—tells us that traditional vehicles on their own aren't giving us the sort of horsepower in today's environment that we need to build our brands and attract more fans. Even more, I'd venture that every person in this room is already saying, or soon will be saying: "I want in on that one word of mouth." That's because today, it's not enough to assume audiences will go to our films because of their fabric, because of their quality, or because of their content. Consumers—*our audiences*—want a stake in what they buy, especially if they're going to recommend it.

So what is crowdsourcing?

The term "crowdsourcing" was coined by Jeff Howe in a *Wired* magazine article, and if you want to find him, he stole the Twitter handle @crowdsourcing.

Jeff smartly defined crowdsourcing as "the act of taking a job traditionally performed by employees and outsourcing it to an undefined, large group of people in the form of an open call."[1]

In our worlds, that looks a lot like getting people to promote our films for us, with us.

Almost immediately, the term, and concept, was applied to just about everything you can think of: Investigative journalism, fan-owned sports teams, graphic design, government and, yes, film.

I would define crowdsourcing as the process of earnestly engaging with the public through a specific call to action with shared goals and shared rewards.

But let's take a step back and look at where we stand today, on November 11th, 2013.

We live at a time when the ability to conceive and realize a good idea is more achievable than ever before. There has never been a time when humankind has been more connected than today. The highway for high-speed innovation and mass collaboration has been slickly paved for us. As we all know:

In 1998, two friends from Stanford questioned convention of search and discovery and set out to organize the world's information and make it universally accessible and useful.

That mission was accomplished, and we call it Google, and use it every day to find answers to just about any question.

In 2004, a college student dreamed of a website that would give people the power to share and make the world more open and connected than ever before.

As a result of Facebook, what were once niches are now robust interest groups. Fragments have coalesced to formed masses, and power has become completely democratized.

And finally, in 2006, a team of technologists designed a simple tool that would give everyone the power to create and share ideas and information instantly without barriers.

Twitter, as you know, went public last week, and has enabled great—and sometimes not so great—ideas to flourish, dictatorships to be overthrown and anyone, anywhere, with access to the internet, to mark their existence, follow others and be followed.

Sharing is second nature to any internet user. Collaboration is a byproduct of our everyday behavior online. Technology is making it frictionless and fun.

So what does this mean for our films?

It means we need to get in on it.

If properly engaged and coordinated, the ability of our audience is far more powerful than that of our institutions. Nobody understands your brand

better than your audience, *and nobody is more capable of expanding your audience than your audience.*

Today, as a result of the innovation from the titans I just mentioned and so many others, we can attract masses not by brute force, but by willing engagement.

So, done right, what does this look like?

Let's examine the difference between advertising and crowdsourcing.

 Crowdsourcing is creating a community and voluntary workforce behind your content.

Advertisements can start to perish once they are aired or printed, while communities grow organically and infinitely, as long as they are nourished.

There's a film releasing today, Veterans Day, with over 116 engagements called *Honor Flight*. It's about an organization that raises funds to make it possible for elderly veterans to visit the monuments in Washington, DC, erected in their honor. When the producers of *Honor Flight* first approached traditional distributors, few were interested. Then they decided they would take matters in their own hands and reached out to veterans groups across the country—in big and small towns—to see if they'd be interested in promoting screenings in their communities. The incentive was that they would not only be responsible for bringing the film to a theater, but could watch it with fellow servicemen and servicewomen, and their family and friends. We—Tugg—worked with them and ultimately achieved well over 150 screenings booked across the country.

The premiere of *Honor Flight* was hosted at a baseball stadium with the community and the filmmakers. That event broke the world record for most tickets sold to a movie event.

What's more is that the filmmakers took this proof of demand that was established in the crowdsourced campaign to the distributors. It went on to become one of the top selling documentaries on iTunes for several weeks, and today it's re-opening in a theatrical release across 27 cities and 116 engagements.

Of the 10,000 people who saw the crowdsourced campaign, 5,000 opened emails this weekend and promoted the film. As we all know, that's a pretty

astounding open rate. Because of the community-building conducted by the filmmakers during the earliest stages of the release, when people received these emails, they didn't appear as a sale pitch. They felt like an invitation from a trusted source, even a friend. As a result, a flightless film literally took off.

Another example is the documentary about the mega boy band One Direction. Here's an example where there is no shortage of awareness. When one of the band members tweets about brushing his teeth, most of the teenage world hears about it.

But how do you turn noise into concerted action?

In the week leading up to the release, Sony asked the fanbase: Who wants it most? By Sony taking the time to identify the highest concentration of fans around the world, Tugg then provided event pages and gave those fans the opportunity to become active advocates: marketers in the purest sense of the word.

Three days ahead of the release, thousands of superfans experienced the film early not as viewers, but as participants. While we and Sony achieved something meaningful, so did those fans, and they knew it. And they talked about it.

The social media that was generated from all this planning and activity wasn't just about a movie; it was about a micro-movement. Now, this movie is theirs. As *Wired* magazine founding editor said best, "Access is ownership."[2]

While these two examples are on completely different sides of the spectrum—one a truly independent film and the other a widely released blockbuster—the success of both came from the same realization that the social capital of the core fanbase was as valuable—if not more valuable—than physical capital, and the result was something money couldn't buy.

More importantly, the community created during these initiatives continues to stay with the film, as an active community behind the film. Both efforts realized that before they could get something from their fans, they needed to first give something to their fans.

So now let's go back to the game we played a few minutes ago. Except this time, I hold in my hand a check written from an anonymous benefactor in

the audience for $1,000, which, if we all whistle together in harmony, will immediately be sent to the Red Cross Philippines Relief Fund. So, who's with me? Can we do this? If you sense any doubt or hesitation from the person sitting next to you, give them a little nod of encouragement. HERE WE GO: 1 . . . 2 . . . 3.

(*RB note: Approximately 95% of the audience offered a strong, cohesive whistle.*)

See, the difference there, versus what I did before, is that we were all in together for a collective goal, not just something I wanted *YOU* to do for *ME*.

So, to wrap it up, when you get back to your desk or board your flight home, and you consider embarking on a strategy that involves crowdsourcing your audience, remember this:

The first ingredient to crowdsourcing your audience is committing yourself to fostering a community around your content, which is also a realization that you are just one fellow in a (hopefully) much greater fellowship, and the only way that fellowship will grow is if you set forth attitudes, interests and goals that can be shared by others, passionately.

The most important aspect of any crowdsourcing campaign is not the money raised or revenue generated, but rather the social capital you accrue.

When you open up a channel to enable crowdsourcing you are essentially creating a voluntary army—boots on the ground who will share more passionately and resiliently than any advertisement.

While the road ahead is slickly paved, it doesn't have all its streets signs. There are no experts in crowdsourcing, just practitioners and students. But if you start today, you will be a pioneer on the forefront of the most exciting thing happening online and in our business today and for decades to come.

NOTES

1 https://en.wikipedia.org/wiki/Crowdsourcing
2 https://www.wired.com/2006/06/crowds/

7

Digging Deeper—
The Power of
Crowdsourcing

Solid keynote by Mr. Gonda, wouldn't you agree? I can tell you first hand, Nick went into the speech his usual, confident self, but (by his own admission) was a bit concerned about connecting with the crowd. For starters, this was the opening talk of the day, and an early start at that. Batting lead-off in the morning when the audience is bleary eyed, caffeine deprived and brain weary is never an easy task. Add to the mix that while all of us—Nick, myself and my fellow panelists—were sitting in the green room, we couldn't help but overhear many attendees in the hall as they made their way into the hotel ballroom. Many, as it might not surprise you now, were amped up to learn about crowd*funding*. Others were fully aware that the next two hours were going to be spent learning about crowdsourcing, but the overwhelming majority had no idea what crowdsourcing actually was.

So let me assure you, as showtime approached, it wasn't only Nick who was feeling a bit uneasy. We were all a little nervous. We knew we had our work cut out for us.

When Nick was introduced to the stage, the audience offered polite applause. As he prepped his notes, I looked around the room and took the pulse of the crowd. Some attendees still had their eyes pointed south toward their phones, texting or posting to Facebook ("At a conference I paid hundreds of dollars to attend. Not paying attention to the speaker. LOL"). Others had

their heads tilted to their shoulders, as if they were entirely too tired to task their neck muscles to support their domes upright. A few offered gaping, audible yawns. Oh, yeah . . . Nick was in for it.

As Nick launched into his keynote, nothing much changed. Active indifference is a term that comes to mind. When he asked the crowd to whistle for the first time, I scanned the room again. A few people looked at their neighbor quizzically. Others choked up a sarcastic chuckle, as if to say: *What's this all about?* You'll remember from my note in the previous chapter, only about a quarter of the people in the room felt compelled to actually whistle. And that was an effort so slight, it sounded more like a light breeze passing through a straw. The kind of effort my niece would call "weak sauce." The kind of effort that would get a lead singer of a band to plead, "Come on! You can do better than that (add name of city . . . incite riot)!"

I'm tellin' ya, ladies and germs, the crowd was tough. Tough, I tells ya!

Sitting in the on-deck circle, our panel a few short minutes away, I was engulfed by a sense of dread. This wasn't going to be merely a tough crowd, it very well might be an impossible one. And if you've done these talks and panels long enough, you know that when you have the crowd, 90 minutes passes like 10, and when you don't have the crowd, each minute feels like an eternity. Your heart quickens, your mind scans its deepest recesses for witty anecdotes and your saliva seemingly evaporates from your mouth and reforms as sweat on your brow.

But even with the somewhat, let's say, lacking response, Nick charged forward unshaken, undaunted and with confidence—saliva seemingly sufficient and brow bone dry. *Brave man*, I thought. No, no . . . Smart man, as it turned out. An intelligent speaker sometimes needs to take the long path to the destination payoff.

In other words, Nick knew exactly what he was doing.

As Nick began to roll, pushing through the Jeff Howe definition (see, it's relevant!), his own definition of crowdsourcing, the coalescing of his definition through his Google, Facebook and Twitter examples and then outlining the difference between crowdsourcing and advertising, I scanned the room again. Phones were being put away, domes became upright, yawns were replaced with wide-eyed smiles and asses shimmied to the front of chairs.

Energy began to fill the room as those in attendance realized that what Nick was preaching was fresh and exciting—a road to the promised land less traveled. To many, so much of making a film occurred in a vacuum. And so much of what constituted the success or failure of a film was out of the control of the filmmaker. Here was someone who was suggesting that a film could be made, or even conceived, in the daylight of public scrutiny *and* with input from a crowd. And by doing so, a filmmaker or producer wouldn't actually be giving up control, but could potentially seize more control of the project from inception, to completion, to distribution, and beyond. You could sense spines straightening with empowerment.

By the time Nick told the story of *Honor Flight*, many in the room were furiously fishing out their legal pads and opening their laptops. When he disclosed that of the 10,000 people who received the crowdsourced campaign of the film via email, half had opened the missive and to o promoting the film, there was an audible gasp from the crowd. And when he mentioned Jeff Howe's quote, "Access is ownership,"[1] nearly the whole room scribbled or punched their keyboard keys in unison.

But then the magic moment: Nick's "Ask" for the entire room to join together and whistle in unison for a common cause. Let's pause before we pursue that thought further. There's another really important moment to absorb first. Prior to the big "Ask", Nick made a smaller, but no lest significant request. He requested that everyone in the room look at their neighbor and if there was a sense of reluctance to join the crowd, to offer that person a sense of support and collaboration. Nick's reasoning was simple. He was one voice. He was the deliverer of the message. Had he done a convincing enough job to persuade others to carry the message? And why was it so important at this point in the process?

Simply, Nick knew that a favorable response from a neighbor would be infinitely more powerful than anything else he could say.

It cannot be overstated that you delivering the message is one thing. A trusted supporter of your message is another thing entirely.

Now, I know what you're thinking . . .

This is, for the most part, a crowd of strangers. Sure, some people might be sitting next to a friend or colleague, but most are probably sitting next to

people they have never met before in their lives. With no previous exposure to one another, how can you or the person sitting next to you be viewed as a *trusted* supporter?

Great question, grasshopper.

And here's the answer . . .

Commonality.

Every person sitting in the room was attending the American Film Market. They all paid good money (badges do not come cheap) to be in that room, signaling a serious commitment to betterment and a desire to learn. They all shared an interest in either filmmaking, the business of the film industry or both. It can also be stated that they were all there to receive information and knowledge that would accelerate their goals and career path. Further still, by virtue of attending a talk and panel on crowdsourcing, they all shared an interest in being educated on the same topic. Putting all this together, everyone in that room was joined by an unspoken bond forged together by shared personal interests. Therefore, by looking at the person next to you, even if you had never seen that particular visage before, you were essentially holding up a mirror. Trust was found in the drive, passion, desire and goals that brought that fellow human being into that room and to the seat next to you.

Nick understood that by requesting that everyone look at their neighbor in an effort to encourage them to whistle for a common cause, he was going to be able to move the people he had already won over to use their substantial power as a trusted peer to move others in the crowd. See, Nick went into this speech knowing exactly what buttons to push. He understood the motivations of each individual in the crowd and how most of those motivations were common in all attendees. He knew that as he moved through his speech, each individual who shared these common motivations would cease to be viewed as individuals to him. They would become a crowd. And, if he could convince these individuals to come together toward a symbiotic cause, he would have effectively sourced a crowd. So, he had set out to involve the crowd, become a trusted voice to the crowd and, once the time was right, ask the crowd to do something that would be mutually beneficial to him, the individual and to the crowd as a whole.

So, when he asked the crowd a second time to whistle, nearly the whole room responded, and enthusiastically at that. This was a policeman's whistle, "strong sauce," a roaring rock and roll audience. At the end, the crowd came together to deliver Nick a minute long ovation. Not bad for 15 minutes of talking to a room of individuals he had previously never met.

That's the power of crowdsourcing.

Let's dig into this deeper by shining a spotlight on some other areas from Nick's talk. The purpose of this exercise is to focus on Nick's precision approach. A crowdsourcing campaign is akin to machinery consisting of many gears and pulleys. While there are myriad things to think about, like building any other seemingly complex system, the process becomes simplified through patience and thorough examination, trial and error, and practice and repetition. My plan, as I mentioned before, is to provide you with all the information and tools to simplify the complexities, allow for the thought process to become involuntary, and let execution of the processes second nature. And we will get there. But, and I cannot stress this enough: It doesn't matter how strong your plan, or how hard you work on your strategy, or if you believe you have a clear path toward your end goal, if your approach toward handling the crowd is faulty. A misstep in this area will put a fiery end to your campaign before your rocket ever leaves the launch pad.

I mentioned that Nick turned this crowd from a restless, cranky and cynical bunch into a legion of supporters and true believers inside of 15 minutes. How did he make that happen?

Yep . . . Approach.

Let's get all *CSI* on this speech and look at the evidence.

NEVER APPROACH A BULL FROM THE FRONT, A HORSE FROM THE REAR, OR AN IDIOT FROM ANY DIRECTION

Thus endeth the lesson.

Back to Nick and his approach to winning the crowd. Let's start at the top.

Graciousness and Humility

Look at how Nick begins his keynote:

> Thank you very much for having me today. It's a huge honor to speak in front of this audience. Thank you also, John, for the kind introduction.

By showing gratitude, a humble nature and graciousness and providing the audience with a sense of worth, the initial seed is planted that not only is Nick a nice guy and, potentially one that can be trusted, but also that he is on equal footing with his audience. There is nothing high and mighty and no notes of superiority that might alienate the crowd. Yes, given the fact that he is standing at the podium, the powers that be at the American Film Market have deemed him an expert worthy of giving the keynote. But Nick does nothing to shove this notion down anyone's throat. To the contrary, Nick is sending a clear message in his desire to connect on a human level. As a jumping off point, and as a first point of contact with an individual or organization, this is a never lose strategy.

Credibility

In the next paragraph, Nick begins with the following:

> Today I want to spend some time defining what I consider crowd-sourcing to mean, and how I am using it in the context of growing our audiences.

To repeat, simply by virtue of being chosen to give the keynote, Nick arrived to the podium with credibility. But when you are beginning a crowdsourcing campaign, particularly your first crowdsourcing campaign, there will be a proving ground you must traverse. Who are you? What is your background and experience? How does your background and experience lend itself to this campaign? Why do you consider yourself an expert who should be listened to and followed?

For Nick, this handicap had been lifted before he stepped into the room. Still, by expressing that he planned on giving his definition of crowdsourcing and the plan to follow it up with real world examples as it related to his company, Tugg, he was reinforcing why he considered himself worthy of speaking on the subject without being overt.

Inclusion

It takes Nick only until midway through his second paragraph—the next sentence, actually—to use the word "we."

> Then I'd like to discuss how **we** can use it by looking at recent successes, and how **we** can apply those learnings to inform future frameworks.

Remember what we discussed a couple of chapters back about being a broadcaster? Notice how Nick doesn't fall into that trap, even though he's the only one with a microphone.

A true communicator—and you absolutely *must* be one to run a successful crowdsourcing campaign—engages and invites interaction. "I" and "me" are replaced by "you," "we" and "us."

In the first paragraph, Nick addressed the crowd; in the second paragraph, he included them in the proceedings. To put this in the framework of time, all of this occurred inside the first minute of the speech.

Authority Based in Fact

We already discussed establishing credibility. There are many factors which can affect this desired result. Experience, as we've discussed, is one way. A cherished referral from a champion of you and your work is the most powerful. But to establish true credibility, you must be able to exhibit authority over the material and/or related content.

All of this is reflected, both directly and indirectly, in this sentence from Nick's speech:

> According to generally accepted market research, one word of mouth recommendation has the impact on an individual of over 200 television ads.

Fact based. Powerful. Even visual in its own way. Certainly on topic.

It's worth noting that Nick deploys this strategy again later in the talk while speaking to how the filmmakers behind *Honor Flight* and Sony Studios (in the One Dimension documentary example) cultivated, involved and

nourished their respective bases. It's pertinent, valuable material, and riveting to boot.

Bottom line: Know your stuff. Don't get caught lying or stretching the truth. You will get called out on it and all credibility, regardless of experience or other merits, will effectively be destroyed. Once you lose the trust of the crowd, it's lost for good.

Levity

Nothing cuts through cynicism like a little well placed humor. If it can be self-deprecating, all the better. Just remember, there's a fine line between charming self-deprecating humor and Oh My God, I'm Going to Run Into Traffic if This Guy Doesn't Shut Up self-deprecating humor. In other words, use it sparingly.

This was Nick's approach:

> My only instructions were to not promote my company Tugg with too heavy a hand. Sidenote: Tugg is an ingenious distribution platform that gives audiences the power of choice in moviegoing, by bringing an on-demand experience to local theaters. And in no way am I promoting that you go to Tugg.com (that's with two g's) or go to our Facebook page.

> See? I kept my promise.

Subtle, but enormously effective.

I can attest that the crowd chuckled warmly at this. They were charmed. The bull's-eye had been hit.

Empathy

How do you connect with the crowd in a meaningful way? There needs, of course, to be the ability to find common ground. That's a great first step, but it's not enough. There needs to be another step toward engagement that is, as we concluded above, inclusive. I've often suggested asking questions as a no lose way toward instigating and inviting engagement—*but you have to be asking the **right** questions.*

To ask the right questions, you must have empathy.

I want to start by raising a question that I think everyone here has faced, possibly even this morning. It's one of the first questions we ask ourselves when we encounter a new project.

It goes something like: "Why will people see this film?"

This is a brilliant approach. Notice the awareness to, and recognition of, the plight of each audience member. Notice the sense of urgency and importance within *"possibly even this morning."* Notice the use of "we" again. Notice the benevolence.

Passion

Remember, the competition for eyeballs and eardrums online and offline is fierce and on the rise. More projects are being produced than ever before. There are more people joining social media every day. New platforms, crowdfunding sites, streaming outlets—more distractions vying for our attention. You need every advantage to keep your audience engaged and marching alongside you. (Again—the crowd marches alongside you, not behind you. That *must* be your mindset.) They must feel your passion and heart. They must believe in your vision . . . always.

> If properly engaged and coordinated, the ability of our audience is far more powerful than that of our institutions. Nobody understands your brand better than your audience, and nobody is more capable of expanding your audience than your audience.

Almost like a *Braveheart* rally cry, no? How can't you be pumped up after hearing those words?

Always bring heart and passion to the party. You'll be viewed as a source of positivity and inspiration, which will lead to more people willing to line up beside you.

Knowing When to "Ask"

As we know, the end goal in any crowdsourcing campaign is to create an environment where the crowd sees the benefits and virtues of carrying the word of your mission forth. But when, exactly, is the right time to make the "Ask"? It's a tricky question, and one we will continue to explore. Cultivating a relationship takes time and patience. There are certainly measuring sticks

one can point to—the response to a social media push, for example. But there also must be some reading of the tea leaves as well. While the average person running a crowdsourcing campaign can take his or her time in how they nourish their audience, Nick's was under time constraints, which meant that he had to move quickly. But, as you can see by our examination thus far, he laid down some serious brick and hit all the right notes. He built trust and confidence. Then, he went in for the "Ask."

> So now let's go back to the game we played a few minutes ago. Except this time, I hold in my hand a check written from an anonymous benefactor in the audience for $1,000, which, if we all whistle together in harmony, will immediately be sent to the Red Cross Philippines Relief Fund. So, who's with me? Can we do this? If you sense any doubt or hesitation from the person sitting next to you, give them a little nod of encouragement. HERE WE GO: 1 . . . 2 . . . 3.

And about 95% of the room whistles . . . loudly.

So we've covered the timing of the "Ask," but let's look at the bones of the "Ask" itself and why it worked. For starters, and just to repeat, the groundwork (building trust and confidence) had been put in. That can't be minimized. But then, Nick not only positions the "Ask" in the form of a callback to the beginning of the speech, but he immediately adds the information about the check for a smooth grand that will go the Philippines Red Cross Relief Fund.

Why?

Well . . . Who doesn't like to be a part of something that benefits those suffering or less fortunate? Who doesn't like to feel good about themselves? And doesn't it always feel better to do something that benefits others in a group setting than in isolation? Sure it does.

Common interests.

Doing good together.

Mutually beneficial.

Community.

These themes will rise up again and again.

Moving on, notice how Nick approaches the idea of the crowd lining up alongside him and taking on the mission: *"So who's with me? Can we do this?"*

Inclusion.

Passion.

The timing of the "Ask" will be different in every situation, but the designs within your approach will always be the same. If you handled each step along the way with awareness, empathy and selflessness, when the time comes to make the "Ask," the crowd will be ready to walk with you into fire.

The point of this exercise was to highlight the importance of approach as it relates to a crowdsourcing campaign. Nick entered the arena with a specific plan, a meticulously thought out plan, designed to explain crowdsourcing to this American Film Market audience *while* crowdsourcing them at the same time. In retrospect, it's pretty fascinating how well it worked, wouldn't you agree?

But when we look again at the eight aspects of Nick's approach outlined above, in a way, it also seems almost obvious, doesn't it? Still, you'd be amazed at how many people do not take the time to plan out their strategy. And then there are some who do plan, but do not maintain the focus, patience and energy necessary to follow through. I think you can now see that if Nick had failed in any category, how the entire plan, the entire mission, might have collapsed.

Before we wrap up the examination of Nick's talk with some random thoughts, I'd like to tackle one more topic that he raised. This is something I was planning on doing a bit later in the book, because it is an extremely important topic to cover, not only from an informational perspective, but from a psychological one as well. But since I brought it up, how about we tackle it right here?

Cool?

Cool.

THE DIFFERENCE BETWEEN ADVERTISING, MARKETING AND CROWDSOURCING

Nick specifically mentioned the difference between advertising and crowd-sourcing. He also mentioned the role of crowdsourcing in marketing, which suggests that the two are somewhat intertwined. And they are to an extent. But in addition to examining the differences between advertising and crowdsourcing, I'd like to also dig down into the differences between marketing and crowdsourcing as well. Why? Because next to the notion that crowdsourcing is the same as crowdfunding, the next biggest misconception I've heard over the years is that crowdsourcing is simply advertising and/or marketing (particularly, the latter) wrapped in a different box. Not only is this notion incorrect, it's cyanide to the planning and execution of any crowdsourcing campaign. Let's take a look at where these strategies divide and why confusing them can prove to be deadly.

Advertising

Here's how Nick addressed advertising in his speech:

> Advertisements can start to perish once they are aired or printed, while communities grow organically and infinitely, as long as they are nourished.

Let's focus on that word "perish" for a second. Can't find a positive connotation in that word, can we? Think about when you watch an advertisement on television. So many things have to go right for you to pay attention, right? First, you have to be interested in the product or service. Second, you have to connect to the messaging. Third, you have to be in the headspace to actually want to consume and digest the commercial—and that's if you haven't left the couch completely to grab a snack, check your phone or, you know, go do your business.

Now, even in a perfect storm scenario where you find an interest in the product or service, the message resonates, you're in the proper mindset to take in and absorb the information and you haven't left to pee, what happens next? Either another commercial vies for your attention, or the content you sat down to consume, your primary objective for staring at the tube in the first place, resumes. As a result, the message begins to

weaken, deteriorate, *perish* . . . until you forget about it entirely. Or until something in your day-to-day triggers a remembrance which, let's face it, is a crapshoot.

Now, here's how marketing expert and author of *Consumer Behavior for Dummies*, Laura Lake, defined advertising in an article she wrote for the website *About Money*:

> Advertising is the paid, public, non-personal announcement of a persuasive message by an identified sponsor; the non-personal presentation or promotion by a firm of its products to its existing and potential customers.

We could spend some time speaking about the word "paid" and how this concept doesn't factor into crowdsourcing on any level. But I trust that this will be extremely evident as we move along. Instead, I'd like to focus our energy on a much more important aspect within the definition. And I'd love your participation.

Given everything we've explored thus far in this chapter, what words from Laura's definition hit you right between the eyes?

That's right, my dear Padawan . . .

Non-personal presentation.

Twice!

As we have discovered, and will continue to discover time and time again, there is nothing non-personal about crowdsourcing. In fact, the guiding, soaring spirit of crowdsourcing could not be more opposite. Crowdsourcing is about a sharing of ideas, not the presenting of them. Crowdsourcing is all about interaction, community and inclusion. As such, clearly, crowdsourcing is not advertising.

One more quick note. Some people *do* pay for crowdsourcing leads with search engine or social media advertising. I frown on the practice. Paid ads are a form of broadcasting. There is no opportunity for interaction. The spirit of what carries a crowdsourcing campaign is invisible.

Organic crowdsourcing will always be received better and with more conviction and faith. Anything perceived as a shortcut will be sniffed out by the crowd, inevitably leading to a dead air.

Marketing

Again, Nick mentioned the role of crowdsourcing in marketing. This is one area where our opinions diverge ever so slightly. I agree that there can be a certain aspect of crowdsourcing within a specifically targeted marketing campaign. But, for the purposes of where I'd like you to be at the end of our time together, I'd like you to instead absorb this inverse thought: A crowdsourcing campaign may include some aspects of marketing.

In our focus group testing and polling for this book, and simply by conversing with people along the way through speaking engagements and on Stage 32, many associate crowdsourcing with marketing. In many cases, I can completely understand why there could be this association and confusion.

You have a product. In this case, let's say it's a film project. It rests in a specific genre and is beyond original and cool, with cutting-edge elements. You are trying to draw attention to this product. You identify who might be interested in such a product. Now you are going to market the benefits of this product to this targeted crowd.

For comparison's sake . . .

Company X has a product. In this case, let's say it's laundry detergent. Better, let's call it the most revolutionary laundry detergent ever. I mean, this stuff is groundbreaking. Removes stains without fail. Makes old shirts look new again. Smells like the wings of an angel. Company X is going to identify who might be interested in such a product. They are going to market the benefits of the product to this targeted crowd.

Sounds similar, right?

Let's come back to that.

In the interim, let's take a look at Laura Lake's definition of marketing from the same *About Money* article:

> Marketing is the systematic planning, implementation and control of a mix of business activities intended to bring together buyers and sellers for the mutually advantageous exchange or transfer of products.

Now what hits you between the eyes about Laura's definition here, dear Padawan?

Correct again.

Mutually advantageous.

So . . . what does this all mean?

Well, I think it is extremely clear that if we were to run some DNA tests, we'd discover that advertising is in no way related to crowdsourcing. However, given the same tests, we might discover that marketing and crowdsourcing are distant relatives, maybe fourth cousins on marketing's mother's side.

But if marketing requires systematic planning and implementation, brings two sides together and is a mutually advantageous practice, why is it not the same as the crowdsourcing? All the elements seem to be there, no?

Seemingly.

But, no.

There are two monumentally important aspects missing:

1 Personal interaction and the potential for a personal connection.

2 The importance and priority of moving the crowd to carry the message.

Let's go back to our film vs. laundry detergent scenario. As painted above, on the surface, there really isn't much of a difference between the two initiatives. There are two products worthy of attention. Both you and Company X have spent time pinpointing who might be interested in your respective product. So what's missing here?

Well, let's start with Company X. If Company X is a known entity, they will use their reputation in the marketplace as currency within their marketing

push. Their road to establishing themselves as experts in this area has already been proven, or, if laundry detergent is a new area for them, their foothold with other products has shortened the road to respectability in this area. At this point, really all Company X has to do is dictate the message through a concentrated marketing campaign. The rush to support their move into laundry detergent will be a byproduct of their history, reputation and message.

But to keep things equal, let's say that both Company X and you are unknown entities. Let's again start with Company X.

Company X has spent years formulating their laundry detergent in labs. They've spent countless hundreds of hours on R&D. Sure, perhaps they've done some focus group testing, but that's information being given by consumers for free pizza or perhaps free product or other swag. And if you're a person in that focus group, you certainly do not feel any ownership in the decision-making or in the shaping of the product. For Company X, the focus group results are just responses on a page—there's nothing personal about it. It's just information and data to be processed and dealt with that may or may not inform Company X's advertising and marketing campaign.

When Company X goes to market, they have a carefully honed marketing message designed to stress the benefits and advantages of purchasing their laundry detergent over that of a competitor. This message is broadcast to consumers. There is no dialogue between them and the consumer. So when Nancy Adams of Wichita, Kansas walks into her local grocery store and picks up a jug of the stuff, she is registered as a "1" in the "Purchased" side of the ledger.

So, sure, for Company X, marketing the laundry detergent has resulted in a mutually advantageous situation for both them and Nancy Adams of Wichita. Company X gets a sale. Nancy Adams gets sparkling clean clothes that smell like the wings of an angel. The world continues to spin.

Now, let's look at your film project. You are an unknown entity. You have this absolutely incredible film project. You have pinpointed the group who you feel would be interested in this type of material. Coincidentally, Nancy Adams of Wichita just happens to be a huge fan of this genre and is a member of this crowd you have zeroed in on as sharing a common interest in said material. Unbeknownst to you, she's sitting at her computer in a t-shirt (which smells like the wings of an angel) with the poster design of a very popular movie in the very same genre as yours.

You have spent countless hours putting together your genius marketing campaign speaking to the merits of the project and why it's so damn groundbreaking. It's clever, smart and, in your mind, irresistible. You decide to fire your first salvos on a popular chat board suited to consumers and fans of your material. You post, broadcast your message out there. You wait for the result.

Nancy Adams of Wichita sees your thread. Her first thought is *Who is this guy? I've never seen him on this board before.* She reads a little further. *Oh, another genius with a film needy for attention.* She lets out a loud "Ugh!" This wakes up her sleeping corgi puppy, Cupcake, who, startled, jumps up in to Nancy's lap and snuggles into her ultra soft, angelic scented t-shirt. Nancy pats Cupcake on the head, makes some goo-goo sounds to the pup and instinctively moves on to the next thread.

You've been forgotten.

Before you were really even a thought.

Your marketing campaign failed. And it failed for the two reasons I mentioned above.

You left no room for a personal connection or a personal interaction

And, therefore . . .

You spent no time on how you were going to get the crowd to carry your message.

You've lost Nancy Adams, Cupcake *and* their legion of supporters and champions . . . forever.

Crowdsourcing

So how do we get the crowd so actively involved in our message and mission that they want to carry the gospel forward? How can that happen without being a broadcaster first? We have to get the information out there, don't we?

There has to be a way to get Nancy and Cupcake Adams of Wichita on our side, no?

Of course there is.

First, let's wrap up this advertising, marketing and crowdsourcing section in a bow and look at some final important thoughts from Nick's talk first. These are all necessary steps on our magical journey.

Here's how Nick defined crowdsourcing in his speech:

> Crowdsourcing is creating a community and voluntary workforce behind your content.

Simple. Elegant. And while I believe we can certainly expand upon it a bit, it's certainly in the strike zone. It's also enough to identify why Nancy and Cupcake of Wichita moved on so quickly.

In the scenario above, you pinpointed the crowd or, to allow for matching up to Nick's definition, the community. *Pinpointed.* But the effort to create a community *behind your content* failed. The message might have had broad appeal to Nancy and Cupcake, but it didn't speak to them as individuals— human and canine. Why would either want to be a *voluntary workforce behind your content*?

This is further exemplified by a few of the final paragraphs of Nick's talk:

> The first ingredient to crowdsourcing your audience is committing yourself to fostering a community around your content, which is also a realization that you are just one fellow in a (hopefully) much greater fellowship, and the only way that fellowship will grow is if you set forth attitudes, interests and goals that can be shared by others, passionately.

> The most important aspect of any crowdsourcing campaign is not the money raised or revenue generated, but rather the social capital you accrue.

> When you open up a channel to enable crowdsourcing, you are essentially creating a voluntary army—boots on the ground who will share more passionately and resiliently than any advertisement.

Remember I spoke about getting the crowd to walk alongside you? Read the first paragraph from this excerpt again. Fellowship. Sharing. Passion.

Commonality.

What hits you in the second paragraph?

Social capital.

When we crowdsource for the first time, we are usually attempting to get the crowd to rally behind our product or cause as opposed to ourselves. Why? Because you have already identified your crowd as an entity that has a common interest in your product or cause. It's known to them.

You, however, are not.

You have proving to do.

You have trust to gain.

The burden of acceptance lies not only in your message, but in who you are.

Now, that might seem scary, and I'm not going to lie to you: infiltrating an existing group of individuals with an established and formidable history isn't easy, but it should be exhilarating all the same. And here's why: Not only is the ability to gather and move the crowd around your project or cause a powerful and motivating occurrence, but it serves to build confidence as well. As long as you deliver on your promises, whatever they may be, the crowd will follow you anywhere. More importantly, they will tell others about the worthiness of following you as well. That's social capital. That's power. And that's how you build the boots on the voluntary army, the boots on the ground that Nick mentions in the final paragraph above.

And Nick is right: the word of someone from your army will share the word of your project or cause or *you* more passionately and resiliently than any advertisement. And since I brought up marketing, the same holds true for any marketing campaign, no matter how brilliant or innovative that campaign might be.

But here's the kicker . . .

It has been proven in case study after case study that the word of a disciple of a product or cause is at least 20 times more powerful than the word of the person or entity behind the product or cause. Twenty times.

Can you see the blessing and the curse?

Let's start with the curse.

To create movement with a crowd, you need disciples within that crowd. To gain disciples, you need social capital. To get social capital, you have to win disciples.

Seems like a loop with no entry point, right?

Wrong.

We've already identified some ways we can go about winning disciples. But, make no mistake, the first crowdsourcing campaign you run will be the most difficult. Winning disciples takes a long and laser focused ground game. It takes selfless and flexible behavior. It takes will and strength. It takes patience beyond compare.

And that's why so many campaigns fail.

That's why so many quit.

And that's why you, by the end of this book, will have such a huge competitive advantage in the marketplace.

Because the blessing is this . . .

If you utilize all the strategies and methods we will explore, if you truly read the case studies and put into practice the action plan of those who achieved enormous success in this arena, you will get your voluntary, and I will add the word willing, army. Your boots on the ground. You will get your disciples carrying your message to people they know, strangers to you. And their voice will carry the word of your project, cause or *you* with an impact 20 times more powerful than if you had delivered it yourself.

The idea here is to build that army (and I can't understate enough, you *must* deliver on *every* promise to do so) methodically and incrementally. And if you do so, each campaign will become infinitely easier.

Another blessing?

Control of all of this is firmly in your hands.

Let me show you how.

Interspersed throughout the remainder of this book, we're going to read and examine a few case studies of successful film crowdsourcing campaigns. I urge you not to rush through these chapters. There is a wealth of pertinent information and various examples of approach and execution to digest. You will also see where campaigns went off the rails and how these incredibly resourceful creatives profiled managed to right themselves and win the day.

I would highly recommend and encourage you to mark these pages up if you're reading an actual book (perish the thought), and to highlight and underscore if you are using a tablet or Kindle, those points that capture your interest and imagination. I believe you will use the case study chapters for reference almost as much as you will the informational and strategic chapters. So, take your time and mark away.

NOTE

1 https://www.wired.com/2006/06/crowds/

8

Case Study #1

Sheila Scorned

For our first case study, we focus on a short film. Over the last few years, the number of short films being produced has never been greater. There are a number or reasons why this is the case. For starters, technology has advanced to the point where the costs for shooting a short film have decreased significantly. Additionally, the method of raising funds through rewards-based crowdfunding platforms has become part of the mainstream. Further, more and more amateur filmmakers are turning to short films as a way to either showcase their talents, or provide proof of concept toward a more expansive story idea, or both. As a result of all of this, not only are more film festivals accepting or completely dedicated to short film programs dramatically on the rise, but increasingly producers, managers and agents have become accepting of the medium, viewing short films in an effort to find new, exciting talent and/or content.

A recent example of a writer/filmmaker who implemented the strategy of filming a short as proof of concept toward a larger story idea is Damien Chazelle. Chazelle wrote and directed *Whiplash*. Chazelle originally pitched his idea as a feature. When there were no bites, Chazelle took matters into his own hands. He reimagined his story as a short film and went about raising financing.

As a result, the feature story of a prodigy drummer and his ferocious and uncompromising teacher had now been boiled down to a taut, thrilling

18-minute short. Chazelle submitted the film and was accepted into Sundance, where it won the Short Film Jury Prize for the Best Fiction Short Film of 2013. Propelled by this win (and leaving no question as to his considerable talents), Chazelle was able to attract a production company interested in his idea of developing *Whiplash* into a fully formed feature film. Before Chazelle could shout "Action!" he was back in front of the cameras and filming his grand vision. One year after his win for the short version of *Whiplash*, Chazelle found himself back at Sundance accepting the Grand Jury Prize and the Audience Award for Best Feature. The film went on to win numerous festivals, association and critical awards, and was nominated for five Oscars, winning three. Pretty good decision by Mr. Chazelle, wouldn't you agree?

When speaking with industry executives, including managers and agents, regarding not only the rise in number of short films, but the increasing notion that they could serve as a calling card and proof of concept for a creative, the response is universally positive. Everyone likes a deep talent pool to choose from. Their challenge is cutting through the bad stuff to get to the good. To that end, a word that gets brought up quite consistently is crowdsourcing. Convenient for me, huh?

See, while managers, agents, producers and directors of development all want to find the next big thing, they don't have a ton of free time on their hands to do so. They have clients and/or projects in development or in production. Their schedules are packed. They work off the referrals of others, but they also go out seeking material on their own. When doing so, they want to look at material that has proven popular in the court of public opinion. They want to know that you've not only moved a crowd to get your film done, but that the crowd will continue to walk alongside you, picking up more advocates along the way.

This is the story of a director of a short film which she knew would cater to a niche crowd, but found a way to connect with that crowd, identify new crowds along the way and keep the support of those crowds throughout. This is the story of *Sheila Scorned*.[1]

ORIGIN STORY

In the fall of 2013, Mara Tasker lived in Los Angeles, working as a researcher for a screenwriter. Every morning at 8am, Mara and the screenwriter would meet to discuss the world of the film he was planning to write—the characters,

locations, themes and motivations. During these meetings, the writer would provide Mara with a list of items for her to investigate. Mara would then spend the rest of her day on a fact-finding mission, filling in the missing pieces of information which would bring authenticity to the author's screenplay.

Some might view hours spent digging up such material as tedious grunt work. But to Mara, a self-proclaimed lover of stories and a perpetually curious person, the position allowed for exploration. It opened her up to new worlds, ideals and cultures. She relished the role of helping shape the screenwriter's stories, and considered this particular job to be her most inspiring to date.

One day, Mara's tasks required her to do some research on the architecture, current social customs, and pop culture of Cairo. Mara jumped online and began taking notes on the layout and the architecture of the city, creating a verbal mold for the feel of the city's grid. She watched videos, newsreels and human-interest stories to get a picture of the day-to-day life: fashion, cuisine, transportation, business, education, entertainment and other cultural touchstones. The deeper and more thoroughly Mara conducted her research, the more immersed she became in what life living in Cairo entailed.[2]

Says Mara,

> We were focusing on all aspects of the youth culture in particular since the characters in the film were to be young, beautiful and cunning. The script was being commissioned by a major studio and, therefore, we wanted to pay meticulous attention to detail. The goal was to create a fictional world within the script that stemmed from the real one—one that had universal and relatable themes which would appeal to a global audience.

As someone who had an unquenchable desire to write and direct, but hadn't quite found an idea or outside project which stoked the fires, Mara took the job hoping the requirements might serve to help her discover a story she'd be interested in pursuing.

As she continued with her research, she came across a series of news articles regarding political revolutions and protests at Tahrir Square. These gatherings began as civil demonstrations. Over time, however, they devolved into ugly, violent affairs. Women were being dragged into the Square where they were beaten and sexually abused. Making matters worse, no one seemed particularly motivated to stop the injustices.

Remarkably, it was the youth of Cairo who rose to the occasion in an effort to quell the madness. Mara read tale after tale of young people taking to Facebook, online forums and chat rooms to explain and educate others on the horrors occurring at Tahrir Square. The goal was to recruit and lead masses of young protestors into the street to speak out against the violence and abuse. In short, a small group of young, internet savvy teens were planting the seeds toward crowdsourcing a movement.

"It was a beautiful kind of chaos," Mara says, and continues,

> The kind I have never seen in the US. But through this fabric of social change, there was the undeniable silhouette of violence against women. There were countless, countless stories of women taking aggressive and terribly disturbing beatings in public—a mass disregard for the female body and psyche. The socio-political revolutions had turned people passionately against each other. What was anger at society became anger against women. The rage felt at the state of the world turned itself into a simpler kind of violence—a stronger person facing and beating down a weaker one. Women had become outlets for blind fury and my head was spinning with questions, the most basic and broad of which was a simple "Why?" But more specific: "In times of war, why rape? In fits of anger, why abuse?"
>
> There were countless stories of young people heading to Tahrir Square to join in the marches and riots. But whenever the masses turned hostile, as they frequently can, women ended up at the heart of a gratuitous violence, their screams rarely answered. Those who tried to help, women *or* men, faced extreme physical risks and were often injured. The headlines sent me spinning and reflecting on how the experience of being female deeply impacts our experience in the world as people— there's an empathy that doesn't break down due to race or geography.

At this point, having worked in Hollywood for five years, Mara had read more scripts than she could count. The benefit to all this reading was that she was getting a master class in storytelling, a top-draw education on what does and doesn't work on the page. Additionally, she learned a great deal about writing character arcs, goals and obstacles. Troubling to her, however, she had read piles of scripts with female characters who were either objects of male fantasy or victims of circumstance or application. Additionally, almost all female characters were presented on the page as passive instead of active participants in the action of the story. This bothered her to no

end. This frustration was exacerbated as she continued her research into the unspeakable horrors happening in Cairo. Women were being treated as disposable pawns, vehicles for angry men to vent their anger.

And that's when inspiration struck. Mara says,

> Simply, I felt really pissed. In many ways, as a woman, even though I was not being subjected to these horrors, I felt misunderstood. Most of all, I felt completely helpless. I knew there needed to be change, and I wanted to be an active participant in that change in some small way, but struggled to find an answer on how to do so. I felt overwhelmingly human, and the only place I had any agency was the blank page on my computer screen. In that moment, I needed to feel and, eventually, believed that I could, create change through art. I retracted into my thoughts. I thought deeply about the plight facing the women of Cairo. I thought deeply about what I wanted to see change. I put my emotions down on paper. That was the seed of the story I needed to water. And then, looking back through all the research I had performed for this other project, I discovered my main character.
>
> It grew from one fleeting image on a computer screen of a woman, barely dressed, her sexual expression entirely overt against a world trying to dictate who she should be. I decided, right at that moment, I wanted to write about a strong woman with real, human qualities who could take down this paradigm of aggression against our gender in one swift action. I wanted to watch a screwed up, non-hero take the world on and knock it all back down. A drama wouldn't let me do that. Dramas adhere to the rules of the real world more often than not. Comedy wasn't going to let me bend reality enough either. But there was one very unexpected genre that would permit me the independence I needed to tell this story. One I had previously had no interest in whatsoever. I was going to write and direct a grindhouse film.

WRITING AND DEVELOPMENT

Now that she had settled on the genre that would grant her the freedom to present an ultra violent, slightly psychotic, revenge hungry character, Mara got to work. Peeking through fingers pressed to her eyes, she pushed her way through grindhouse films she previously had avoided at all costs. She

perused Amazon, researching and then buying books about film techniques used in classic B-movies from the '60s and '70s. She consumed the more recent films complimentary of the genre such as *Fight Club, Kill Bill* and (the original) *Oldboy*. She then took to the internet and researched, visited and eventually frequented a number of chat boards and forums, joining discussions related to grindhouse films. The strategy was not only to learn more about the genre, but to understand what makes a fan of these kinds of films tick. She knew that grindhouse films were viewed and admired by a very specific audience. And she knew she would eventually have to source that audience. She joined discussions, involving and integrating herself into the community. Most important, she asked questions.

What attracts you to this genre?

Why do you feel women are always the victims in these films?

Can you accept a woman protagonist in a grindhouse film?

What themes would you like to see such a film explore?

What do you think a cool name for my protagonist would be?

With this selfless approach, Mara was developing an interested, invested and devoted following: those who provided information and insight willingly, frequently requesting updates on the progress of her project. She had identified the crowd for her film and, simply by virtue of coming from a place of genuine curiosity, honesty and transparency, had engaged them as well. As important, she was using the crowd to inform the path of her protagonist as well as the themes and challenges she would explore. By being truly inquisitive and receptive to receiving information, Mara was quietly, but powerfully, giving the crowd a feeling of ownership. She says,

> The feedback was overwhelmingly positive and the information people provided was invaluable. The crowd was completely invested in my story, even though I hadn't written a word yet. The more I proved and validated that their opinions were valuable and carried weight, the more feedback they provided. I took notes on everything and, before I knew it, I was outlining the script. Soon, I had a worldview of my main character, a woman whose conscious doesn't hold her back in any morally conventional way. I had also designed a world for her to exist in, one where the

rules were different than the ones we are accustomed to experiencing. This would not have come so quickly without sourcing the crowd.

The wealth of material from the crowd, in addition to Mara's own dedication to the project proved to be a winning combination. Mara needed only three days to write the first draft of the screenplay, which she titled *Sheila Scorned.*

> After watching all the films and reading all the books, I had an idea of where I wanted to go, but it was so much information, it was almost overload. It was only when I started engaging people who were fans of the genre and filmmakers who worked on similarly themed projects that these ideas began to consolidate, and the characters and story began to crystalize. Before I knew it, I had written 18 pages of b-movie narrative with elements of heightened drama. Needless to say, it was inspiring and exciting.

Once the first draft was written, Mara sent it to her friend and producing partner, Jess Engel. Together, the two of them, using the feedback from the crowd and their own sensibilities, fleshed out the main character's arc and sharpened the dull edges of the screenplay. Eventually, they cut the script down to 16 taut, suspenseful pages. At that point, Mara went back to her growing legion of online supporters and, again, gave them even more currency and ownership by inviting them to read and critique some pages. Their enthusiastic response gave Mara and Jess the confidence to move forward.

Their next step was to enlist the help of a good friend, Pip Ngo, and ask him if he wanted to help produce the film. Pip read the script and not only immediately signed on, but suggested an actress he had attended New York University with and greatly admired, Laine Rettmer.

Says Mara,

> We were excited when Pip jumped on board. But we were a little cautious when he mentioned Laine. Not that we didn't trust Pip. Quite the opposite. It was just that Jess and I wanted to make sure that our lead actress wasn't just taking the part as a showcase, but because she believed in the message we were trying to get across. We wanted a kindred spirit. We had built an audience for this story. We had earned their trust. Further, we felt attuned to their sensibilities and expectations for a film such as this and we wanted our actors to connect in that fashion

as well. We didn't know Laine at all and we had some other spectacular L.A. actresses in mind, so, naturally, we were concerned.

Pip made the introductions via Skype and let Jess and I do our thing. It was awkward at first. We traded niceties and felt each other out a bit. Trying to get organically to the project as opposed to just jumping right in, we talked about what it means to be a woman in the world. What it means to feel fear walking alone at night. What it means to be stereotyped or judged. Laine had much to offer on these subjects and mentioned that many of her friends shared similar feelings and fears. When we finally got around to the script, Laine not only provided some fresh insights on the backstory of our main character, but suggested that we use some of her personal experiences to help shape the character further. We knew that we not only had the right actress for the project, but another true advocate of the mission of the film who would take to the streets in an effort to spread the word. Most important, we knew we had somebody who could embody the Sheila we had presented to, and was partially molded by, our extremely supportive followers.

From there, Mara and Jess went about meeting with casting directors, who would be charged with finding the male actors who would serve as foils to the Sheila character. They faced a couple of challenges. One, they hadn't raised any money yet, so anyone coming on board at this point would be doing so on good faith. Two, they wanted to work with someone who was going to treat this as more than just another gig, someone who connected with the material and would make his casting suggestions accordingly.

After a number of interviews that went nowhere, Mara and Jess were introduced to Candido Cornejo through a friend. Candido's understanding and vision regarding the script was impressive and all personalities clicked. The lack of available funds proved not to be a problem, either. For Candido, money was secondary to his desire to be involved in the project.

Says Mara,

His raw passion for the project coupled with his abilities of discovering talent made our jobs easy. He cared deeply about finding exactly the right people for each part. I had some strong preconceived opinions on what type of person I wanted to fill certain supporting roles. He challenged my ideas constantly and, at times, suggested we go in an almost

entirely opposite direction. But he would do so in a calm, detailed and informed manner. It took me a little while to relinquish control to his expertise, but I learned that his intuition is always on point. Further, he has a roster of actors who trust him and his instincts. It was an incredible learning and collaborative experience.

But Candido also brought something else to the table. In the original script, Sheila's main nemesis was to be a man named Barry. Although he kept it to himself at first, Candido believed that the story would be much more impactful if that character was changed to a female. Mara resisted. Going all the way back to the first seeds of this idea, back when she was researching the horrors occurring at Tahrir Square, she believe that Sheila had to live within a man's world, both mentally and physically. Allowing for the possibility that she was being too rigid, she allowed Candido to bring in two women to read along with the ten men already set to audition. It was no contest. Hearing the same lines delivered by a woman packed a huge punch. Barry was now Berry.

CROWDFUNDING

As we will see in future chapters and case studies, crowdfunding is its own animal. Mara and Jill did their research and the decision was made to devote at least two months planning out their marketing and crowdsourcing strategies. Doing so forced the duo to do some soul searching. They asked themselves the same questions over and over: Why were they truly making this film? What was it really about? What were the themes and the messages they were trying to get across? Who were they looking to connect with?

Although they had already found a core group of supporters for the project, could they be counted on to monetarily support the project and carry the message of the campaign? And, now that there had been much more character and story development, plus other new elements added to the script, could they uncover more people, groups and/or organizations who might want to support the project?

Says Mara,

> For me as a director, asking these questions again and again wasn't an exercise in insecurity. It forced me to clarify my vision. Sheila went from

being a pile of sketches and script notes to being a three-dimensional character with a style and brand all her own. So these questions were not only valid, they inspired creativity that stretched beyond the filming and into the promotional arena. For example, we spent an enormous amount of time creating a special font for the marketing we felt spoke for itself or, perhaps better, enhanced the message and feel of what the film was about. For association purposes, we selected still photos from the films that served as an influence and inspiration and used them to create our own marketing. Using the font I previously mentioned, we placed quotes from the script or information about campaign incentive goals and placed them over the photos. Before we took anything live, I ran samples past friends and our crowd of supporters, from the bloggers to the fans and champions on social media. I asked for feedback. I asked for suggestions. I asked for opinions. People were so enamored of some of the work we created and were so honored to be part of the process, they not only shared the images with their followers and groups, but would ask if they could help in any way and begged to be informed when more might be available. On Facebook, some of the images were so well received and shared so often by our supporters, they ended up getting hundreds of likes and comments, which only served to bring new supporters and fans of our initiative into our realm.

While all this was occurring, Mara and Jess were also researching the crowdfunding platform they felt was best for them. They settled on a new and little known startup called Seed&Spark instead of Kickstarter or any of the broader, mainstream platforms, believing that in this case smaller, and therefore less competition, was better. Additionally, Mara had reached out to the founder of the company, who took a vested interest in Mara's story and the project. She began crowdsourcing on the project's behalf and introduced Mara and Jess to groups and organizations she believed would have an interest in the film. Mara parlayed this support into three writing assignments for *Bitch Flicks*—an online resource for women's horror and B-movie writing (and a perfect fit) as well as a guest writing spot on the very popular independent film news site, *Indiewire*.

Says Mara,

> We utilized the crowd and our supporters to make introductions that would bring the story of our project to a wider audience. These articles were big wins for the team. Not only did it show we had broad traction and

interest in the project, but by posting these articles on our social media pages, blogs and other outlets, it gave our project an air of legitimacy and importance. As a result, our already large, but now rapidly growing, fanbase was more eager than ever to share the content. It's worth noting, *all* of this was happening *before* we had launched the actual campaign.

Next, Mara and the producers had multiple meetings in an effort to hammer out a realistic budget for the film. They didn't want to sink the campaign by posting a goal that seemed excessive, realizing that psychology plays a huge part in the success or failure of a campaign. However, due to locations, set design, elaborate shots, lighting, makeup (for all the gore) and, ultimately, a sizable crew, they kept coming in around the $50,000 mark—a daunting number for a crowdfunding raise, particularly for a short. In an effort to get the number down, the team began thinking about where they could ask favors and for possible equipment donations. Over time, they whittled the budget down to a still considerable, but more manageable $36,000.

"We were honest with ourselves during the whole process," says Mara. She continues,

> We never felt like we were being precious. We wanted to create the right world, which was imperative to telling the story in the correct fashion. That meant paying more crew and getting the right equipment. I won't lie, there were quiet moments where I questioned whether we were overshooting as it related to the budget. I wondered if we could just shoot the film more simply and make it for $10K. It never felt right. This wasn't a simple project. It was conceived as something bigger and we needed to stay true to that. We knew the raise wouldn't be easy. But we also knew that we already had put in the time to engage and communicate with a large number of possible would-be supporters to the campaign. And we had the friend and family angle to play. We moved forward with cautious optimism.

The week before the campaign began, Mara and Jill created a large list of personal (friends and family), industry and online (social media/blogger/ chat room) contacts. They then took that master list and divided it into three separate target priority lists, which they called tiers.

They emailed everyone on the Tier 1 list a week in advance of the campaign launch and asked them to donate in the first two days of the campaign. This

was done to present the appearance of immediate and valid interest in the project. Two days before they launched, they sent a friendly reminder email to those Tier 1 people and posted on all their social media accounts, notifying their followers as to the launch date.

The planning and efforts paid off. In the first day, the campaign was pulling in over $10 per minute. By day four, 30% of the raise was already in the bank. But, at the end of the first week, as is often the case, the campaign hit a lull.

"We had been warned that the second week is the worst," Mara says.

> And it certainly was. So we hunkered down and got creative. One of the reasons we liked Seed&Spark was they allowed your supporters to pledge money toward a specific need. Like a wedding registry, you can list the items that you need to complete the film and how much it will cost. So, for example, wardrobe for one of the actors might cost $100. A supporter can know that his or her money went toward that piece to make the film happen. It gives them more ownership.

> We contacted a friend who worked at a store that offers camera rentals. After a few days of tense negotiations, he donated the entire camera package plus two lenses in exchange for an agreed upon credit on the film. This entire package, which included a RED Epic Dragon plus lenses, was valued at $4,000, and as soon as he entered the camera loan into our donations page, the needle spiked. More magical, he also became part of our crowd of supporters and one of our greatest allies in spreading the word of our project to his contact list. The needle spiked again. Suddenly and swiftly, interest was renewed and people began to donate again.

This is a great lesson. Most times when a campaign begins to lull, the natural instinct is to double up the marketing efforts with more posts on social media or other digital outlets. Most times, this approach only serves to thicken the air of desperation hanging over your project. It also can serve to diminish all the good will you've created. The right move is a shift into a bunker mentality. To regroup. To spitball new ideas, see if there are any other stones to turn over. You need to take the pulse of your campaign. What's working, what's failed, what strategies worked the best, what groups have been the most engaged. This is in game planning at its finest. It requires

resourcefulness and an unfiltered eye. You have to figure out how to get that ball rolling again in the most organic way possible. In short, you can't force momentum, *you need to build it.*

Now that the campaign had some positive mojo again, the team emailed their Tier 2 list and asked them to take a look at the project and contribute. In the third week of the campaign, they mailed to all on their Tier 3 list with the same "Ask." In between, they were servicing their existing fan and contributor base by posting new videos, information, blog posts and other content not only to the campaign page, but through their social media pages as well. The contributions continued to roll in from a variety of sources. One very enthusiastic supporter was so impressed by the content, the message and the devotion to the cause, he contributed $2,000 to the campaign and urged others to do the same. Now, that's engaging and moving the crowd! It's also a perfect example why momentum is so essential to the psychology within the life of a crowdfunding campaign.

The team didn't only rely on an online push and their three-tiered mailing approach as the methods of drumming up interest and support for the campaign. Throughout the four-week plus journey, Mara researched people and organizations she believed might find her story and the story of the project compelling or relatable. Once she had compiled a targeted hit list, she took to the phones, making and taking as many meetings as she could all over Los Angeles. She spoke at a women's conference in Santa Monica, making certain she was never simply just talking about the film, but the *purpose* of the film, and why the entire project mattered to her. And when she did speak about the film, she spoke about the main character and what her journey would signify.

Says Mara,

> Creating a brand and character that captivates people, and staying a member of your own audience by listening to what people say they want to see, really helped us to create a character who was loved intensely before we even went into production.

Also during this outreach, the team came across an organization called WAM! (Women, Action & Media). This is a group of creative women who run conferences around Los Angeles, where members give mini Ted Talks on topics such as writing better female characters, the female gaze and the implications of the characterizations of women in today's mainstream

projects. Mara reached out to the group and expressed a deep admiration and interest in their initiative. She asked if she could attend a conference. The group did her one better.

> A WAM! conference happened to be taking place during our campaign. I thought it might be a good idea to attend and do some networking. I admired what the group was accomplishing. To my surprise, I was asked to speak. In front of a packed room of professionals and students who were invited to attend, I spoke about the importance of the kind of images we use in media to portray women and the effects of victimization in storytelling. I used examples that had nothing to do with our project. But, at the end, I was given the opportunity to bring *Sheila Scorned* into the fold and explain what we planned to do with these themes as it related to the film. The response was remarkable. Everyone was eager to learn more. I was overwhelmed by the support. I spent as much time as allowed answering questions and left behind fliers with more information about the film and my contact information if anyone had further questions or just wanted to talk. A number of people took me up on the offer and became influential supporters. It was an incredible event and evening.

As if these initiatives weren't enough, midway during the campaign, Mara and Jill spoke with the Angel City Derby Girls, a Los Angeles based women's roller derby league, and asked them if they could set up a booth at their next event and assist in helping with cross promotion. The league agreed.

The *Sheila* team made some social media posts to their fans urging them to come to the event and support the Angel City Derby Girls. The response was beyond expectations. Their supporters came out en masse. At the event, the girls set up a red carpet in front of a step and repeat and passed out *Sheila Scorned* tattoos to the fans. Then, they took pictures of the fans sporting the artwork for the film and asked the fans to share through their social media accounts. At halftime, the owners gave the team a shout-out so that people who had missed the group in front of the arena would know that they would be available to speak to them about the project upon leaving. The team handed our flyers and spoke passionately about the project, ultimately asking for support. Once they returned to their office, the team immediately started posting pictures of people sporting the *Sheila Scorned* tattoos, tagging the Angel City Derby Girls in each one in an effort to give them a new audience as well. This was a huge win-win for all involved, and an example of crowdsourcing at its finest.

The grassroots efforts paid off. Mara and her team had managed to bring myriad new and diverse audiences, all too happy to spread the word, to the project. Suddenly calls, emails and social media posts were coming in from all over the country. Mara and her team took the time to respond to all correspondence. The outreach and the individual attention (which cannot be stressed enough) led to a spurt in donations.

As the campaign entered its last seven days, the team still found themselves about 20% shy of their goal. Fortunately, they had anticipated and planned for such an event. As a result, there was no panic, just calm, collected execution.

Says Mara,

> We wanted to make sure that we kept some of our bigger ideas in storage for when we needed them most. So we were very prepared for the final week of the campaign. We listed some creative giveaway opportunities and time sensitive incentives. Also, we had made a list of some of our most ardent supporters with whom we had cultivated relationships and appealed to them to donate goods and services. These were genuine friendships and bonds we had formed, so the response was fantastic and inspiring. This support not only overwhelmed us on a human level, but as it related to the task at hand, it helped to lessen the amount of actual cash we needed to make the film.

In the end, 287 supporters either contributed cash, services or goods to the campaign. *Sheila* hit its $36,000 goal with room to spare.

PRE-PRODUCTION

Now that the money had been raised for the project, Mara and her team had to move quickly. Each of the actors had limited schedules and some had only a short window in between projects. The team estimated they needed about three weeks to bring the entire project from start to wrap. Buoyed by the remarkable support they had received throughout the campaign from their fans, they decided to try and crowdsource locations in an effort to cut down on scouting time. They went to their social media and offline fans and followers, seeing if people would donate certain locations that were a match for those listed in the shooting script. Again, the response was swift and overwhelming. Although it was going to be a delicate juggling act matching

the actors' schedules with the availability of certain locations, the team was fired up by the support. They were now not only invested in making this film for themselves, but for every single person who had thrown their weight behind the project.

Says Mara,

> There is an undeniable feeling of power you get when you feel you have an army of support behind you. Every time we looked at the challenges to seeing the film to completion, we felt energized that we could fight through it. In our minds there was no way this wasn't going to work out.

Now that the schedule was in place, the team divided and conquered to make sure all bases were covered for the first day of shooting. The producers got in touch with every contact who had donated goods to the campaign, locking in craft services, all crew gear and RED Epic and Dragon cameras. Meanwhile, Mara worked with her DP around the clock to figure out what color schemes and lighting they wanted for different characters and scenes. From there, the duo worked in lockstep with their production designer to come up with the right look for each of those scenes.

"With filming only two weeks out, the crew went into overdrive," says Mara.

> We always felt a responsibility to each other, as any good team should, that we were going to pull together, give our best individual efforts for each other and make the best film possible. That should always be enough. But every time we discussed the project something would remind us of the crowd. Whether it was knowing we had the money to shoot on a location we otherwise might not have been able to or know-ing that we had this incredible equipment that had been donated to us to work with, we felt a huge responsibility, and I mean this in the most positive way, to work our asses off for those who had supported us. We had a responsibility to each and every one of them. We all stepped up our game that much more. The actors met with me during the oddest of hours just to work through backstory and technique. Laine, who is New York based, flew out ten days early and slept on an air mattress on my floor without a second's thought. Tired as we were at times, we spent every possible moment together working through the script and adjusting the dialogue so it felt right for her, and the character speaking through her. I had her take dance classes while I was at work so that

when we met up at night, we could talk about the elements she wanted to incorporate in the film.

Two days before production, my special effects supervisor, my DP, Laine and two of the actors and I did a stunt rehearsal with our fight choreographer. This was not an easy process. It was long and carefully orchestrated. We created a pre-visual so that we could see exactly what angles we needed to truly sell the fight scene. The actors remained patient even while the most technical of details were worked out.

The night before production, my DP and I met up under the neon beer lights of a diner and walked through every shot. *Every. Single. Shot.* We had created a list of more set-ups than was really possible given the timeline but we really didn't care about the clock at that point. We believed that anything and everything was possible.

Again, many actors would go to the same lengths in an effort to find their character, and all crew members want to go the extra mile, especially on a small set. But there was something more magical here for us all knowing that although we hadn't shot a frame of film, we already had an audience watching our every move through our constant updates, rooting for us, and ready to watch this movie. It wasn't only ridiculously inspiring, it was empowering.

PRODUCTION

Because of all the preparation and sacrifice, the production of *Sheila Scorned* ran as smoothly as possible. The actors came ready to play. The lighting, tested again and again, set the perfect mood. The FX artists executed and saved valuable on set time, allowing for the director and her cast to roam and make discoveries while shooting, some which made it into the final cut. The only hiccup came on the last day, which had been earmarked for the film's toughest scene. Still, the crew found the wherewithal and a reason to hold things together.

Says Mara,

We had been warned that the fight scene would take far longer than the time we had allotted. And the truth is, we did build in what we felt was not only enough time to shoot the scene, but to have extra time to

try some things out. Between the blood, the costume changes and the milieu of angles we needed to get, we found ourselves running out of time. It was getting down to the wire. And it was the only time during the entire shoot that I saw doubt and frustration set in. My DP, the picture of calm, was stressed out. We were too close to the finish line to let things unravel. We gathered ourselves, talked about how much the film meant to us and, again, talked about how close we were to wrapping, heading into post and having a product to show our supporters. The idea that people were waiting to see this film got us fired up again. After 4.5 hours, we had all of the footage. The best part for me was watching my producers, the actors and the crew huddled around a screen in the video village viewing the fight footage. They were all tensing up watching the fight go down. This was without music and without cuts that would make the fight all that much more dynamic. It was the best feeling to see people already reacting to what we were making. I couldn't wait to show it to our supporters.

Somewhere in the chaos, it all came together. Everyone hustled, the actors nailed it and all of us simply communicated at a high level. I've never felt it more than I did in that moment, but the importance of having a team of people you trust, on and off set, is invaluable. From the crowdsourcing, to the crowdfunding, to the shoot to the aftermath, that's the one definitive takeaway.

After production, I felt a high like no other for a week. I couldn't sleep that night and when I woke up, I cried that it was already over. It was the most exhilarated and terrified I had been in a long time. And I wanted it back immediately. Fortunately, so did everyone else on the crew who sent me emotional text messages the next day. We all agreed that our work was not done. We had to finish *Sheila Scorned* not just for us, but for those who backed us. Our work was far from done.

POST-PRODUCTION, FESTIVALS & DISTRIBUTION

While in post on *Sheila Scorned*, Mara and her team took turns reaching out and responding to not only their crowdfunding supporters, but the bloggers and other supporters they had gained through the entire journey. They shared updates, stills, videos and stories from the set. Their teaser videos played especially well. Interest in seeing the film continued to rise.

Although in the early stages of their distribution strategy, the team identi-
fied 21 film festivals they believed were a fit for the material. They also tar-
geted a second wave of 15–20 festivals that they planned to submit to a few
months later based on the response and feedback they received from the
first 21 submissions.

> We were meticulous in our research and realistic about not spending
> money on submissions for the sake of spending money. We came up
> with a targeted list and then ranked them by order of priority—the fes-
> tivals with major markets attached to them, the best festivals for grind-
> house films, the top women's film festivals and high profile action film
> festivals.

One of the first festivals *Sheila Scorned* was accepted to was the Los Ange-
les International Underground Film Festival. Mara called upon her and the
film's following to get the message out about the screening and many of
the film's supporters showed up anxious to see the finished product. They
were not disappointed. The film was extremely well accepted with the crowd
reacting and connecting exactly as Mara intended. In fact, the crowd con-
nected to the material and the plight and journey of the main character so
well that Laine won the audience choice award for Best Actress.

Sheila Scorned has also played the Minneapolis Underground Film Festival
and the Hollywood Underground Festival.

Says Mara,

> Sitting in a theater, watching the film play in front of the niche audience
> it was made for, and hearing people laugh at the references tucked into
> its folds, is like a Christmas morning that repeats itself every time it
> plays another festival. The best part of the whole process has been the
> discovery of this character and this new and profound appreciation of
> our audience. Further, to see the brand that we created in our initial
> setup pay off and hit the bull's-eye has created an unparalleled sense
> of satisfaction. That brand, that message, continues to ignite people to
> rally behind the character and the world and, as a result, helps the film
> gain traction by word of mouth. The best part of the whole process has
> been the discovery of this character and this new and profound appre-
> ciation of our audience. And for them, we'll consider where we should
> have the film live in perpetuity. We made it to be seen by as many people

who might connect to the material as possible. So as we continue our distribution journey and, eventually, figure out which platform offers us the most robust release, *Sheila* will be coming for everyone. And even then, our work will not be done. We will continue to try and identify and engage new crowds of possible *Sheila* fans while making certain we stay connected to those amazing people who helped make this journey a reality.

NOTES

1 Please note all quotes in this chapter are from Mara Tasker (current position title if any), in discussion with the author, Month Year of interview(s).
2 "Sheila Scorned," written and directed by Mara Tasker (released Oct 19, 2014), short film, https://vimeo.com/109404659

9

What Word in Social Media Don't You Understand?

Before I started Stage 32, you wouldn't have caught me dead (or even drunk!) on social media. I just didn't see the appeal. Friends, family members and business colleagues would spend hours trying to convince me of what I was missing out on. Quick updates, pictures of adorable babies, precious kittens, the best salads on the planet, self-absorbed musings, inspirational quotes, narcissistic behavior, true confessions, selfies, LOLs, LMAOs, LMFAOs and a staggering arsenal of smiley face emoticons. Didn't I have a desire to be social, to expand my stable of contacts, to be instantly and constantly connected, to be in the know, part of the scene, hardwired to the collective consciousness? I reminded them that I was out socially practically every night, lived a life tethered to devices that afforded me the luxury to receive texts, emails and phone calls, and, honestly, with all due respect, could care less what they had for breakfast, if they thought last night's episode of *Real Housewives of Topeka* was amazeballs, or if their child just had the most excellent bowel movement EVER.

These were my struggles with social media as a human existing. As a creative and entrepreneur, the mass social networks (Facebook, for example) held even less charms for me. They were too broad of scope, seeking an all-inclusive audience, which, of course, was the intent. Friends and acquaintances fought for the same attention and held equal status as, let's say, like-minded creative colleagues or business relations. Because of this, it

was tough to deliver one's message or share information with a particular segment of your network. Anyone and everyone could chime in and water down the power of your message. Further, due to the popularity and, as mentioned, the inclusiveness of the broader social networks, there was simply too much noise to cut through. When a video of a sheep that barks like a German Shepherd gets 300 likes and 150 comments, but your filmmaking reel gets two and ten respectively (nine of which are "Cool!"), well, you know this isn't a platform that's going to help you move the rock on your career.

Further, I believed the social media sites with a bent toward making professional connections worked much better for white-collar professionals. To test my theory, I created an account on a popular networking site aimed at professionals, listing myself as a screenwriter and a producer. Within days I was inundated with network connection requests by other screenwriters, but also from people working in such industries as medicine, insurance and real estate. Still, based on speaking to my screenwriting friends who were on the broader social networks, this was a big step up. I was somewhat encouraged. I researched each person carefully and was stunned to discover how many hadn't bothered to add a bio or any other information about their past, or their future plans and desires, on their profile pages. Not willing to be "that pessimistic guy out of touch with the times," I stayed the course, soldiering on and accepting most of the requests to join my network. And that's when the hammer fell. Next time I logged in, I had over a dozen direct messages. Almost all were requesting that I read their script or support their crowdfunding campaign. This was not networking. This was not social. This was a bull rush. An ambush. I deleted my account immediately.

Over the years, the mass social networks have attempted to address these problems by introducing segmented categories or groups and giving more control to the user as to who can and cannot reach you based on your chosen preferences. In 2010, for example, Facebook did an overhaul on their user privacy settings (something they constantly tweak even today) and introduced Facebook Groups. Groups permitted any member to start a private or public targeted group. Immediately hundreds, if not thousands, of groups related to the business of filmmaking and the disciplines that lie within were created. Sounds great, right? Well, like any gold rush scenario, the opportunists came running full speed. Open, or public, groups were soon being overrun by scammers and spammers rendering relevant and interesting threads useless. Closed groups suffered a different, but similarly destructive fate as many administrators abandoned their pages, effectively

preventing new members from being accepted or added to the group. Many groups simply shriveled up and died.

Since then, Facebook has corrected many of these issues. And during this time, I continued to watch certain groups focused on topics I was interested in from afar. I was willing to allow myself to be convinced that there were discussions and information being shared within these groups worthy of my valuable time. But too many times I saw conversations wander off topic. People in the group would still post pictures of their kids, their kittens, their food. Other times, conversations regarding the craft for which the group was formed would turn into pissing matches with no one policing the action, with the mood and atmosphere turning toxic and uninviting.

I wanted something more niche, more focused. I stuck to chat boards and forums related to my chosen discipline, which were not nearly as dynamic as far as networking was concerned, particularly with most of those posting hiding behind aliases. But they were still much more informative and active as far as discussions on a particular craft or the industry in general was concerned. An additional bonus was that most of these boards had moderators who flashed the nightstick if anyone stepped out of line.

While I was conceptualizing Stage 32, I was well aware that in order to give the platform the highest probability for success, I would have to take the concept, mission and brand to the airwaves of the broad social media platforms. Because of my experiences and observations, this was not an easy view to accept. In fact, I pushed back against it with every last ounce of my being for as long as humanly possible. This was a startup. And like many startups about to launch, there were only a couple of people involved in the day to day. That meant wearing many hats and tackling many initiatives on a daily basis. In my mind, these social media efforts would be a time suck. They would cost me precious hours of mindless effort a week to reach a diluted audience. Broad social media, I would cite to anyone who dared to listen, was "evil." Yes, I was the crazy person on the corner, standing on a milk crate in a ratty robe bellowing into a megaphone.

Still, almost out of pure defiance and, I'm not at all above admitting, with an underlying motive of proving myself right, I set up Stage 32 accounts on Facebook, Twitter and Google+, plus a personal account, as Founder and CEO of Stage 32 (as opposed to Actor/Screenwriter/Producer) as my primary employment, on LinkedIn and went about, well, being social.

Slowly, like a snail pushing a bowling ball, my feelings about broad social media as it related to promoting, engaging and getting others to carry the message about the concept, mission and brand of Stage 32 changed from evil, to necessary evil, to necessary, to imperative. Let me be clear, this is the Founder and CEO of Stage 32 speaking, not the actor, screenwriter, producer. The entrepreneur in me had become a true believer. The creative in me remained an agnostic.

I had, of course, been using Stage 32 for my own creative devices in an effort to further my career. Working within the framework of a niche community of people who shared my interests and had relatable experiences inspired me to be more social, open and active. Although people knew I ran the joint, I made sure my contributions to the network put an emphasis on my creative pursuits and away from my day to day business responsibilities in running the site: just another creative looking to get things done. I measured my success in not only how I was doing with that juggling act, but the proof of concept of the site itself by contacts made or accomplishments within the four walls of the site leading to positive movement in my creative career. And over that first year, there were many, which only served to stoke my fires even further. As it related to my creative pursuits, the only non-Stage 32 participation remained on dedicated acting, screenwriting and filmmaking chat boards and forums. But because of the success I was having within my own site, and tiring of the anonymity prevalent on these sites, I found myself becoming a passive rather than active participant, and then a participant no longer.

In the meantime, I worked our Stage 32 social media accounts with increasing gusto. Almost daily, I would be asked for information regarding my personal social media accounts. I still didn't see a reason to create any for myself. But in running our business accounts, I found myself being pulled by one broad social media platform that intrigued me more than most. One that I found myself gravitating to and focusing on much more than the others. One that which, ultimately, *three years* after starting Stage 32, I finally bit the bullet and opened a personal account.

THE POWER OF 140 CHARACTERS

In August of 2014, cloaked with trepidation, I created a personal account for myself on Twitter. There were many reasons why I chose this to be the broad based social medium platform to promote my personal (creative and

business) brand, but the biggest was this: I didn't see Twitter as a broad based platform at all. What I saw was an open, all-inclusive network that could be *tailored* toward the feel of a niche network at the discretion and whims of the individual account holder.

I wanted to follow and connect with film, television and theater creatives along with entertainment and tech journalists, entrepreneurs, CEOs, and those working within the world of venture capital, to name a few. Although this was a personal account and I have other hobbies and interests such as sports, fitness, wine and meditation, my goal was to keep my Twitter newsfeed dedicated to the things that would help me either as the CEO of Stage 32 or in my creative endeavors. Sure, I would still tweet about my beloved New York Rangers, workout routines I was trying out, meditation apps I found useful or any other variety of interests from wine to travel, but only for the purposes of presenting a rounded persona of who I am and what I'm about. I didn't need people who shared or wanted to comment on my hobbies or interests cluttering up and diluting my news stream. I could (and would) find them on my own and in my own time if and when I so desired.

So while this was to be a personal account, you would be right to say I kept my interests focused on my professional interests. However, I committed myself to creating tweets that were personal, insightful and informative. After years of tweets from behind the logo of our @Stage32 Twitter and other Stage 32 social media accounts (outside of Stage 32 where I was always posting from in front of the brand or, if you will, as the brand), I wanted people to get to know the man behind the curtain. And although I can't take credit for coming up with it, I wanted my Twitter account name to be reflective of my personality as well, which was how @RBwalksintoabar was created.

Now there were some detractors that thought this handle to be unprofessional. Why not @RBCEO or @RBwriterproducer, they wondered. Why not? Because it's boring. Because it's not reflective of sense of humor, style or personality. Because it's not inviting or interesting. Because I have 140 characters in my bio to explain who I am (more on this below). And most of all, because it's not *social*.

So, my Twitter handle locked in, the challenge I now faced was *being* social. Now, look, I'm a very social guy. More people in my life have asked me if I ever shut up as opposed to asking if I ever talk. Put me in the proper setting and I can chatter the paint off the walls and have the most staid swinging from the chandeliers. But place me behind a computer with a blinking

cursor begging for 140 characters about what's going on in my life or what's on my mind and, well . . . not so much. With the @stage32 account, this came easy. The banter was usually inspired by and related to content I posted or questions about Stage 32. Now I was about to go out and attempt to give people who chose to follow me a *reason* to continue following me, retweet and favorite my posts, add me to relevant lists and spread the word about all the brilliant, funny and relevant things I had to say.

However, although the approach for the @stage32 and other Stage 32 social media accounts were different than what I was about to embark on with my @RBwalksintoabar account, the experience I had gained through running those accounts was invaluable. I had seen the mistakes, the shortsighted approaches and the failed engagement campaigns. I had seen the narcissistic, selfish and downright foolish approaches. I had seen people who had tried to build a following by broadcasting the same message over and over crash and burn. And I had seen those who looked to inspire and move a crowd miscalculate so badly that the very crowd they were hoping to carry their message picked up pitchforks and torches and ran them the hell out of the village.

Regardless of the differences in the setting, posting technique, groupings or networking parameters of any broad based social networks I review, the mistakes made by the member base remain the same. Whether bred by pomposity, entitlement, chutzpah or simply a lack of initiative in educating one's self on how best to utilize a particular platform, the results can be fatal. The good news: These mistakes are easily avoidable. The better news: Because so many people do not take the time to learn how to use social media correctly, you'll have a considerable advantage of being seen, heard, admired and followed by doing things right.

So with a nod to the now retired and Rip Van Winkle bearded David Letterman, from the home office in Manhattan Beach, California, here are the Top 10 Mistakes Made on Social Media (and How You Can Avoid Making Them).

FIX IT!

1 You're Strictly a Broadcaster

Sometimes a rookie mistake, sometimes an uneducated mistake, sometimes a mistake fostered by impatience, most times one of those blinded by ego and hubris mistakes, being strictly a broadcaster represents the most

common and most viper venom deadly mistake you can make on social media. *This is arguably the most important lesson in this entire book if you are planning on using social media as a means of crowdsourcing. You simply will not build, engage and move an audience if you are strictly broadcasting. To the contrary, you will be ignored or blocked at best, and invite abuse at worst.*

Social media is all about engagement and interaction. It's about give and take. Most people get that backwards. Even worse, many others live their social media existence under the banner of take and take; a guaranteed losing strategy if ever there was one.

You know how your grandmother used to preach that God gave you two ears and one mouth for a reason? Well most social media pages have many "Reply" buttons but only one spot to make a new post for a similar reason.

It's easy to find people with like-minded interests. Depending on which platform you use, and if you've handled your contacts correctly, you'll have plenty of posts from people in your network to which you can respond. Take some time. Be smart and prudent in your approach. Respond to 20 posts before you make an original one yourself. Then watch as the number of people who want to be in your orbit (and in your network) rises.

2 You're a Narcissist

Sorry, but some of you reading this have a "Me" problem. And some of you may not be like this in the *real* world, but you are on social media.

You want proof? As I type this, our @stage32 Twitter account has slightly under 200,000 followers. I spent the last hour pouring over ten days' worth of posts to our stream, over 350 in total. Not responses to original posts or content, mind you, but posts directed strictly at the @stage32 account. Here's what I found:

▶ 17% of them included demands.

"Yo! Look at my acting reel"

"Hey my video is awesome. Check it out."

"My s*** is sick . . . Retweet my s*** to your followers"

"Donate some bucks to my campaign. You can afford it."

Let it be known that these are all actual tweets. Worth noting: The last genius didn't even attach a link to said campaign.

▶ 97% of the posters making demands weren't even following the @stage32 account. They simply looked at the fact that our account has over 170,000 followers and got wide-eyed and greedy.

▶ Of the last 50 tweets promoting crowdfunding campaigns who applied some variation of the "Yo, I don't know you, but give me money" approach to soliciting funds, guess how many hit their goal? Not. One. In fact, only two of them passed the 50% mark of the proposed raise, with the high water mark being 64%.

▶ Further still, of those 50 tweets I mention above, 29 of those posting decided that a great marketing approach would be to tweet *the same exact message* to literally dozens of accounts. This is akin to walking into a social gathering, approaching each person and screaming "ME!" Odds are, security would escort you out. The result on social media is worse. You'll get blocked.

All of this brings me to . . .

3 You Don't Cultivate Relationships

Everyone in this world is looking to accomplish something. Whether it's to climb Everest or achieve legendary status as The World's Laziest Human, everyone has a goal. The same holds true for people investing time on social media. But an investment of time doesn't necessarily equal success, as points #1 and #2 in this section illustrate. And even if you course-correct your method of how you deliver a message, you've only solved a piece of the puzzle. You have to identify the individuals or group to which you want to deliver your message. You have to identify and then build a network complimentary to your end goals.

For example, I began building an audience for this book nine months before I wrote word one. On social media, I did this by identifying and targeting people I felt would be interested in the subject of my initiative. I provided these new users

with content I believed would be interesting and of use to them. I answered and asked questions. In short, I stayed active and in constant communication.

I also reached out and began communicating with film industry professionals I hoped would contribute material to the book, as well as filmmakers, producers, marketers (and the like) who I hoped would be interested in reading the book. I asked for advice. I offered my viewpoint and asked if I was missing any details that might be essential to the overall subject of crowdsourcing. Essentially, by taking this tack, I was crowdsourcing the material, in effect killing two birds with one stone; getting people who might want to contribute to or read the book involved and invested.

A very important point: It's safe to say that every single person I accepted into my social media realm has myriad dreams of their own, desires and missions related to their pursuits in film. This also means that every single person I have accepted into my social media realm is most likely on social media themselves for a reason beyond simply networking—educational, promotional, crowdfunding, crowdsourcing reasons, for example. I was acutely aware of this. When someone was feeling challenged in a certain area, I offered advice or unearthed and posted a piece of content I believe would ease their anxieties and help their cause. I embraced a collaborative, selfless spirit. Not surprisingly, by posting an inclusive and informative string of information, I accumulated a legion of supporters willing to line up beside me.

Social media relationships are no different than real world relationships. This is something that's often forgotten when sitting alone behind the soft glow of the computer screen. But make no mistake, just because you can't actually see a person's face when you are making a direct post to someone, this *is* a face-to-face interaction and should be treated as such, even if on the surface it's avatar to avatar. Your goal is to build trust and credibility. I've outlined a few ways you can make that happen over time, but there's a way to do it instantly and quite painlessly. How, RB, you ask? *How*?

Ask questions.

The horror! *But what about me*? (He cried, arms thrown to the heavens.)

Patience, grasshopper.

When you have a small network, it's very easy to take time to address people individually. Take a look at a person's bio (assuming they have one . . . if they

don't, feel free to move on. That's their problem, not yours), see what their interests are, where they've been, where they're going. Ask them about their projects. Have they read any good books on Subject X lately? How long have they been practicing their craft? What's their favorite movie? Where were they, exactly, in that gorgeous beach photo they posted? The one where they're holding a cocktail housed in a coconut? You get the idea.

This kind of engagement not only breaks through the natural defense barrier many harbor on social media, but it also leads to likes, favorites, retweets or whatever other positive indicators your network of choice offers. This leads to more followers. This leads to trust. This leads to support.

But what if you have a huge network and don't have the time to address every new person who enters your realm? Well, first off, congratulations, you're doing something right. But the rules remain the same. Only instead of addressing each person individually, post questions to the group. Some examples of first-thing-in-the-morning posts on my accounts were as follows:

- ▶ Today is another day to do something creative. What's your plan?

- ▶ What's the best independent film you've seen this year and why?

- ▶ If you've run a crowdfunding campaign, what's the biggest lesson you've learned?

- ▶ What made you choose your discipline of choice? We're you born with this dream or did it come later in life?

- ▶ If you could accomplish one creative goal this year, what would it be?

- ▶ As a creative, what's the single best piece of advice you've ever received?

- ▶ Do you have mentors? How have they helped you?

- ▶ Where do you draw your creative inspiration from?

All of these posts put the spotlight on the reader. They invite engagement and show selflessness. But this is only part of the equation. You must take the time to respond to *each and every person* who responds. You don't have the time? Find the time. Why? *Because it's worth the time.* As we've discussed,

one day you are going to have something to present to the people in your network. You're going to have an "Ask." And as the great Maya Angelou wisely stated, "I've learned that people will forget what you said, people will forget what you did, but people will never forget how you made them feel."[1]

People *will* remember how you treated them, good or bad. And they will remember if and how you engaged them. These variables will make the difference in whether they support you or dismiss you, whether they ignore your message or carry it forward.

4 You're on Too Many Networks

I host a monthly webcast on Stage 32 called *On Stage With RB*. It's usually a 3-hour affair where I go over site features, bring on guests from the film, television and theater industries and answer inquiries from the community. As you might imagine, I'm often asked questions regarding how best to utilize social media. The most common kickback I get from the advice I dole out is that it's too time consuming, that there's simply too many networks to effectively gain any traction. When I get this response, I'll usually ask the member to send me their social media outline and daily plan—the number of sites they're on, the number of posts they make, whether they post original or previously published content, examples of their posts and other pertinent information. I would say nine times out of ten the problem is identifiable within two seconds: They're simply on too many networks.

We've all heard the saying that it's better to do one thing well than ten things half-baked. The same fact holds true for spreading yourself too thin with your social media efforts. Now, it is possible and, in many ways, essential, to do more than one thing well within the framework of a particular social media network. But trying to do those same things well across a plethora of networks will inevitably cause your intent and message to be diluted rather than saturated.

As previously mentioned, for my creative endeavors I have chosen Twitter as my mass social media site and Stage 32 as my niche social media site. This has served me very well as I've landed jobs, acquired my screenwriting manager and made other influential contacts, including the one that led me to the offer to write this book, through those platforms.

On the business (Founder/CEO) side, I have chosen Twitter and LinkedIn as my mass social media sites, although I use them in a very niche way, carefully targeting my audience. And to be straight up about it, I use Twitter

for this purpose much more than LinkedIn, which for my purposes mainly serves as a directory of contacts.

By sticking to only two full time platforms (Twitter and Stage 32) and one (very) part-time platform (LinkedIn), I can manage my social media accounts with ease and with very little strain on my time. Hell, I can fly through a day's worth of Twitter responses while cooking a mean chicken pizzaiola with parmesan polenta while sipping a vintage Barolo (take that, Batali!). And with the endless supply of third party social media tools out there which allow for timed posts and other helpful time savers (more below), managing an account has never been easier.

What number of social media accounts is right for you? That's up to you to decide. But if your excuse is not enough time, *you're on too many*.

5 You're Not Painting the Right Picture of Yourself

The beauty of most social media platforms is that they allow you to provide as much personal and professional information as possible (Twitter and their 140 character limit is an exception). Yet, I'm consistently floored by how many people do not take the time to utilize these vital sections. This is your time to shine, an invitation to step out into the light and present your best self. Further, because you've now changed your social media habits and are no longer being strictly a narcissistic broadcaster and are cultivating relationships and posting pertinent, interesting and engaging content, you are successfully inviting people to click on your profile in an effort to learn more about you, your experience, your hopes and your dreams. If the biographical section of your profile is blank, lacking or missing the proper media (i.e. you state you're an experienced filmmaker, but have no reel posted), guess what? You've not only made a horrible first impression, one that states you're lazy at best, can't be bothered at worst, but you likely will not get a chance to make a second one.

Let's take that *real* world example again. Would you show up to an open job interview without a resume? Would you show up at an audition without a headshot? Would you show up to a first meeting with a producer regarding the prospect of being hired for a filmmaking gig without a reel of your work? Of course not. (I'm giving you the benefit of the doubt here.) So if your end game is, at the very least, to make new and important contacts that could help move the needle on your career, why would you give anyone looking at your profile *no* information about where you've been and where you hope

to go? Why would you not share your headshots, your loglines or screen-plays (if registered with the Writer's Guild of America, West and Library of Congress, please), your acting, cinematography or filmmaking reels? Why wouldn't you list your credits and awards you've been nominated for or won (if applicable)? This is actually your chance *to be a narcissist*! Take advantage!

According to various social media reports, anywhere from 30–37% of active social media users (defined as those logging in at least twice per week) have zero information in their bio fields. Think about that. Three to nearly four out of ten! It's madness, I tell you . . . Madness! Further, and I'm sure the Beastie Boys would agree, it's sabotage.

In late 2015, we sent a survey out to over 1,600 Stage 32 members who had hired another Stage 32 member to fill a cast or crew role for a project through the site and asked them the following question: When looking at a member's profile, what constituted the most important criteria instru-mental in your desire to contact or hire that individual? Ninety-one percent chose: Comprehensive biography/portfolio.

Many film industry professionals I know who use social media as a method of networking, hiring employees or securing cast and crew will not look twice at a network request without a bio or other pertinent content. The general attitude is: If it's not worth their time, it's not worth my time. I understand, relate to and hold the same beliefs. But what about those who are uneducated about the world of social media, you say? I have never seen a social media platform worth its salt that does not have a thorough FAQ or Help section. And, of course, there's Google, which by its very existence effectively elimi-nates all "I don't know how" excuses in the modern internet age.

Look at filling out your bio and all other informational sections of your profile as a text selfie, but one that everyone actually wants to see! And if you are using a platform that allows you opportunity to post videos and photos, do so.

6 You Post Stale Content—Or No Content at All

We've already talked about posting and broadcasting nothing but self-serving content, but posting stale content—either content that is very old or has been seen a million times before—will also cause people to tune you out in equal measure. Time is a valuable commodity. Check that. Time is our *most valuable* commodity. You want people whom you target or whom are in your network to view you as someone worthy of their time. Further, if you

are utilizing social media as a method of gaining trust and, in turn, a following for a particular crowdsourcing campaign, <u>you want to be perceived as very knowledgeable in the topic you post most about or about which you are hoping to be perceived as an expert.</u> This means not only posting relevant and timely articles, infographs and videos pertinent to the subject at hand, but also creating original content as well. And now that you are on fewer social media sites, you have more time to create original content!

Let me stress, original content, especially when attempting to establish yourself as an expert in a particular area, will carry you much further than content created by another source, especially as you gain juice as a trusted voice in that area. That doesn't mean you shouldn't pepper your feed with content from other fertile minds, but make sure to have an opinion on that material as well.

[margin note: original content]

One other perk about posting original content you won't get from posting non-original content: If your work is engaging, pointed and, where possible, ripe for debate, you will elicit a reaction. If the reaction is positive, your crowdsourcing efforts will begin taking root and you can ask those providing a positive response to carry the message forth by sharing the content. If the reaction is negative, the door has been opened for (peaceful and rational, please) debate, which will further allow you the opportunity to put your expertise on display.

<u>Create and engage.</u> <u>Thank and ask.</u> <u>Win the moment.</u>

7 You Let Your Emotions Get the Best of You

For the start of this section, I turn the microphone over to monk and poet extraordinaire, John Lydgate. John, how do you feel about engaging people on social media?

"You can please some of the people all the time, you can please all of the people some of the time, but you can't please all of the people all of the time."[2]

John was born in 1370, and by all accounts was a brilliant and forward thinking individual, so I'm quite certain he had Facebook in mind when he spoke these very astute words. OK, I kid. He was talking about society as a whole, but his lesson is one you should carry with you on social media.

Look, not everyone is going to agree with you. Not everyone is going to like you. You're not going to catch everyone on their best day. And you are inevitably going to run into someone who has Big Ball Syndrome, defined as

anyone who has the testicular fortitude to spout something nasty your way while sitting safely behind the soft glow of their computer screen that they would never in a million years say directly to your face.

For some, negative behavior directed their way is a deal breaker and turns them off from social media forever. Don't let this happen to you. Don't let negative comments rob you of utilizing one of the most vital networking tools in your arsenal. Instead of surrendering power, seize and wield it.

I look at every unfounded, nasty attack on my words, thoughts or character as an opportunity not only to prove my intelligence and knowledge on a particular subject, but to further prove myself as a (somewhat) sane and magnanimous human.

I make my points . . . pointedly, but I kill 'em with kindness doing so.

How you handle yourself on social media can make or break you. Remember, you may be responding to only one person, but an entire audience is watching—an audience you hope to one day deploy carrying your message. You can, and should, be pointed and show authority, but in a way that establishes that you're level headed and in control.

And if the abuse continues, if the culprit is miserable for the sake of being miserable, block or remove him or her from your network and keep to your mission.

8 You Go for Quantity Instead of Quality

I've been fortunate to have the opportunity to teach, mentor and speak on panels regarding social media and networking all over the world. I always find it quite interesting how many people will approach me after a class or conference session and gush about the size of their networks. I'll ask them how they managed to grow such a large network without, you know, being Lady GaGa. Was this all organic growth? Did they do something noteworthy? Are these fans of their work? Colleagues? Associates?

With the rarest of exceptions, the networks in question were built by buying followers or likes or by using mass (and time consuming) following and unfollowing methods and tricks.

I often ask them what they intend to do with such a large following. I've never once received an answer back that made sense. Most simply cite the

perception advantages that come along with having such a large number of likes or followers.

So let's talk about perception for a second, because it is important. To me, there are two main areas where perception plays into social media:

1 The Number of Followers You Have

I'm not going to deny that there is a lemming aspect to social media. People see a big follower number and they want to follow that person too, although—and this is not cynical, but rooted in reality—with an ulterior motive in mind. Perhaps they want to engage you. Your entire network sees you trading some back and forth with this person and a few here and there decide to follow them. That's a win for them. Perhaps they post something to you about a project they're working on, a book they're writing, a crowdfunding campaign they have running. If you respond, that's a win for them.

Maybe they have no agenda or ulterior motive. Maybe they're just another follower. But does that help you in your crowdsourcing efforts in any way? I think not.

2 The Quality of Your Posts

That brings me to the perception that comes with the quality of your posts. You're reading this book because you want to learn more about crowdsourcing. We've already talked often about identifying a crowd and engaging them. So, yes, you could and should identify and follow people you believe would be engaged by and gain from your insights on a particular subject or subjects. There's nothing wrong with that at all. But organic growth is the most powerful growth you can have on social media. It's people taking the material you're posting and sharing and retweeting that material with others in their network who have a similar passion for the material. The more people you have in your network who will not care about the material you're posting, the more noise there is and the harder it is to be heard.

Bottom line: As it relates to crowdsourcing efforts on social media, it's better to have 10,000 targeted followers than 100,000 random followers.

9 You Use Poor Grammar and Spelling or Post Broken Links

Yes. It matters.

You can be the most well versed human on the planet on a particular subject. If you make posts with spelling and grammatical errors or, worse, post links to original content that is sloppy, ill formatted and mistake laden, no one is going to take you seriously, never mind line up to be a disciple of you and your message.

Take the time. We live in a world where just about every program and application comes equipped with a spell checker. Blog software practically formats itself. Most social media sites even shorten links for you.

Make sure you have no underlined (misspelled) words. Make sure your syntax is correct. Make sure you have no formatting issues. Make sure your links actually go where intended.

It all takes a few seconds. And I'll repeat . . .

It matters.

10 You Don't Use Any of the Endless Supply of Social Media Posting and Analytical Programs Available

Remember, if you are handling your crowdsourcing efforts correctly, you're effectively running a campaign. And any good campaign not only needs to run around the clock, but requires analytics so that individual facets of the strategy or overall initiatives can be bulked up or wiped out entirely depending upon user response and engagement.

Unless you're undead (and if you are, I envy your productivity potential), you're probably not awake 24 hours a day. Nor do you likely have the time, resources and capital to put someone in charge of posting while you sleep. With the variety of posting software and applications available for the mass social media sites such as Buffer (www.bufferapp.com) and Hootsuite (www. hootsuite.com), to name a couple, that's quite OK. Simply enter your posts and the time you'd like the posts to run, and have a restful slumber. Just remember to reply to those who responded overnight while you're having your morning cup of java.

Buffer and Hootsuite as well as a variety of others also offer valuable analytics tools. Some of these are free and some range from a few dollars to tens of dollars per month (almost all offer a free trial). Be sure to check out the features and terms and read some user reviews (remember, Google is your friend) before committing.

Want to know how many people clicked on a particular link? Want to know the impact your content is having on your follower base? Want to know what time of day seems to be the best for posting certain material? Want to know how that tweak in your strategy is working out? Of course you do! Your campaign's success hinges on the answers. Utilize an analytics program and eliminate the guesswork. *Information is more than power; it provides peace of mind.*

BUT DON'T JUST TAKE MY WORD FOR IT

You don't really want another opinion on this, do you?

OK, fine.

Jessica Sitomer is a long-time expert in the entertainment industry, having worked in all areas, from writing and acting to directing and development. She's produced a sitcom pilot as well as two television series, one for MTV and one that is, as I type this, in post-production. Previously, she worked in development for Debra Hill and with Antonio Banderas on his directorial debut, *Crazy in Alabama.*

Simultaneously, for 17 years, she's been a career coach for entertainment industry professionals. Within that period she served for seven years as the in-house career coach for the International Cinematographers Guild, Local 600. There she coached over 1,000 people one-on-one.

In January of 2008, Sitomer launched her own business, The Greenlight Coach, Inc. Her upcoming reality show, *Lights, Camera, Action!,* is *Top Chef* meets *The Apprentice* for the entertainment industry. Only instead of getting contestants fired, the goal is to get them hired! Much more noble and progressive, wouldn't you say?

Jessica has toured the world sharing her knowledge as a keynote, college and seminar speaker who teaches both professional and novice how to generate more work, better work or different work in the entertainment field.

Further, Jessica is also an author. Her outstanding book *And . . . Action! Powerful, Proven, and Proactive Strategies to Achieve Success in the Entertainment Industry* is available on Amazon. She also offers free advice on her website www.theGreenlightCoach.com.[3]

And finally, besides being a dear friend, Jessica is also a colleague. I've been honored to have her teach many of the most popular Next Level webinars (stage32.com/webinars) we've ever had on Stage 32, such as *How to Move to L.A. and Work in Entertainment, Create Stability in the Freelance Industries, How to Network as an "Out of Towner"* and *Get an Agent and Rock Episodic Season!*

I feel like Jessica is qualified to ring in on this subject? How about you? Cool . . . Let's move on.

Although Jessica outlines numerous rules and proper practices in her Greenlight Marketing Blueprint Seminar, I asked if she would be kind enough to share with us a few of her top tips for building relationships on social media. As is her nature, she selflessly and enthusiastically agreed.

Greenlight Coach Jessica Sitomer's three simple and easy rules to get started on building relationships on social media:

Rule #1—Comment on Peoples' Status Updates

This is the first step to building an actual friendship. By commenting on a person's status, you are making yourself known as well as helping draw attention to what the person shared. A win-win. Remember, the goal is to be social. Don't be afraid to take the first step in creating a dialogue or simply showing someone you're paying attention.

Rule #2—Acknowledge People for Their Success in Your Own Status Update

I love to pause a television show when I see the name of a client or friend pop up, grab my camera and snap a photo of the name on the screen. Then, I can post the picture with a congratulatory status update that includes his or her name, the name of the show, the network the show is on and the day/time it airs. Not only does this give him or her exposure, but it shows that I'm appreciative of them and their work.

This tip can be applied to just about any situation. Someone in your network have a good day? Send some good cheer their way and watch the relationship blossom. Positive energy goes a long way.

Rule #3—Share Yourself as Well as Your Business

Too many people post only about what they do in the industry and not about who they are. This is a big mistake. Like attracts like. If you want to help you, first they have to know you. Share photos that include hobbies, family, pets, travel, favorite movies/television shows, etc. Now, some people go overboard the other way, and that's not great either. The key is to find balance. Being one dimensional will present you in one light over and over, and that will cause people to tune out.

Just like watching your favorite character on TV makes you feel like "you know" the actor, what you put out there on social media makes your online audience feel like they know you. Creating a strong, balanced online presence on social media will not only expand the pool of people you are trying to reach, but make it much more likely that people will be willing to help and support you.

IN SUMMARY

Social media represents the biggest weapon in your online crowdsourcing efforts. It's a rocket launcher designed to deliver your message to the—if you've handled your identifying process correctly—targeted masses. This is one area where the investment of time can pay quick and steady dividends. But you must use your time wisely and not get sucked in by persistent and ever present white noise or by spreading yourself (and your message) thin by utilizing too many platforms. Have a plan, act on it, review and adjust. Be cool, be giving, be honest, be magnanimous and don't, *when the time is right*, be afraid of the "Ask."

NOTES

1 https://www.goodreads.com/quotes/5934-i-ve-learned-that-people-will-forget-what-you-said-people
2 https://www.goodreads.com/quotes/699462-you-can-please-some-of-the-people-all-of-the
3 https://www.amazon.com/Powerful-Proactive-Strategies-Entertainment-Industry/dp/1583852840

10

Taking It to the Streets—Networking Offline—Get off My Facebook and in My Face

So I just stated that social media represents the biggest weapon in your online crowdsourcing efforts. But what about crowdsourcing offline, RB? Should it be part of my overall strategy? Or should it be a variant strategy that is project dependent? Given the fact that I can reach the world through online efforts while sitting in my underwear and devouring an entire bag of Pepperidge Farm Milano cookies, is it really worth my time to shower, toss on some decent clothes and go put on appearances by eating a heart conscious salad with one or two individuals at a time? Doesn't that seem counterproductive and a waste of energy?

I mean, seriously, RB. Do I need to crowdsource offline at all?

Well, if we're to trust the responses of the polling and focus group studies I mentioned way back in the "Let's Get One Thing Out of the Way Immediately" chapter, many of you do not believe crowdsourcing offline is either necessary or worth much of your time, if any at all.

As Jules Winnfield says in *Pulp Fiction*—Well, allow me to retort.

Let me assure you that crowdsourcing offline isn't only necessary, it's vital. Regardless of the fact that you can reach almost anyone online with a quick

search engine query, via social media or even through premium sites which search public records (and beyond, in some cases), in many ways, networking offline is not only an easier endeavor, but can produce expedited results. Further, due to the immediacy, transparency and intimacy of face-to-face interactions, offline networking can be infinitely more satisfying.

Identifying people who, and entities which, can carry the message of you or of your project or cause in person should not only be part of your overall crowdsourcing campaign plan, in many cases, it should be the *first* step. Doing so will not only allow you to potentially target wide swaths of people in an instant, but potentially provide you with vital data speaking to how large your target audience might be as well. Is the crowd super niche or broad? Further, identifying and engaging an offline audience will likely help shape your online strategies and efforts.

Unfortunately, for many, the pursuit of people or entities offline in an effort to satisfy the goals of a crowdsourcing campaign is either ignored entirely or is only utilized as a last resort strategy (which can, and likely will, make you appear desperate in the eyes of your target audience). And, as we've discovered, if you get to the point where you're bombing Hail Marys downfield in an effort to satisfy the goals of our campaign, the game, almost always and inevitably, has already been lost.

You: OK, RB, you have my ears and interest. Tell me more about why I need an offline strategy within my crowdfunding campaign.

Me: Sure! First allow me to blind you with some statistics about individual internet, social media and micro-blogging usage to prove a point.

You (under your breath): @$*!@

WE'RE ALL CYBORGS

Me: I heard that.

Trust me, there's a method to my madness.

Have I let you down yet?

Wait!

Don't answer that until the end of our trip.

Let's keep moving by reviewing some pertinent data. To start, let's first take a look at online usage trends, how this information skews public perception, how you can use the particulars within to your advantage and then, finally, tie it all in to why you need to be crowdsourcing offline.

Trust me, it'll be fun!

Our goal is to identify the reasons why some people prefer online interactions to those offline. To understand those reasons, let's look at *how* people spend their time online.

As we'll see below, as it relates to the time people spend connected to their devices and what they are doing on said devices, the trends point one way . . . up.

▶ A 2009 Harris Interactive poll found that the total number of US adults on the internet—whether at home, work, or elsewhere—was 184 million. This represents around 80% of the total population now online, up from 56% in 1999. In an effort to prove that this jump in usage was due to an increase in social acceptance of the internet as opposed to increased demands in the workplace, the report also claimed that the percentage of people surfing the web at home increased to 76% as compared to 46% in 1999.

The study also stated that the average American spent 13 hours per week online as opposed to seven hours in 1999. Fourteen percent of all users were online for 24 hours—a full day—or more each week.

▶ In 2013, Oxis Internet Surveys released a study showing that British people spent an average of 11.3 hours per week online at home. In this same study, they introduced a new category, "internet on the go," which categorized the average use spent on mobile devices. They determined that another two plus hours per week were spent using a mobile device for online endeavors. The report also stated: "The continuing centrality of home and the rise of internet use on the go are two clear trends to note and watch for in 2015."

▶ In 2014, communications regulator Ofcom realized this trend when it said UK adults spend an average of eight hours and 41 minutes a day on media devices, compared with the average night's sleep of eight hours

and 21 minutes. (Note to self: An *average* of eight hours and 21 minutes of sleep a night? Explore moving to the UK.)

▶ Also in 2014, the Nielsen Total Audience stated that Americans averaged 18 and older spend an astonishing 11 plus hours per day watching TV, listening to the radio or using smartphones or other electronic devices. You would think at this level, we might have reached a tipping point. Think again, because . . .

▶ A study conducted by the Supercomputer Center at the University of California, San Diego estimated that online media consumption for the average adult would top 15 hours a day in 2015. (15 hours!)

Some staggering numbers, no? We're connected to our devices for more time during the day than we're asleep. And, incredibly, the numbers are trending ever higher. We really are cyborgs!

We need to discuss some of these findings. In isolation, there would be many variables to explore and dissect. But since the goal is to bring this all full circle back to the importance of crowdsourcing offline, I'd like to narrow our focus by coupling the overall internet usage and media consumption with some findings regarding social media and micro-blogging.

GlobalWebIndex, a company reported to be "the world's most detailed syndicated research into online consumer behaviors," profiles consumers of content in 32 countries. This group represents 89% of the internet audience worldwide.

Since 2012, GlobalWebIndex has been tracking the daily time that people spend on various forms of media. Here are some findings from their 2014 GWI Social Report, which polled 170,000 internet users about their online and, more appropriate for our needs, their social media and micro-blogging habits:

▶ The average user logs 1.72 hours per day on social platforms, which represents about 28% of all online activity. That number was up from 1.61 hours in 2012 and 1.66 hours in 2013.

▶ Micro-blogging, which includes Twitter, is also up to .081 hours per day, which represented about 13% of total time spent online. This represented a 9% rise over 2013.

I think you would agree, these are also staggering figures. Over 40% of an average person's time online is spent either on a social media site or micro-blogging platform. And the trend, again, is upward.

I know what you're thinking. This goes against what you've heard in the media about Facebook, Twitter and other broad based platforms losing old members and having trouble enlisting new ones. As a matter of fact, GlobalWebIndex's Social Q1 2015 Summary Report states that Facebook still had the most members of any broad based social media platform, but also saw the largest decline in its base, 9%. The report also states "That Facebook has an image problem among certain key demographics is clear."

It should be noted that the media embraced, blasted and repeated (ad nauseam) the theory that social media use is on the decline based on this one story thread. Few journalists conducted some actual investigating into underlying reason for this decline. Shocking, I know. But, hey, that's why I'm here. To do the work for them (and you)!

Here's the reality—more and more platforms are being introduced each year, both broad based and niche. There are more choices. People are being more selective and concentrated in where and how they spend their time. Regardless of how much of their day they are spending online, and clearly for some this represents all their waking hours, they want to use that time wisely. They want results, a return on their investment of time.

I'm not saying this because I run a niche social network, or because this exact thinking is what led me on a personal level to start Stage 32 in the first place. I'm saying it because the story is playing itself out in front of our eyes. Focused, concentrated social platforms are exploding, and they're stealing time, eyes, likes and shares from the broad based networks. That's great news for you, the film creative, who is looking to crowdsource a project. It allows for less time identifying and more time for engaging your target audience.

So why am I harping on all this online data in a chapter allegedly dedicated to crowdsourcing offline?

I'm getting there. I promise, grasshopper.

BACK TO THE POLLING AND FOCUS GROUPS

So let's go back to the polling and focus group studies I mentioned earlier in the book and referenced again above. Those who had at least a general knowledge as to the definition of crowdsourcing were asked further questions in order to gauge interest in individual topics within the spectrum of running a crowdsourcing campaign.

One of those questions was asked as follows:

> Are you interested in learning more about utilizing social media more effectively as a means to identify and engage a crowd for your crowdsourcing campaign strategy?

As you might imagine, a majority applied in the affirmative. Those who responded to the negative were asked to list their reasons. Here are the top four reasons people were not interested in learning more about utilizing social media:

1 Time restraints

2 Platforms are too crowded/Difficult to forge a meaningful identity

3 Belief that social media usage will wane

4 Prefer face-to-face interactions

Let's address these four pushback points.

Time Restraints and Platforms Are Too Crowded/Difficult to Forge a Meaningful Identity

I've joined these two points together as I believe they go hand in hand. I think we've already illustrated, quite thoroughly I might add, the importance of being an active participant on social media. We've also discussed at length why it is absolutely paramount that you forge an identity and brand online if you have any intention of being successful in your crowdsourcing efforts. There are simply no excuses here. If honing our craft and/or developing a business strategy behind our film project is half our job, making connections and building our brand via social media is the other half.

I believe we've also illustrated, again quite thoroughly, how best practices and techniques will allow you to cut through all the clutter and rise above all the noise on social media. Your competitive advantage will be secured and solidified by your approach, and we have explored numerous proven approaches to asserting your identity and purpose.

So let's not belabor these points any further. We're all going to commit to investing time in ourselves and our goals. And, we're all going to use a concentrated strategy based on the recommendations within this book to assure that we stand out from the crowd.

Let's move on . . .

Belief That Social Media Will Wane

We've certainly presented some compelling data already speaking to the notion that interest in, and usage of, social media platforms is on the rise. But to pour some more cement into the foundation of this thought, I bring you further findings from GlobalWebIndex's 2014 GWI Social report:

> As a share of the time we spend online, these engagement figures mean that social networking now accounts for almost 30% of our daily internet activities, with micro-blogging approaching the 15% mark. That's important food-for-thought given how many commentators have been willing to proclaim that the social networking "bubble" has burst and that the top networks are dying. Rather, we're actually spending more time on networks now than in the earlier part of the decade—with the rise of the mobile internet, and the ability it affords us to connect to networks at any time and from any location being a major driver of this.

The numbers don't lie. But, for me, the real meat of this analysis lies in the last sentence. First time I read it, I found myself nodding in agreement. Hard to argue, right? If you need more convincing, the next time you dine out, grab a latte or sit in traffic, check out how many cyborgs, um, people around you have their heads buried in their phones.

Enough said.

Let's all agree that the time spent on social media sites and micro-blogging platforms is growing, and that the trend isn't reversing itself any time soon.

I still will argue, however, that the trend is moving toward more niche social media sites and micro-blogging platforms.

But I digress.

Let's look at the final pushback point.

Prefer Face-to-Face Interactions

This seems like a valid reason why certain people wouldn't have an interest in social media, no? Haven't we lost touch with our fellow man or woman? Aren't our personal relationships and interactions suffering due to all this online connectivity? Didn't we just say that people have their heads buried in their phones, tablets and wearables? Is there anything wrong with these people wanting to put their devices away and have a conversation or discussion while looking another person in the eye? Or do these whiners just need to adapt and get with the times?

I have a thought on this (and the crowd says, "Really, RB? We're stunned"), but before I get to it, let me first return to the research we conducted for this book and another question that we asked the focus and polling groups.

Are You Interested in Learning More About Crowdsourcing *Offline* as a Means to Identify and Engage a Crowd for Your Crowdsourcing Campaign Strategy?

For this question, the responses to the negative were much greater than those who answered negatively to the social media question (although still a minority overall). Here are the top three reasons people were *not* interested in learning more about using offline efforts in their crowdsourcing strategies:

1 Not enough time

2 Can cover more ground (not geographically, but hit more people with a message) on social media in a shorter period of time

3 Didn't like/were uncomfortable with face-to-face interactions

Let's break down these three pushback points.

Not Enough Time

Sound familiar? Yes, the number one reason people didn't want to learn about social media OR about using offline efforts as a strategy toward their crowdsourcing efforts was a lack of time.

I'm going to let you digest that for a second.

Digested?

Not discounting the probability that many of you are busy and the demands on your life are, well, demanding, if you are reading this book because you are casually exploring the idea of film crowdsourcing and, therefore, any and all aspects of filmmaking as a *hobby*, you're absolutely right, you don't have the time. Or better yet, you don't have the mindset and conviction to commit the appropriate amount of time necessary to be successful.

However, if you are reading this because you are interested in making film *your life* and realize the importance of film crowdsourcing as a tool to get you to the promised land, then I have only one response to those who feel they don't have the time to network offline . . .

Find it.

Finding time often comes down to one thing and one thing only, and that's prioritizing. What's important. What can wait. Can you save binge watching *House of Cards* for a night when things slow down a bit? Sure you can. Can you skip that massage, haircut, manicure until another weekend? Absolutely. Can you get up 20 minutes earlier, set your calendar and have a definitive plan on how you're going to accomplish your goals that day, or, more applicable to the subject at hand, who you can meet with that might be able to help push your project rock forward? I'm willing to bet on you.

How about taking occurrences that are part of your daily routine and tweaking them to work to your advantage? Instead of checking Facebook while you're in line at Starbucks (you've scheduled all your social media posts anyway, right?), use that time to send a few emails, texts or make calls with people you want to network with or who might be interested in joining you in your crowdsourcing efforts. Instead of taking a hike alone, why not invite

along an individual or group of individuals you believe might be willing to take your creative journey with you?

The old English proverb states: Where there's a will, there's a way.

Allow me to be more blunt.

Make plans, not excuses.

Can Cover More Ground on Social Media in a Shorter Time

As for covering more ground on social media than you can in a "real life" situation, I can't argue with you there. God knows you can bang out 50 tweets in the time it takes to extricate a business card from your purse or wallet. But ask yourself, what's the quality of these interactions? And further to the topic of crowdsourcing, are you targeting or carpet-bombing? More pertinent, since we have so little time and are so stressed, when are we making these posts—on line at Starbucks, waiting for our Uber, sitting on the throne or whenever else we have a free half-focused second? Are we using emoticons, LOLs and abbreviations of words that will never make it into the Oxford Dictionary? We've already explored the fact, and it's an absolute one, that social media is an unassailable and supremely impactful tool when used correctly. But when used in a haphazard manner, you will lose your ability to effectively engage, build trust, gain social collateral and establish yourself as an authority. You will become the face of superficiality as opposed to authenticity.

Point? If you can focus your energy on the proper ways to use social media, if you schedule your posts (remember programs such as Buffer, Hootsuite and the like are your friends) and plan a time to interact, you'll free up more bandwidth. This will give you the opportunity to attend panels, conferences and seminars and/or schedule offline interactions with individuals, groups, organizations and the like who you've identified as those you want on your team as it relates to your crowdsourcing efforts.

Didn't Like/Were Uncomfortable With Face-to-Face Interactions

So we've come full circle here. The people who didn't want to learn more about social media listed a desire for face-to face interactions. The people who didn't want to learn about crowdsourcing offline had no use or were uneasy with face-to-face interactions.

Let's address this. (The crowd cheers.)

By looking at some more data. (The crowd groans.)

In 2014, eMarketer Report ran its own study on user behavior. Unlike some of the other surveys I've outlined, their poll eliminated consumption of media—streaming of television, TV, internet radio, podcasts and the like—and strictly concentrated on online usage either by computer, phone or other device for the purposes of communication. Their research showed that the average user was spending 23 hours a week emailing, texting and using social media or other forms of online communication such as chat. This number represented 14% of total awake time in the week. More or less in line with many other studies.

But, eMarketer took things one step further. They weren't only interested in finding out how often people were using their computers and other devices to stay connected, but *what impact this was having on their lives.* Was there user burnout? Were they beginning to disconnect?

Here's what they discovered:

▶ 54% of survey respondents said they have tried to decrease their reliance on technology in the past year in favor of more in-person contact.

▶ 62% of survey respondents were hopeful that they would be able to decrease their tech usage in the coming year so they could have more face-to-face communication.

OK, so now I've really muddied the waters, right? I've made the case that the amount of time that people are spending online is continuing to grow. And with wearable technology, watches, glasses and implants (oh yeah, they're coming) already with us or about to become a reality, there's no question that the numbers will continue to trend upward.

I've also made the case that social media growth is not slowing at all. To the contrary, although a large amount of traffic is now spreading across niche platforms, the sheer number of people who are utilizing some form of social media continues to grow. And it only stands to reason that if it's estimated that the amount of time that people spend online is going to continue to increase, then social media usage will as well.

But then I also illustrated that there is at least a modicum of online and social media fatigue. That there is at least a segment of society that is sick of staring vapidly into their computers, phones, tablets and other devices. They crave human interaction and value it more than black text against a white screen.

So again, the people who didn't want to learn about crowdsourcing online preferred face-to-face interactions. The people who didn't want to learn about crowdsourcing offline had no use for face-to-face interactions.

The evidence above would point to both sides having a valid argument as it relates to the value they perceive in how they network and crowdsource. So who's right?

Neither.

Your social media efforts should complement and inform your offline efforts and vice versa. They are both equally important arrows in your quiver. To not fire them both is to place yourself at a competitive disadvantage at best and drastically shortchanging your chances at a successful crowdsourcing campaign at worst.

Take a moment and think about the *Sheila Scorned* case study we reviewed a couple of chapters back. I know I've previously said to consume this book as a straight narrative, but if you need to, flip back and breeze through it. No, seriously, it's OK. I'll wait.

Back?

Good.

What did you discover?

That's right, the success of *Sheila* involved an extensive offline campaign that complimented the online efforts of Mara Tasker and her crew. One could make the argument (quite clearly) that the overall crowdsourcing campaign of *Sheila Scorned* would not have been successful without the offline element.

So let me stress this again . . . as you are planning a strategy for your crowd-sourcing campaign, you *must* include an offline initiative. What people (or an individual person), groups or organizations should you target? Why

might they be interested? How will you get to them? Why would they even grant you a meeting? How do you turn strangers into champions?

What Will Be Your *Approach*?

Notice I separated that last question out from the pack. Can you guess why?

Because of the answers to all the prior questions cannot be answered logically, truthfully or insightfully without answering the question I've isolated.

Or, more to the point . . .

Approach is everything.

Say it with me one more time, brothas and sistas . . .

Approach is everything.

And here's the exciting part. Approach is a learned behavior. That means that you can work and rework your style down to an art. That means you can walk into any situation with a distinct advantage. A head start, if you will.

I can understand why some people are uncomfortable with face-to-face interactions. You see, believe it or not, although I do fantastically well in social situations, I've never found it easy to be the one to initiate conversations. No one would ever confuse me with being a true introvert. To the contrary, I'm quite the extrovert in almost every way. However, for many years, I found myself hesitant to approach someone in a social setting who I wanted to engage. I didn't want to bother them. Didn't want to waste their time. Further, why would they want to talk to me?

I know many of you are nodding your head in agreement. I know many of you are thinking, "That's me!" And I know many of you who probably consider yourselves even more introverted are probably just shuddering at the thought of being in a crowded room and spotting someone you'd like to engage.

I'm going to put you at ease by telling you a simple truth.

Even if you are more terrified of being in public settings than sitting in a bathtub of spiders (you're welcome for the imagery), guess what?

You still have a competitive advantage over a majority of people.

Come again, RB?

What's that you say?

Have you hit your head?

No, I haven't. I speak the truth.

Allow me to illustrate why.

THE AUSTIN FILM FESTIVAL FAIL

Every October in Austin, the Austin Film Festival is held at the historic (some say haunted) Driskill Hotel on 6th Street. In many ways, it's like any other film festival. Short and feature films are screened over a week and then there's a ceremony announcing the winners at the end. Overall, it's a brilliantly run festival and one I'd highly recommend planning a trip around if you're ever thinking about visiting the fine and proudly weird city of Austin.

But what the Austin Film Festival is best known for is the screenwriting conference attached to the festival. It's one of the only film festivals of its kind where every panel, event and party revolves around screenwriting and screenwriters. And the powers that be do an incredible job flying in top-notch speakers from all around the world. Renowned writers and filmmakers such as Lawrence Kasdan, Jonathan Demme, Vince Gilligan, Shane Black, Norman Lear and many others routinely make the scene.

Cooler still, all of these writers and panelists are readily accessible, hanging out after their talks, sitting in on roundtables, attending luncheons and events and, in what has become a ritual of sorts, hanging out each evening in the cavernous and ghostly Driskill Hotel bar holding court.

With such access and a chill vibe throughout, there is an everyman feel to the festival.

A few years back, I was sitting on a couch near the bar, speaking with a most famous screenwriter/filmmaker. Many would call this gentleman a legend.

And, considering he's been nominated for multiple Oscars, written some of the highest grossing films of all time, has had enormous success in the independent world and has somehow managed to survive (with some hilarious stories along the way) the Hollywood machine for three decades plus, the "Legend" stamp certainly, in my opinion, fits.

For a variety of reasons, I am not going to identify him by his name. But, for the sake of this story, let's call him Phil.

Having attended the festival for many years, first as a writer, then as a speaker, I had the privilege of forging a friendly relationship with Phil. On this occasion, we were about 20 minutes into an intense conversation about the state of the film industry when I picked up my head to see about 15 writers nervously pacing near the couch. They were waiting for an audience with the master. I nudged Phil on the shoulder and nodded toward the crowd.

A sinister smile crept across his face—I should mention, Phil suffers no fools—and he whispered to me, "Let's see who came to play."

With that he stood up and asked everyone to form a line. He asked the second in line to stand ten feet back from the first. His purpose for doing this would be so each conversation would be private and not overheard by those in the queue.

The first guy in line stepped forward with obvious swagger. He hadn't even reached Phil before he said, "How ya doin'? So I'm down here telling people about my sci-fi script and . . ."

The "and" went on for about eight interminable minutes. During that time, Phil casually checked his watch, halted a waitress, ordered him and me a drink and sighed five times, each one more audible than the next. Undaunted and ignorant, the guy rolled on with his pitch.

The guy finally got to the end of his story and concluded with, "So what do you think?"

Phil was staring at a television playing SportsCenter just over the guy's shoulder. "Huh?" he asked, without making eye contact.

"What did you think of the story?"

Now he made eye contact. "Oh, were you talking to *me* this entire time? You see, when people talk to me I usually know it because they introduce themselves to me by name first. Allow me. I'm Phil." He extended his hand.

"Joe," the guy answered, swagger seriously diminished.

"Nice to meet you, Joe. Now, what is it that you wanted to ask me?"

"My script . . . Do you want to read it?"

"Well, Joe, let me think of the best way to put this." An exaggerated stare at the ceiling for effect. "Not if we were marooned on a desert island and I had lost all my prized books at sea."

He then motioned for the next person to come forth. Joe slinked away.

Up came a young woman. You could tell by her body language and the way she struggled to make eye contact that she was nervous and out of her element.

"Mr. (last name), such a pleasure to meet you. My name is Grace."

"A pleasure to meet you, Grace. Please, though, call me Phil."

"OK, Phil. May I ask you a question?"

"By all means. Ask away."

Grace proceeded to ask Phil about a movie he wrote and directed. This was not one of Phil's hit films. In fact, it was perhaps, especially by box office standards, his biggest flop. She wanted to know about a specific scene. Why did he make the choices he made? Did he allow the actors to improvise? Did anything change from the page to the screen?

Phil complimented her on her perception and then launched into a terrific story about how they had filmed the scene exactly as it was written, but almost everyone on set agreed it wasn't working. Finally, the lead actor came up with a line he believed would change the dynamic of the whole affair. Phil told him to go for it. Low and behold, it gave the entire scene a more naturalistic feel.

Grace had a few follow up questions about the scene in question. Phil answered every one of them in his trademark self-deprecating style. He then began to ask her questions:

How long have you been writing? What made you decide to be a writer? What do you hope to accomplish here at the conference? How many screen-plays have you written?

Grace answered every question with a quiet confidence. Phil continued to do what he could to put her at ease. Finally, he reached into his back pocket and pulled out a card.

"I bring three of these to the festival every year. Most years they all come home with me. I've never handed out all three."

He presented her the card. It had all his contact information on it.

"You send me your favorite script. I'll read it and we'll have a chat. That OK by you?"

Grace's smile reached the wall.

Later that evening, I ran into Grace again. I complimented her on how she handled herself. She confided in me that she was "not great" in crowds and was "terrified" of approaching people in any manner. She was not confident in initiating a conversation. And when she saw Phil sitting on the couch, she was awed and frozen all at once. But then she watched him for a moment. Even though she had this larger than life image of this guy, here he was, sipping a drink, noshing on some cocktail nuts and looking like an everyman. She began to think of how much joy Phil's movies had given her over the years. She also thought about how reading one of Phil's scripts was instrumental to her learning story structure. And she had always had a genuine interest in that one scene she inquired about. This was the perfect time to tell Phil what his work meant to her and to get an answer to her question. So, she stepped outside of her comfort zone, got in line and made the conversation about him. That is until Phil made it about her. Both walked away from their talk feeling good about themselves and a relationship was birthed.

A month later, Phil called Grace and complimented her on the work. He gave her some notes, suggested other changes. Grace agreed to rework the

material. Three weeks and one draft later, Phil sent the script to one of the top managers in town. A week later, the manager signed Grace. Phil continues to mentor Grace to this day. They have shared many meals and laughs together. He even bounces story ideas off of her. They admire each other on equal terms.

Now let's think about this for a second. Joe and Grace are both screenwriters. Joe and Grace both want a career. Joe and Grace both spent their hard earned money to attend this conference. Joe and Grace both wanted an audience with Phil. Both were granted that audience. Joe entered like a lion and left like a lamb. Grace entered like a lamb and left like a lion.

Why?

Approach.

Building a network, building a community, building a brand all begins with building relationships. Ask yourself, when was the last time you trusted a complete stranger at first blush? It's not a very common occurrence, is it? You need information. You need to feel a commonality. You need to believe.

EASIER SAID THAN DONE

While Grace's approach illustrates how one can overcome their fears in an effort to be more engaging, I realize it's only one example. I certainly do not want to discount the idea that many of you are uncomfortable in face-to-face situations or consider yourself to be introverted. In this section, we're going to hear again from Jessica Sitomer, the Greenlight Coach. And after Jess, I've asked my good friend and master networker (among other talents I'll lay out shortly), Heather Hale, to give her insights on how to handle in person interactions.

Let's start with Jessica and her two rules for creating relationships.

According to Jessica:

No matter where you live in the world, knowing people in the film industry (locally and globally) is essential. The mistake most people make when meeting someone for the first time in person is telling people what *you* need

or, worse, asking for work. It's important for you to understand that successful people in our industry have a lot of responsibility and limited free time. Being successful, they've been working for a while and have established many long-standing relationships. On their lists of people filed in their mental Rolodex, there are those who have mortgages to pay, health insurance hours to earn, and kids to put through private school. In other words, people they care about.

Now, this is not to say you can't make inroads. You absolutely can. But I illustrate these points to say that when you approach anyone, you have to respect the fact that they had a history and had built relationships before that moment. So it's up to you to find a way in and to build a relationship with them. To become someone they want to network with. That means you have to have a sound method of initiating communication as an entry point to cultivating the desired relationships.

I often have the opportunity to speak in front of organizations and businesses regarding face-to-face networking. There are two top rules I always begin with as necessary for building relationships.

Rule #1 for Creating Relationships: As a Point of Entry, Do Not Ask for Work or for a Read. Either Ask Them Something About Themselves or, If Time Is Limited, Ask for Something They Can Say Yes to

Think about the person you are approaching. If you were in their position, would you say yes to a stranger you just met? They know nothing about you. They have no idea how talented you are, whether you're easy to work with or if you are emotionally capable. You may know that you're professional, reliable and skilled—but they don't. To break into their mental Rolodex, you must get them to care about you.

You may have had this experience: You've met someone once, had what appeared to be a meaningful conversation and gleaned career-changing advice. Several months later, you call that person to say thanks and follow up. And then you realize (or they tell you straight out) they have no idea who you are. How, you wonder, could you have had such a moment where a person had such an impact on your life and you've not even a blip on your radar? Although it might feel that way, I can tell you that it's not personal. Rather, it's because you thought you had established a relationship with that

single conversation, when in actuality, you had not. Likely, you had made this conversation all about you. The person you were speaking with was simply being generous with their time or simply doling out some free advice. But they didn't leave the conversation feeling it was anything more than one-sided. You have not gained a champion of you. Nor do you have an advocate.

You must alter how you utilize the first moments of the conversation and take the attention off yourself.

Rule #2 for Creating Relationships: It Takes Three Conversations to Create a Relationship

How do you begin this process? You're meeting new people at a party, screening or set visit. What to do? Well, hopefully, you've taken the approach set forth in Rule #1 and have put the person you are speaking with at ease. Now, you can ask for advice. Have him give you at least one action he believes (based on the information you've given him) that can move your career (or whatever you are hoping to accomplish) to the next level. If he has much more experience and success than you have achieved at this point, ask him to recall when he was in your position and if he knew then what he knows now, what he would do differently. Then, politely, ask for his contact information so you can follow up to tell him how his advice worked for you. Remember, if you find someone gracious enough to advise you for any period of time, there is a high probability that he is giving his time to many people. Therefore, you must do your job and follow up while you're still clearly in his mind. But remember, telling him how his advice impacted you is making it about him. Be sure to let him know that his words and advice led to your gains.

Your second and third conversations, similarly, should begin with inquiries to how he is doing, followed by, again, how he's impacted you in a positive way. But they should also include inquiries into introductions he feels might benefit you and your goals.

In my experience, it's by the end of the third conversation where doubt erodes and the relationship takes on an organic state.

* * *

Next, I asked Heather Hale to ring in on this subject. Who is Heather, you ask? Well, besides being a terrific, loyal and cherished friend, Heather is quite

simply one of the best and most efficient networkers I know. Heather is also a master connector—she uses her overflowing Rolodex to selflessly and progressively connect like-minded people. And for the last decade plus, Heather has run Mastermind groups featuring some of the industry's heaviest hitters.

But that's not all. Heather is an independent film and television director, screenwriter and producer. An approved independent producer for NBC Universal, Heather was pre-qualified by the International Film & Television Alliance, the nonprofit that runs the American Film Market, for whom she booked some of the speakers (including my panel on film crowdsourcing) and served as their Industry Liaison in 2013.

Heather directed, produced and co-wrote *Absolute Killers*, a thriller that starred Edward Furlong, Ed Asner and Meat Loaf Aday in 2010. She also has produced over 50 hours of award winning television, including *The Courage to Love*, a $5.5M original Lifetime film.

And if that wasn't enough, Heather has also written a book for this fine imprint called *How to Work the Film & TV Markets*, and is directly responsible for me landing the gig that led to the writing of the tome you hold in your hand.

Trust me when I tell you, Heather is universally loved by those who know her. She makes everyone feel important and worthy. In networking situations, I have simply never seen anyone with a better approach—and, I should add, a more effortless one at that.

I could think of no one to put a final stamp on this chapter. No surprise, my request to answer a few questions about networking offline was met with enthusiastically.

According to Heather:

1 How should one go about identifying the crowd offline for a specific project?

Brainstorm who might like your project—and why. Who are your affinity groups (a group of people linked by a common interest or purpose)? Where does your theme align with the mission or interests of other groups, organizations and movements?

For independent filmmaking or content creating help, join local filmmaking groups. Check out the film commission (or commissions), chambers of commerce and schools and universities in the area. Make friends with your local art house theater owner. Nothing beats face-to-face relationships, so walk in and introduce yourself to these groups.

Do your research! If you're doing a project on motorcycles, use Google to find groups in your area. Is there an Eagle Rider outlet that rents Harleys? Call and talk to the manager. He probably knows all the players in that affinity group in his area. Is your project on muscle cars? Is there a vintage car show coming up? Corvette or Miata clubs?

To help with your offline efforts, use your online resources. Study your comps. On IMDB, what are films that have similar themes to yours? Do your research to find out what groups they marketed to. On Facebook, create posts that engage your crowd and use Facebook's marketing tools, such as Ads or Boost Posts, to communicate with your target audience. Utilize Stage 32 to network and find offline communities near you through Stage 32 meetups.

Mind map everyone you are trying to reach and notice the intersections in a Venn diagram of where these interests and demographics most overlap. Target your efforts in those sweet spots.

2 What should be the approach when finally identifying a person or organization he or she is hoping to engage?

Your approach should be customized for each prospect. It should be authentic and relevant. *Why them? Why you/your project? Why now?*

Win. Win. Win. But know what you're hoping to win. What signals a win for you? What's a win for your prospect? What's a win for your project? Envision it as a three-legged stool: Knock out any one of the triad—and the whole house of cards comes crumbling down.

I try to always start my query with genuine praise that's relevant to my project and our intersection: "*Waking Ned Devine* is one of my favorite films of all time, and the dark comedy I'm working on, *Bad Timing*, has that same fun, driving comedic force of a grand lottery lie." Or: "*Fargo* was so fantastic, I'd love you to consider taking a look at *Bad Timing*, sort of a *Fargo* in the desert."

You want to eliminate the W.I.I.F.M. question—What's in it for me? What is it about your project that serves *their* needs?

Once you've cultivated your relationships, the crowdsourcing "Ask" comes down to presenting it in such a way that the benefits to them are obvious and compelling. But remember, it all begins with networking. Look at networking as simply synchronizing resources in such a mutually beneficial way so as to support one another in achieving parallel goals.

3 **How long should someone wait before making the "Ask"—How long should be spent cultivating a relationship first?**

Network two years ahead of yourself at all times. Perpetually. Always be thinking the long game.

I realize that might not be realistic in all situations, and perhaps you are terrific at networking and bringing people into your trust enough that you build relationships quickly, but you do still need to give yourself some runway. You can't just jump right in to the "Ask."

Therefore, you must begin building your networking net before you need it. Try to give five times before you get. I cannot stress this enough. Do so many favors and be so helpful, your sphere of influence is inspired to find ways to reciprocate. Your ten-fold return may come from where you least imagine.

Karma is never a straight line.

If you are going to go in for an "Ask," always return the favor. The greatest source of litigation, broken friendships and heartbreak in Hollywood (and anywhere else where film happens, for that matter) always comes down to thwarted expectations. Be clear. Be specific. Be realistic. Keep your word. Expect others to keep theirs. If they don't, move on and consider yourself lucky to have found out when you did.

4 **What are some of the common mistakes people make at networking events?**

Hit and run. It's all about them and what they want. They're so eager to move on to the next person, or hit the gym, or race home, that they never bother to stop and listen and actually be present and in the moment *there*. There's

always another person they are eyeing to talk to or something else they're rushing to that they don't realize they're not connecting in a meaningful way.

Another mistake is they get so caught up in the illusion of barfing out their default bios and knee-jerk credit spews, oozing as many business cards as possible about the room that they never actually stop and engage in a meaningful conversation. Worse still, they don't realize the person they are speaking with has their own agenda for being there. They don't value that person's time as they do their own.

It's far better to have two half-hour memorable conversations with prospects who might actually become peers (or even friends) than to fool yourself into thinking that running through the room handing out business cards will have a better result. Most of those cards will just get tossed. A business card only works when there's a meaningful encounter behind it.

Yet another issue is that people don't block time to actually follow up on their conversations. They'll be really good at a lot of the important things—being themselves, enjoying the conversations—but they end up six months later going through the car wash only to find a stack of (now) foreign business cards. Who are these people? Where did I meet them? And keep in mind, painful as it is to point out, the reverse will likely be true if you don't follow up. People you actually really hit it off with and who might be able to be a huge help in your career might not remember you if you get around to calling them too far after the fact. Worse, they might feel that you deemed them unworthy of contact sooner.

So much of our business and career success comes down to these moments. You simply can't squander them.

Allocate time—and energy and focus—for each meaningful communication. And here's something else, if you're one of these people standing off on the sidelines waiting for the perfect moment or deriding everyone else who's schmoozing, you might as well be at home on the couch watching the content other people are hustling to get made.

In an ideal world, you'd block time out right after the event to swing by your favorite coffee house or sit at your breakfast table and write follow up cards. I keep them stamped in my trunk so I can literally mail them before I get home. Imagine how surprised the people you just met will be with

your efficiency! You've just demonstrated your professionalism. Boom! Your sincerity, integrity and follow-through have just been executed in real time. You're cementing who you are and what you stand for.

If the immediate follow up strategy is unrealistic, here's an idea that will assure when you do follow up, you'll remember all aspects of your conversation. Take some breaks during the event to hit the bathroom, lobby, car, hotel room or other quiet area to scribble down notes on the back of their cards (or dictate notes to yourself in your cell phone). Then, make an appointment with yourself to follow up on the weekend with nice, personalized emails: "It was a pleasure meeting you at . . . XYZ. Good luck with your competition next weekend! And congrats, again, on becoming a new uncle!" Otherwise, you've diluted all the benefit of all your hustle. Make it count. Close the circle.

Oh, and you'll notice by my sample note, make it about them before you make it about you.

5 **What are some other ways filmmakers can crowdsource offline (film locations, etc.)?**

It depends on what you're looking for. What you need. Who's got it. Although it should be emphasized, the approach should still be the same.

Research land owners who might have vacant property they'd rent out. Be resourceful. A big box store that's sat vacant for years could be a fantastic poor man's studio and production offices. The local landowner could finally secure some fair market rent—albeit maybe deferred as equity in your film.

The local Rotary Club business owners might love their 15 minutes of fame as extras in your film in exchange for you to use their businesses as locations. The local camera shop might donate equipment in exchange for you marketing them to your crowd online. The approach, as always, should be selfless and a win-win-win.

LET'S BRING IT HOME

My thanks to Jessica and Heather for their time and thoughtful input. I think you'll agree that their mindset and approach to networking mirrors many of the central themes and strategies we've explored throughout our journey

thus far. Over and over we hear about selflessness, energy, focus and aware-ness. We hear about building trust.

It's only when you plant the seeds of trust that a relationship can grow. And as I've said many times, I believe that all begins with asking questions, with being selfless, with putting your needs or the notion of what you can gain from an initial conversation far, far below what you can offer the person or people standing across from you.

And if you are an introvert or simply have a hard time making the first move, think about how quickly you're disarmed and how your cynicism fades upon being asked a simple question about your well-being, your work or (if appli-cable) your personal life. Think about how great you feel when someone actually cares about *you*. This is the power you hold in reverse.

This is only one step, one strategy to deploy. As we learned above there are so many more entry points to making an impact and alleviating your fears. Everything, however, begins with a commitment to the self. As the Chinese philosopher said, "A journey of a thousand miles begins with a first step." Overcoming fear or apprehension does as well.

Work these simple strategies into your approach. Gauge the reactions. Hone your style. Try again. Keep moving forward.

I promise you, the more you put yourself out there, the more you put these strategies into practice, the easier face-to-face networking will become. You will look at it as a part of your whole and you will win more days than you will lose.

And most importantly, as it relates to why we're taking this ride together, it will immeasurably improve your chances of running a successful crowd-sourcing campaign.

But let me put my money where my mouth is by presenting another case study. This time, we'll look at a feature film where those connected to the project used a powerful combination of online and offline crowdsourcing to create a massive groundswell of support.

11

Case Study #2

Rising Star

Many filmmakers looking to get a project off the ground via a crowdsourcing or crowdfunding campaign fail to plan beyond (or before) the launch phase. Instead of taking the project as a whole and implementing a strategy that involves all aspects of production and beyond, they just want to clear the starting gate. The mindset revolves around grinding the gears, getting some traction and letting positive momentum push them through pre-production, production, post and distribution. This is a troubled strategy that will invite peril and leave you chasing promises, killing morale and bankrupt in ideas and in your wallet.

The smart filmmaker takes a worldview approach. Each step of the process from concept to distribution to the afterlife of the project is thoroughly thought out before launching a campaign. Now, some may think this line of thinking to be somewhat Pollyannaish, irrationally optimistic, perhaps even egotistical or pompous. How can one even think about distribution at the concept stage? Well, that's exactly when you should be thinking about such things. You may put together your film in phases, but those phases are part of a whole and to look at your project as anything but is doing you and your cast and crew—and ultimately, your supporters—a disservice. And while problems will most certainly occur and adaptability will be a reality you'll always need to embrace (not to mention an inevitable part of the process),

you'll be able to face and acclimate to your troubles more effectively if you've planned out a road map ahead of time. Not only will the speed bumps you encounter be flatter to the surface, but you will more easily maintain control. You will not be viewed by your cast and crew as irrationally optimistic or egotistical, but instead will be seen as a prudent and confident leader. *B. S.* People will want to line up alongside you, do favors for you, make sacrifices for you, and give you their best effort. You will, in theory, and then in practice, be effectively crowdsourcing your own people. If you can encourage and motivate your cast and crew to the point where they see the project as more than just a gig, you will form an army of passionate, dedicated champions of your vision.

Screenwriter, director, producer, Marty Lang and his team took the worldview approach when setting out to shoot his debut film and, despite a few admitted missteps, ones you can certainly learn from, it paid off in spades.

This is the story of a team that didn't let any obstacle stand in the way of making their feature film. It's a story of identifying and accepting mistakes, minimizing damage and adapting on the fly. It's a story of resourcefulness. It's a story of innovation. It's a story of community. Most of all, it's a story of crowdsourcing ingenuity.

I love this story.

This is the story of *Rising Star*.

ORIGIN STORY

In the summer of 2009, Marty Lang was a few years removed from film school, residing in his home state of Connecticut and living a life dominated by work. Working as a video producer for an engineering company, Marty was making more money than ever before, but that doesn't mean he was fulfilled. In addition to his long hours at the engineering company, Marty was also working part-time as a college professor, and every summer spent a bulk of time as the director of a month-long government-run workforce-training program for the film industry that he created called the Connecticut Film Industry Training Program (www.ctfilmworkforce.com). On the surface, everything seemed fantastic. Beneath the surface, Marty was anything but settled.

Prior to his video-producing gig, Marty had been laid off four times, falling victim to both the dot-com bust of 2000 and the economic meltdown of 2008. Additionally, the engineering company had begun making cuts and the fear of once again being out of a job hung over him like a black cloud. Marty made sure to have three jobs at all times just in case the worst occurred. All the personal activities Marty loved so much—playing basketball, shooting short films on the weekend, even spending recreational time with friends—went by the wayside.

His social life non-existent and the scales of his work/life balance heavily tilted, Marty did some reflecting and soul searching. He wondered if he was alone in experiencing the toll a weakened economy had taken on him. So he started talking with his friends. Candidly. What he found out was that he wasn't alone. Not by a long shot. His friends had passions they had abandoned. Their work lives had become their default lives. They had lost a sense of self.

The tales inspired Marty to turn back to his biggest passion, film. For some time, he had thought about filming a feature, and now felt he had a subject that would be compelling. Says Marty:

> To tackle making a full length film, I knew the story had to be something I was familiar with and passionate about. After listening to my friends explain their troubles I knew I had two things: A story I knew would resonate with people, and the beginnings of my audience.

One hell of a crowdsourcing starting point, no?

At this point, Marty began constructing what he called an "Artistic Statement." This exercise served as a way to not only make the motivation and the promise of the film clear in his own mind—a North on the compass, if you will—but also to inspire others to take this journey with him.

ARTISTIC STATEMENT

> As an American in my early 30s who's been laid off four times, I've struggled with the question of whether I should live to work, or work to live. I know many others feel similarly, and questions about one's identity often revolve around what someone "does." I thought this

would be an interesting issue to explore in a film, and I feel that setting the story in Hartford, Connecticut, the insurance capitol of the world, would only help to enhance the contrast between being a "company man" and being someone who works on their own terms.

I don't think many recent films have touched on this topic from the point of view of younger people; many people my age are living through the current economic downturn as veterans of the dot-com implosion at the turn of the century. Our working lives have been marked by tragedy, but we have parents who have pensions from companies they've worked for their entire lives. We've gotten mixed signals every step of the way. We don't know exactly what to do. I don't know exactly what to do. But I hope this movie can at least show young people what their choices are, and help them to begin a dialogue about it. As we move into the future, the notion of employment in America will become something much different than anything it has ever been before. I hope RISING STAR will help people to discover what that new notion will be.

—Marty Lang,
Writer/Director/Producer—RISING STAR

Marty presented his "Artistic Statement" to people in his inner circle—a controlled focus group, if you will. Not only was it extremely well received, but many expressed interest in joining and/or supporting the project. Marty was encouraged to move forward.

WRITING AND DEVELOPMENT

Now that Marty had his concept and his vision committed to paper and interest from various parties, he seized the momentum and quickly went about putting his team together. Marty's job at the Connecticut Film Industry Training Program (FITP) was to run a month-long film training program designed to teach Connecticut residents to work in below the line positions on film and TV sets; production manager, assistant director, location scout, script supervisor, prop master, etc. Marty contacted and solicited professionals from the International Association of Theatrical and Stage Employees (IATSE) and the Directors Guild of America (DGA) to work as instructors teaching classes on skills they actually employed in their day-to-day lives. In the final week of the program, the students worked within

their discipline on a short film which, once completed, would be released for audience consumption.

At the end of this process, Marty asked his production manager teacher to point him to the top student in the class. He was led to Matthew Giovannucci, who happened to be an alumnus of the college at which Marty was a professor. Gary Ploski, an actor, instructional technologist and a friend of Marty's from college, signed on not only to help produce, but to play the lead. Only now that Marty had his production team in place did he begin to seriously work on the content. That bears repeating. *Regardless of the fact that he had not committed a single word of the script to paper, Marty had already found champions who were willing to follow him based on trust, leadership and his passion for the content.*

> Once Matthew and Gary came on board, I quickly began writing and working through the story conflict points and arcs. Since Hartford is the "Insurance Capitol of the World," I would make Chris an insurance adjuster, a buttoned up conservative fellow who is a slave to his job. He would meet his polar opposite, Alyza, a free spirited woman who follows all her passions. They would be polar opposites on the work/life spectrum. Through their interactions, they would both become closer to finding a balance.

While wearing his screenwriting fedora, Marty also threw on his location scout cap, driving the city daily, looking for compelling places to shoot. His desire was to include cultural landmarks, so he visited the homes of renowned authors Harriett Beecher Stowe and Mark Twain. He also visited the grave of Pulitzer Prize-winning poet Wallace Stevens, who was not only buried in Hartford, but was also the Vice President of The Hartford Insurance Company.

Shooting at landmarks is not always easy, but Marty's scouting trips piqued the interest of the Hartford arts community. Whenever presented the opportunity, Marty would answer questions and speak passionately about the plight he and his friends faced and why the film was so important to him. Many not only found his story relatable, but were rapt by his enthusiasm for the project. This won him even more fans and supporters.

Soon, word of the pending production was spreading all over town. People were talking. There was a buzz. A great place to be considering Marty had yet to type "FADE OUT" on the first draft of the script or raise a single penny in financing.

CROWDFUNDING/PRE-PRODUCTION

Marty, Matthew and Gary decided to use the Kickstarter platform for their crowdfunding campaign (www.kickstarter.com/projects/garyploski/rising-star-the-movie). This was in the early days of Kickstarter, so theirs was one of the first films on the platform looking to raise funds. The team wasn't sure whether this would serve as an advantage or a handicap, but they proceeded methodically. Much went into the planning on how much money would be needed to bring this project across the finish line. They settled on a 45-day campaign with a $15,000 goal which was to commence on August 2nd, 2010 and end on September 15th, 2010. Production was slated to begin on October 4th, 2010, just a bit over two weeks after the completion of the campaign, a very short window. Keep in mind, Kickstarter's terms state you must reach your goal in full or all donations are returned to the supporters. So if the campaign wasn't fully funded, the producers would receive nothing and the film would be a no-go. All the cast and crew who had arranged their schedules and committed to the start date would be screwed. In retrospect, Marty recognized the lapse in judgment.

> The first of our mistakes in this campaign was crowdfunding while we were, for all intents and purposes, in pre-production. We honestly had no idea how difficult it was to run a campaign and the challenges we would face along the way. And we were prepping the movie at the same time, a process fraught with challenges. If we were to do it over again, we would have put everything toward ensuring the success of the campaign by beginning to network and market *well* before the campaign launch, moving on to prep only once things had taken hold.

Overwhelmed and a bit out of their element, the principals soldiered on. They approached friends and family about the film, told them about the pending crowdfunding campaign and asked them to be the initial financial supporters, a very smart (and always recommended) first move. As for the campaign itself, they prepped 24 backer updates—videos and written updates about the project so those who supported would not only be engaged, but feel involved and invested in the progress. In a creative masterstroke, perk levels were tied to the story of the film. Since *Rising Star* was a story about unemployment, layoffs and the culture of the workplace, perk amounts were based on statistics dealing with unemployment in the United States. For example, at the time, the unemployment rate was 9.6%, thus a perk for backers of $9. Additionally, since 14.6 million people were out of work, the team listed a

$14 perk. The fact that 28.6% of American households had at least one person unemployed led to a $28 perk being created. The use of this strategy might sound a little downbeat, but the team felt it helped illustrate the gravity of the issue. And they balanced things by adding some levity. In a nod to *The Hitchhiker's Guide to the Galaxy*, where the number 42 represents the answer to life, the universe and everything else, they added a $42 perk. Backers donating $42 or more received a personalized "Awesome Video," starring producer Matt Giovannucci and actor Michael Barra telling that backer just how awesome they were. A cool idea in theory, but not one the team thought all the way through as it related to available time and resources.

"We made 17 of these videos," says Marty.

> We did fake commercials, celebrity spoofs, musical numbers, that kind of thing. Some had special effects or were graphic intensive. The pro was they made for excellent viral marketing pieces for the campaign. Once someone received a video, they were so pumped they would immediately share it on social media and other outlets, bringing more attention to the project. The con was the amount of time it took to produce each video. Each video ran about 2 to 3 minutes, but took much longer to compile and edit. At the start, we were able to churn out 2–3 a day which allowed us to deliver the perk in mostly timely fashion. But as our production ambitions increased, our free time became more limited, and the investment of time into making the videos, even though they were being shared, promoted and giving us exposure, was taking us away from what we needed to be concentrating on, namely moving the project along. If we were to do it again, we would still have personalized videos as there is definitely value in doing so, but we would have them be no longer than 10 seconds, with simple editing, no more than one camera shot and text.

Adds Gary,

> When we ran the campaign, I was much more plugged into social media than I am now. Ideas were flowing fast and furious and I had as much fun creating videos for our campaign as I did on-set. Every time Marty and I were near each other we would make a point to record something to share with our backers and internet following. I certainly saw the value, but given the opportunity to do it again, we would probably tweak things slightly.

Of course, all the innovative marketing, attractive, incentivizing perks and creative communication don't mean a thing if nobody knows they exist. A team running a crowdfunding campaign needs to not only sell people on donating, but to sharing and promoting the campaign to similarly interested parties. And they need to come up with other new and inventive ways to spread the word not only online, but offline as well. This is where the *Rising Star* team really shined.

First, they tackled the obvious and necessary, namely launching a website (www.risingstarmovie.com) and Facebook (www.facebook.com/risingstar movie), Twitter (www.twitter.com/risingstarmovie) and YouTube (www.youtube.com/risingstarmovie) pages for the film. Then they shut down their computers, took to the streets and got innovative.

In an effort to fulfill their goal of endearing themselves to the City of Hartford—remember, they had already created buzz just through communicating their mission and answering questions during location scouting—they went to the Kinsella School for the Performing Arts and offered to give free filmmaking classes to 7th and 8th grade multimedia students, a brilliant idea the school's hierarchy embraced immediately. Classes began shortly after the Kickstarter campaign launch and footage from the classes was added to the *Rising Star* pitch video. "Our hope was our educational focus would help attract backers," says Marty.

They then again leaned on friends and colleagues informing them about the recent happenings surrounding the project and asking them to help carry word of the campaign to those who might be interested in contributing. Marty reached out to all 352 FITP graduates. Gary contacted his peers at Sarah Lawrence College, where he worked as Assistant Director of Research and Instructional Technologies. Matt and his family, active in the Italian community of Bristol, Connecticut, utilized the Unico organization. All three were very successful in bringing financial support to the cause.

Additionally, through contacts carefully cultivated through social media within the independent film community, spots were secured on a variety of film podcasts. These recordings were then promoted via Twitter, Facebook and other outlets, serving the double purpose of providing a steady stream of content for fans, followers and supporters of their Kickstarter campaign.

Most important, they communicated with other independent film fans, not by broadcasting, but communicating on social media, blogs, forums and

other online outlets. They posted content, asked questions and kept things informative and engaging. Day by day, they were building a bigger fanbase, earning the trust of the community and finding more people willing to carry their message.

Then came a really creative, but potentially disruptive idea. One that would require open-minded thinking for a closed-minded goal: Gary thought it might be a good move to engage with a new online community, namely the vegan/vegetarian community.

"My idea was called The Alyza Challenge," says Gary. "We would change our lead character, Alyza, into a vegetarian or vegan. This would make the film's story eco-friendly, since eating those types of diets puts less strain on the environment. It would allow me to reach out to the online vegan community."

Marty wasn't convinced, but was open to taking a shot to allowing a character in the film be crowdsourced, a move that would give the crowd even more ownership and, in turn, more investment in the project than before. "I said if the fans decided she should change, I would do it."

Emboldened, Gary asked fans of the project to tweet with the hashtags #VeganVegRS or #OmnivoreRS to the film's Twitter feed, depending on what they wanted Alyza to eat. The campaign caught fire and was featured on eleven vegan/vegetarian and eco-friendly blogs and news sites.

"I called off the challenge within a week," deadpanned Marty. "I rewrote the character the next day."

All this effort and innovative thinking paid off handsomely. When the campaign ended on September 15th, 176 backers had supported the film, resulting in a raise of $15,211. *Rising Star* was a go.

PRE-PRODUCTION

As mentioned, while the crowdfunding campaign was in full swing, Marty and company also had their focus on pre-production. Fifteen thousand dollars would not be a ton to work with, especially with so many prime public locations on the schedule. Marty believed they would have to crowdsource

locations. For starters, they took a shot meeting with the City of Hartford's Mayor's Office.

"They immediately took to what we were doing and saw the vision," says Marty. "So much so, we were granted permission to shoot on any city street or in any park for free, as long as we let the police know when and where we were planning on shooting."

Free Shooting Locations

The City so bought into the mission of the film, they facilitated an introduction to the Mark Twain House and Museum. Marty had staged a pivotal scene at this location with the clear understanding that he might have to eliminate or move it should they be denied or the cost be prohibitive. They were offered a deal of $300 an hour. They estimated six hours for the shoot. Eighteen hundred dollars represented over 10% of the budget, a price they simply could not afford.

A choice needed to be made: Surrender, and likely dilute the impact of the film by finding an alternative location, or find an innovative way to satisfy the needs of both parties. The boys chose the latter.

"We needed that scene, that location. So we offered them a deal," Marty recalls.

> If they let us shoot in the house for $50 an hour, a $300 total cost, we would host a focus group screening of the film at the Twain Museum. They have a 200-seat theater on site. They would keep all revenues from the ticket sales. It would be a win-win. We'd be able to get feedback on the movie while it was being edited, and they'd have an event that would tie them into the local independent film community. They loved the idea and even more, they were impressed by our passion, creativity and our willingness to make the deal as much about them and their supporters as ours. So before you knew it, we were setting up shop at the Mark Twain House.

In addition to securing public locations for the shoot, the crew also used public locations to work. They prepped in coffee shops and Panera Bread stores. Inevitably, curiosity would get the best of people. When approached, the guys would hand out business cards and information about the project, including a link to the Kickstarter campaign. This not only brought more backers into the mix, but others who asked how else they could support the project, offering everything from time to locations.

So moved by the public support, Gary suggested creating a Google Document to be populated by a form on the film's Facebook page so that fans who wanted to show support in means other than donating cash to the project could offer services or other benefits that might assist the production. Nearly 160 people responded.

Says Gary,

> We found a still photographer in that group, as well as a family who allowed us to shoot in their house for free. We also received some offers that were so cool, we worked them into the film. One woman offered us a flock of sheep we could film. A classical violinist offered his services and ended up playing in the movie. A tradesman donated welding and excavation services. We were awed and humbled.

The Facebook promotion also landed the project a key location and another producer.

"When I wrote the script," says Marty.

> I set a key scene at Sully's Pub, a famous bar and music venue in Hartford which, ironically, I had never been to. But I chose the location because it was the first place my lead actress, Emily Morse, had ever performed spoken-word poetry. And her character, Alyza, raps for the first time in a music venue. I thought it would be perfect for Emily to draw on that experience while performing in character. Amazingly, Darrell Sullivan, who owns Sully's, saw our Kickstarter campaign and had gotten word of the progress of the film from around town. He loved the project and asked how he could help. I went to Sully's to meet Darrell for the first time and we immediately hit it off. He offered his venue for free. I gave Darrell a small cameo in the film and an associate producer credit for all his help.

PRODUCTION

The money in the bank, the locations, cast and crew set, it was now time for the cameras to roll on the set of *Rising Star*. Smartly, the producers understood that just because production had begun, the crowdsourcing efforts needed to continue. They took a divide and conquer approach, with

each assuming specific roles designed to keep all aspects of the production functioning.

Marty, of course, was on set. His job simply defined: Get the movie made on time and within the budget. Gary, when he wasn't acting, took over all the various campaigns, which included creating new support videos and social media updates for backers of the project. Just because the money had been raised didn't mean that the supporters and fans could or should be neglected. To the contrary, they would be called upon again to carry the message when the film was about to be distributed. This strategy would not been able to be implemented without keeping the crowd engaged throughout.

Again, the videos proved to be time consuming. But, unlike when they were produced in the funding and pre-production phase, these videos were designed as straight marketing products for the backers and fans to carry forth. Content included location presentations, interviews with cast and crew and fun videos with Marty (taking his first ever shot of wheat grass at a health food restaurant set, for example). Stills taken by the on-set photographer (who had also donated her time) were immediately posted on Facebook and Twitter.

Also, to show their support to all those in the vegan/vegetarian community, the cast and crew participated in Meatless Mondays during each Monday of the shoot. This move endeared them further to that particular crowd.

The entire production lasted three weeks and, due to the massive amount of planning in pre-production, experienced very few challenges.

POST-PRODUCTION

Editing of *Rising Star* began immediately after production, with a first cut ready for public consumption in January of 2011. Making good on the promise to the Mark Twain House, the focus group screening was planned with tickets made available on Facebook and Twitter. The 200 available tickets sold out quickly, and 75 seats were added in a second room converted into a theater. At $15 a ticket, the Mark Twain House actually earned twice as much as they would have for their original location fee request. Additionally, Marty and company received the input they desired, which greatly influenced their second cut of the film. A win-win, indeed.

In May of 2011, it was decided that two days of reshoots were needed. A scene cut short by inclement weather needed to be re-filmed. Also, during the editing process, Marty had conceived two new scenes he believed would add cohesion to the story. With time of the essence, again Marty turned to the crowd.

> We approached one of our actors, Gary Craig, who is a local radio personality, and asked if he would broadcast our need for extras. The scene in question took place at a nightclub. We had limited time and we needed the place to look packed. We also had two crew members canvas the local community. Because of our endless outreach, many knew about the movie and were happy to be a part of it for free. Thanks to Gary and our crew, we ended up with more people than we needed.

Editing continued into the fall. In September of 2011, a new cut of *Rising Star* was chosen by *Indiewire* magazine (www.indiewire.com) as their Project of the Day. Energizing the crowd once again, the crew asked their supporters to vote for the film to be Project of the Month. The competition was stiff, with two VOD darlings, both of which had name actors in lead roles, standing in the path. In the end, Rising Star's supporters came out en masse, casting well over 600 votes in 24 hours. The film was named Project of the Month and the producers were invited to consult with and send the film to one of the programmers for the Sundance Film Festival.

Sound work continued through winter 2011. In February 2012, the film was finalized at PostWorks in New York City, where a former student of Marty's completed the film's color correction.

FILM FESTIVALS

The producers designed a streamlined approach to submitting *Rising Star* to film festivals, researching and carefully choosing their targets. Using a combination of Withoutabox (www.withoutabox.com) and personal relationships, the producers entered the film for consideration at Sundance, South by Southwest and 12 midsized film festivals. The first to come knocking was the Seattle True Independent Film Festival (STIFF) in May of 2102. Marty and Gary hit town with Gary's wife, Ali Berman, who also served as the film's eco-sustainability planner, music supervisor Matt Willison and actor/soundtrack artist Klokwize, a Hartford based hip-hop artist. As a Seattle native, Matt was able to get many Seattleites interested in seeing the film

before the rest of the team arrived. Klokwize was preparing to release his new record, *Hood Hippie: The Album*, and held a listening party to help promote the screening. Marty and Gary continued their social media outreach as well. All of this led to a sold out screening which marked the first time an out-of-town film had sold out at the fest. The success led STIFF to create a new award, Best Premiere, which Marty and Gary accepted while tweeting the news out to fans of the film.

In August 2012, the sold out Connecticut premiere of the film took place at the Connecticut Science Center. The producers also partnered with the City of Hartford Marketing, Events and Cultural Affairs Department for an outdoor screening of *Rising Star* at Bushnell Park, another location in the film. Klokwize and Emily Morse, lead actress and soundtrack artist, performed live before the show. Over 400 people showed.

Finally, the film played to a packed house at the Southeastern New England Film, Video and Music Festival, winning the award for Best Regional Film.

DISTRIBUTION

After exploring their options, the producers settled on Film Marketing Services to assist in sending out *Rising Star* to distributors. They eventually signed with Content Film in 2013 on a worldwide deal which was covered on *Deadline Hollywood* (www.deadline.com). The film has screened in Australia, Africa, Malta, Mauritania, Estonia and throughout South America and the United States. Marty, Gary and Matthew continue to let their supporters know of each new deal where the film is playing via social media. They have received fan mail regarding the film from as far away as Klerksdorp, South Africa.

The film currently has a 6.7 of 10 rating on IMDB and a 3.2 of 5 rating on Amazon (www.risingstarmovie.com/amazon).

CODA

While there is no denying that *Rising Star* was a smashing success on every level, Marty and Gary took away many lessons. Marty has gone on to raise funds for a number of films and each project has had a crowdsourcing

element not only on the funding side, but on the production side as well. Every time I speak with Marty, he is finding a new way or innovative way to engage and move an individual, group or organization, in service of either a new project or his personal brand. His inspiration and passion is contagious. He carries a spark that ignites the creative fire in others. And he has found another topic that elicits strong reactions from his friends—student loans. He is now developing a one-hour television pilot about the American student loan debt crisis.

As for Gary, after we had discussed *Rising Star* to the point where we had gone beyond the meat and reached the bone, I thought he would never want to discuss the project again. But as is the case with most brilliant creatives, reflection on the past is necessary to inform and cultivate the future. About a week after finishing our interviews on the project, I received the following email in my inbox, which Gary has graciously agreed to let me share with you.

Dear RB:

Taking on a feature film in any capacity was completely foreign to me in 2011. My experience with filmmaking was modest and nearly all of the projects I'd been a part of were independently funded. *Rising Star* would hold to that standard though I found that I needed to call on my experiences in project management from my day job to help wrap my mind around what we were undertaking.

I can say that in hindsight, if someone were to ask me what they should do to prepare when entering into a project would be the following:

▶ **It's the situation, not the person**—This is nearly always going to be true. Tensions run high because of time, money, and for personal reasons. Wait 10 seconds and a reaction might be completely different.

▶ **Stay the course**—If you believe in the project do not let hiccups get in the way of the project.

▶ **Solve problems instead of harping on them**—So what if all the lighting equipment is locked up in a van and the crew member has driven off with it—Yes, this happened to us. Figure out a solution. Call friends and family and make it work.

▶ **"It'll cost $100" means plan for $200**—Never ever imagine that your planned budget will match up with the actual cost of your project. If it does you're in golden territory! Set those funds aside for another piece of the project. Ahem, Post-Production and beyond.

▶ **Time is not your friend**—Plan your schedule with padding every chance you can. Traffic happens. Equipment breaks. Name it, it'll happen.

▶ **Crowdfunding is its own production**—That's right. There is a pre-production, production, and post-production side of a Kickstarter campaign. Plan your schedule accordingly. Remember what I mentioned about time and budget?

We did a ton of things right with our crowdfunding campaign, but there are certainly things, in retrospect, we might have done different the second time around. If there was one thing I believe we missed the mark on when we were raising funds for *Rising Star* it was with our pitch video. I believe if we focused more on the struggle of work/life balance, I believe that we would have found more people outside our social circles.

That said, our social circles were vast. It was amazing that 85% of our backers knew us or gained knowledge of us through our pre-campaign efforts. I am still amazed that 15% of our backers were unknown to us because our video conveyed the individuals who made up the story more than the concept of work/life balance. Any time I told a new person I'd meet about the struggle of "Working to live versus living to work," they'd immediately connect with the idea and ask me to tell them more about the film. There's a lesson there.

As the lead actor and co-producer on *Rising Star* I did more work on-set than I imagined because I was running social media through my mind throughout the production. Figuring out how to balance both roles was interesting and wonderful.

What was probably the hardest balance to maintain was the non-production related pieces of my life. A sale of a home in NY, a purchase of a home in NY, and a 2 person 90 minute play that rehearsed during the *Rising Star* production in CT. Driving from place to place was exhausting and is something I will be much more cognizant about in

the future. I should note that the play itself did not impair my performance in *Rising Star*. In fact, I believe it helped me to focus more because I was using my craft on-set and then on-stage almost 7 days a week for 3 weeks. The acting adrenaline high was amazing!

In closing, for all the daily project struggles I experienced, I can say I'm a better and more knowledgeable person and professional. Through the contacts made via crowdsourcing, I know how to speak and deal with people in a more professional and respectful way as well as know oodles more about shooting a feature film and what traditional distribution consists of. The entire ride was invaluable.

Yours,
Gary

NOTE

Personal communication, email dated _____

12

Crowdfunding– Get Your Money for Nothin' and Your Chicks for Free

No book about crowdsourcing for film would be complete without information on the subject of crowdfunding. The advent and acceptance of crowdfunding as a viable way to raise capital for a project has proven to be a Holy Grail for both novice and established filmmakers. Crowdfunding has launched or changed the career path of many a film creative while allowing for some remarkable, innovative and immensely successful projects to be realized. Whether it's shorts, features or documentaries, projects that would otherwise face an uphill rise in securing funds through traditional methods now have an alternative way to raise capital. Many filmmakers have turned to crowdfunding not only as an alternative way to fulfill their budgetary needs, but have also recognized that crowdfunding allows them more autonomy as well as full control on how they cultivate a support base and audience. They run their campaigns with an eye not only on various aspects of the project, but on creating and forming their brand as well. They are savvy to what each platform provides, who is likely to frequent them, what the competition is doing, and how they can best separate themselves from the pack.

But for many, the basic tenets of crowdfunding, or simply how to run a competent and engaging crowdfunding campaign, remains a confounding mystery. Some, blinded by ego and hubris (that theme again), believe that

by simply posting reels showing off what they believe to be a considerable skill set, people will be so dazzled by their talent, they will have no choice but to donate to their project. I call this the "If you build it, they will come" approach. Others simply do not take the time to review and utilize the legion of information regarding how best to plan and run a successful campaign and choose to ignore the tools most crowdfunding platforms provide. Many more launch a campaign blindly, with no blueprint for how to attract and keep an audience or fanbase engaged, neglecting to realize that any crowdfunding campaign requires constant attention, nourishment and caressing. For all these reasons, and many more we'll outline in the next chapter, failed campaigns greatly outnumber successful ones.

To understand how best to run a successful film crowdfunding campaign, we must first understand the history of crowdfunding, the different types of crowdfunding, how various crowdfunding platforms operate (which will inform which platform is best for you), discuss the vast competition within the crowdfunding arena and investigate and dissect a few successful campaigns.

In this chapter, we'll explore everything mentioned in the previous paragraph, and, in the next, we'll identify the aforementioned problems and cover strategies to help you run a successful film crowdfunding campaign by rising above the din, standing out from the pack, identifying and moving the crowd and creating engagement that guarantees the best possible odds for success.

A BRIEF HISTORY OF CROWDFUNDING

Crowdfunding, particularly online crowdfunding, has become something of a phenomenon across the world over the last half decade, with legions of people donating money to projects, causes, services and a variety of other initiatives. As documented by Reuters, journalist Kylie MacLellan, crowdfunding websites helped companies and individuals worldwide raise $89 million from members of the public in 2010, $1.47 billion in 2011 and $2.66 billion in 2012. Of this, $1.6 billion of the 2012 amount was raised in North America. According to The Crowdfunding Industry Report compiled by Massolution (an advisory and implementation firm that specializes in crowdsourcing solutions for private, public and social enterprises), the nearly $2.7 billion raised in 2012 was generated from over one million

individual campaigns. Mere weeks before writing this chapter, *Forbes* reported that global revenues from crowdfunding spiked to $5.1 billion and projected that in the year 2025 revenues generated from crowdfunding would reach $25 billion . . . wait for it . . . *in China alone!*

Did I mention crowdfunding is hot?

But, and this is a big but, that doesn't mean that every project is right or, more importantly, ready for a crowdfunding campaign. This is especially true in the increasingly competitive world of film crowdfunding. We've already spoken about the fact that the barrier of entry for making a film has never been lower and, thus, the number of people entering the space has never been higher. And as the hardware market becomes more competitive and costs continue to decrease, software becomes more sophisticated and intuitive, and as the proliferation of media outlets willing to host and distribute content continues to rise, it only stands to reason the barrier will drop even further. Countless more people will not only be seeking to make a film, but be looking to finance their projects through crowdfunding. So, is that good news or bad news? Well, it depends on your viewpoint. Let's come back to that thought in a moment.

A crowdfunding campaign with a compelling bent, coupled with a sound marketing and crowdsourcing strategy, is a revolutionary, game changing way for a filmmaker, producer or any other DIY creative to raise funds for a project. Beyond the obvious, as a means of potentially raising money from people you don't know, it also serves as a way to build an audience and fanbase for your project, and the talent connected to the project, *before* you even consider entering pre-production.

With a traditional raise for a film (and I've been involved in more than a few), you operate within a bubble. You go hat in hand to various individual investors or investor groups, usually with a business plan (many of which look alike, say almost exactly the same things and reference the same batch of previously successful independent films) and a well-oiled sales pitch on why your project is different from every other in the stratosphere. Or, perhaps, if you have any, you dog and pony the name attachments on your movie in front of your potential investor(s) in the hope that your target will become star-struck and, as a result, anxiously loosen their purse strings. Whatever the method, these meetings are usually done in a hush-hush fashion. Besides a unique opportunity, you're pushing exclusivity—the fact that,

true or not, the person you're pitching is getting a first look at the plan. No one wants to be presented a pitch for a project they view as either stale or saturated.

With crowdfunding, the particulars of your raise are completely out in the open—absolute transparency is the name of the game. You will not only be targeting individuals, but groups and organizations in an effort to get them to support your project financially and get behind it by promoting the merits of your mission to others. This is why, as we stated very early in this book, every single crowdfunding campaign has an element or elements of crowdsourcing. However, accomplishing the mission of support from the crowd will require months of planning and a commitment that goes far beyond making a couple of creative/interesting posts or uploading a piece of media when the mood strikes.

This will be a full time job. It will require research. It will require business and entrepreneurial sense and style. It will require a temperament that is patient, receptive and adaptable. It will require you to find people who love you and your project and have the qualities that lend themselves to helping you run the campaign. Even if you feel you have what it takes to get the job done alone (and, again, it's a much more formidable undertaking than you think), forming a team to manage various aspects of the campaign is highly recommended.

But this is all macro strategy talk, which we'll distill in the next chapter. For now, let's get a little more micro as it relates to our crowdfunding overview.

TYPES OF CROWDFUNDING

There are five types of crowdfunding: Rewards, equity, charity, litigation and debt. For the purposes of our subject, film crowdfunding, we only need concentrate on two—rewards and equity.

Rewards Crowdfunding

According to business crowdfunding website Fundable, the history of crowdfunding began in 1997 when UK rock band, Marilion, financed their reunion tour via ArtShare. At the time, ArtShare was a fan funding website (where they ran a substantial crowdsourcing campaign long before the word

crowdsourcing was coined). Mainstream websites such as Indiegogo came into focus in 2009, establishing a new form of crowdsourcing financing, or *crowdfunding*.

In rewards-based crowdfunding, funds raised for projects are provided by individual supporters who make up the crowd (sometimes referred to as the community). The person or group running the crowdfunding campaign sets rewards levels (sometimes called perk levels) spelling out what reward is to be received for donating a certain amount of money to the cause. For example, a film rewards-based campaign might set a level one reward at $5 and give anyone donating that amount a thank you on their social media pages. The next level may be $25, for which the donor receives a poster of the movie. The next could be $50, which guarantees the donor a DVD of the film and so on. The more attractive and innovative the rewards, the better.

Since rewards-based crowdfunding allows the individual or group running a film campaign the advantage of raising capital without offering a return on their investment, it effectively eliminates dealing with the contracts, attorneys, securities issues, profit and loss statements and accounting nightmares that are part and parcel of a traditional film equity raise.

Equity Crowdfunding

Equity crowdfunding involves monetary investment into a commercial enterprise—for example, a film. However, instead of receiving a chotski or some other perk for their money as in rewards-based crowdfunding, the investor is hoping for a monetary return based on the proceeds of the film. Due to the fact that equity crowdfunding involves investment into a commercial enterprise, it is almost always subjected to rigid and, for investors, restrictive securities and financial regulations.

Hoping to exempt relatively small investment offerings (defined as $1 million or less), sold to the public in small blocks, from the registration and compliance requirements demanded of large public companies, a group of advocates band together, eventually forming a lobbying group called Startup Exemption. In 2011 Startup Exemption presented a crowdfunding exemption plan to members of Congress and other influential political leaders. Soon after, the Entrepreneur Access to Capital Act was introduced, and in March of 2012 it became part of the JOBS Act, which was signed into law by President Barack Obama on April 5th, 2012.

The crowdfunding provision of the JOBS Act tasked the Securities and Exchange Commission (SEC) with composing detailed rules for crowdfunding, specifically crowd investing. They were given a Congressional mandated deadline of 270 days to write the rules. As of the writing of this chapter they are over two years past due. Further, SEC Chairwoman, Mary Jo White, has given no indication that we should expect a response or resolution to this matter any time soon.

So in spite of the JOBS Act passing way back in 2012, it remains primarily useless due to unworkable rules proposed by the US Securities and Exchange Commission.

Now the good news . . .

Impatient and certainly more progressive of mind and matter, many states have decided not to wait on the government and handle things on their own. At the moment, 13 states have intrastate crowdfunding exemptions in place and 14 more are in the process of enacting/considering sponsored legislation regarding intrastate crowdfunding. A couple of these states, Texas to name one, have some extremely liberal guidelines.

Equity crowdfunding for filmmakers is an exciting and potentially game changing proposition, but it's still in its infancy and will be evolving for years to come. However, that doesn't mean you can't start planning or participating now. Just be sure before doing so, you review the rules (they vary greatly) of each state and cover your bases by consulting an attorney.

THE PLATFORMS

As more states pass legislation to allow equity-based crowdfunding online, you can expect many new crowdfunding platforms to pop up. But, for the purposes of this section, let's concentrate on what's mainstream: Rewards-based crowdfunding platforms. Here's how most work:

You, the project manager, upload a project and set a monetary goal. In this example, let's say that's $10,000. Again, we'll touch on the planning and strategy on how all of this goes down in the next chapter, but assuming you have all your ducks in a row, you'll start your campaign on a certain day and begin taking monetary pledges for the project in exchange for rewards based on the tiers you've decided on.

I, the person donating, make a pledge to your project. Let's say $500. This payment can be made through a credit card or through an online payment entity such as PayPal, Amazon Payments or Stripe. Assuming the monetary goal of your project has not been met yet, my card will only be checked to see if I have the funds available for what I pledged. If so, that amount will be held and you will be notified of the pledge. Additionally, the amount will be reflected in the total on your campaign page. My card will be charged the $500 donation on the final (deadline) date of the campaign *only if* the project goal has been met or surpassed. (Some platforms allow the campaigner to keep any and all pledges made to the campaign. In this instance, I would be charged immediately upon making my pledge. More on this below.)

On a majority of rewards-based crowdfunding platforms, there is a 3–5% processing fee which will be deducted from each donation to the project. Additionally, the company running the platform will take a cut as well, typically 4–9%, but sometimes as high as 15%, depending on the rules set forth by the platform.

On a sidenote, there are some crowdfunding platforms that allow you to keep any monies raised even if you do not reach your set goal. Sounds great, right? But there are a couple of drawbacks. One, you will pay a much higher percentage to the platform off the top of your raise, typically 5% or higher than if you had hit or surpassed your goal. Two, some potential supporters look down at this practice, feeling that if you did not do your job marketing and attracting other donors to the project, you probably don't have your act together or, perhaps, aren't serious about the project and therefore shouldn't be trusted with their donations. For many other potential supporters, this isn't an issue. They feel if they're behind a project, that's all that matters. Ultimately, no matter which platform you choose or whether you decide on an "all in" or "any money raised" strategy, you should set reasonable goals and properly promote your campaigns so that the end game is collecting all the money while paying the lowest fees possible.

There are numerous platforms to choose from, and new and intriguing sites enter the mix regularly. Each comes with its own personality, following and rules. I'll outline some of the more popular ones below, but it's up to you to do your research and due diligence to decide which platform is right not only for your project, but would be best suited for the crowd you're hoping to engage and move.

Indiegogo

One of the originators of the crowdfunding space remains one of the brightest innovators within the space. Indiegogo does a phenomenal job keeping their audience informed, engaged and educated. The site is easy to navigate, has a wide, global audience and provides stellar customer service and support. With sections such as their Campaign Playbook, they are consistently progressive in developing offerings for project managers in an effort to provide the tools and information required to give each campaigner the highest probability of success.

Whether you're an independent filmmaker of shorts or features, a documentarian or webseries creator, Indiegogo will allow you to post your campaign while giving you the course knowledge (and personal hand holding, if so desired) necessary to get it in front of the most eyeballs.

Indiegogo also allows you to choose a fixed or flexible funding campaign. With a fixed campaign, you will only receive your funds upon reaching or surpassing your goal. With a flexible campaign, you'll receive any funds raised on the closing day of your campaign.

FEES (Fixed or Flexible Campaign)

▶ 5% platform fee (upon reaching your goal)

▶ 3% + $.30 processing fee for credit cards

▶ 3–5% processing fee for PayPal

▶ $25 wire fee: Charged once when non-US campaigns have raised funds in US dollars via credit card. The funds are wired in one lump sum to a non-US account after the campaign has ended.

▶ Additional currency fees may also apply.

Kickstarter

The other behemoth in the space along with Indiegogo. Film represents Kickstarter's second most popular category after tech, but with a somewhat tougher review and project acceptance process than most platforms. That

doesn't necessarily mean it's the best platform for all filmmakers. Some projects are taboo altogether. For example, if you are looking to crowdfund an industrial film on Kickstarter, you'll have to look elsewhere.

Some view Kickstarter's stricter parameters and selectivity to be a huge plus, allowing for less quantity and more quality. Fewer posted projects provide a higher concentration of eyeballs and greater opportunity for support. A higher quality of projects brings legitimacy to the campaign, the thought being that if the project is worthy of Kickstarter, it's worthy of attention and, in turn, a donation.

The Kickstarter Basic section offers a robust FAQ, user tools and other information designed to help you get the most out of your campaign.

Fees

▶ 5% platform fee (upon reaching your goal)

▶ 3% + $.20 processing payment

▶ Pledges under $10 have a discounted micro-pledge fee of 5% + $.05 per pledge

GoFundMe

According to GoFundMe's getting started section, most people use the platform to raise money for themselves, a friend or loved one during life's important moments. This includes things like medical expenses, education costs, volunteer programs, youth sports, funerals and memorials—even animals and pets. However, GoFundMe users also list products and services as well. Because of the lack of heavy competition, many filmmakers choose GoFundMe as their crowdfunding platform of choice. Films that carry a social message work well on GoFundMe due to the socially conscious and charitable donors who frequent the site. A recent perusal of the various film offerings listed on GoFundMe found campaigns for a narrative on bullying, a documentary on marijuana legalization, and a short on the subject of child trafficking all performing exceptionally well.

GoFundMe allows users to create their own website to fully explain why they are looking to raise money. They also allow campaigners to share their site via integrated links through social media.

Unlike many other platforms, you need not reach your goal with GoFundMe to receive the monies donated. You can withdraw any or all of the funds in your account whenever you please. Also, there are no required time limits or deadlines associated with a campaign. However you can choose an "All or Nothing" option which requires you to set a time limit to hit a certain goal. Failure to do so results in a forfeiture of all monies raised.

Fees

▶ GoFundMe deducts 5% from every donation received

▶ Approximately 3% processing

Seed&Spark

Unlike the platforms mentioned above, Seed&Spark is devoted strictly to filmmakers *and* film lovers. It's a truly independent community where film-makers and audiences can join forces to fund, promote and watch the best new independent films.

Seed&Spark takes a different approach to crowdfunding. There is still an overall monetary goal to be obtained, but Seed&Spark's crowdfunding tool is designed to work like a wedding registry. Filmmakers make a "wish list" of the individual items they need to make their film. Supporters can contribute money towards a specific line item—say, costumes or camera—or, if they have that item themselves, they can loan it to the filmmaker directly and the loan counts toward the overall goal of the campaign. This wedding registry approach allows for a more personal interaction between the supporter and those running the campaign and effectively gives the supporter a feeling of more ownership in the project than merely being a financial supporter.

As an added perk for filmmakers, Seed&Spark offers distribution on their platform so that the fans the platform services have the opportunity to view films funded through the site. They have also announced that they will soon be extending offerings out to other distribution platforms as well.

Like other rewards-based platforms, filmmakers offer incentives to their supporters, but unlike other platforms, Seed&Spark offers incentives to backers as well. For funding, following or sharing a project, users earn

"Sparks"—rewards points that can be redeemed to watch movies on their streaming platform.

Seed&Spark does not require you to hit your goal in full. If you make it to 80%, they will release your funds. Additionally, although they take a mostly standard 5% for their fee, they also offer funders the opportunity to add 5% to their contribution to cover the site's fee on the filmmakers' behalf. According to Seed&Spark's FAQ, over 70% of backers choose to add the extra 5%. In 2014, filmmakers paid on average 1.95% in site fees and no third party payment fees (such as to Amazon or PayPal on other platforms).

Seed&Spark claims a current campaign success rate of 80%, which they claim to be "the best in the business."[1]

Fees

▶ 5% upon reaching 80% of your goal

▶ 3% flat processing

Remember, carefully reviewing which platform you will use to house your film project's crowdfunding campaign should be a very big part of your pre-campaign strategy and should not be minimized. Take your time and do your homework thoroughly. Do projects similar to yours have a high success rate on a particular platform? How does the platform list or rank all of their projects? Is it a random process or will you be able to control your own destiny based on certain criteria (example: money raised in a 24-hour period), or is it possible to purchase a premium placement? Does the platform offer personalized service, guidance and hand holding when needed?

These are just some of the questions that need to be asked. I would also highly recommend seeking out people who have successfully crowdfunded a film campaign and ask them (kindly, complimentary and with genuine interest) if they wouldn't mind sharing their experiences. You not only want to learn what pertinent strategies they believe were paramount to their success, but missteps made along the way, what they did to adjust/pivot, and what strategies they would implement to prevent similar pitfalls the next time around. Not only might you gain some insight that will help you decide whether the platform in question is right for you, but you may also gain some critical course knowledge along the way.

THE COMPETITION (OR *!#$@! ZACH BRAFF)

So now you're ready to dig in and begin looking over the various crowdfunding platforms. You sit at your computer, your creative synapses sizzling and snapping, your fingers tingling with excitement. You're about to take the first step in your project's journey. How cool. You pause for a second, reflect on the road that brought you to this moment—the hard work, the late nights outlining and planning, the insecurities you had to overcome as a creative to feel compelled to believe that your project is a worthy crowdfunding candidate. You channel your inner Stuart Smalley and think to yourself: *I am going to post the coolest campaign ever and be so engaging and informative that people are going to beg me to take their money. And you know why? Because I'm good enough, smart enough, talented enough and, goshdarnit, people like me.* You punch the keys of your keyboard with confidence and authority, typing in the URL of the first crowdfunding platform for review. An impenetrable wall of film crowdfunding campaigns loads before you like an endless skyscraper reaching above and beyond the clouds. You load the next page . . . another wall. The next page . . . yet another.

You feel a light gurgle push up from your stomach, rising higher until it escapes from your lips in the form of a nervous laugh. Your eyes dart back and forth across the screen. Campaign after campaign. Hundreds, no, seemingly thousands of them. Webseries, music videos, promotional videos, documentary shorts, full-length documentaries, shorts, features! And wait, isn't that the guy I went to film school with?! The guy that didn't know which end of the camera to look through?! He's raised 75% of his goal in seven days?! And isn't that the guy who won that huge film festival last year?! He's looking for money too?! And that writer, the one who won that screenwriting contest . . . I know him . . . He's a filmmaker now?! *He's* looking for money?! And, wait a second . . . I think I recognize tha . . . isn't . . . it can't be . . . *Is that *!#$@! Zach Braff*?!?!?! What the hell does he need money for?!?! How many millions?!?!? But he's famous!!!! He has more money than God!!!! Or at least the guy who played God in that movie I saw!!!! Holy shit, I'll never watch *Scrubs* again!!!!!!!

Your synapses go from sizzling to singed. Your hands from tingling to numb. If Stuart Smalley was in front of you, you'd punch him in the teeth.

Relax. It's OK.

Let's start with Zach Braff and celebrity crowdfunding in general. The first high profile celebrity crowdfunding campaign—or at least the one that caused everyone to jump out of their seats and cry foul—was *The Veronica Mars Movie Project*. *Veronica Mars* was a fairly popular television show created by Rob Thomas that aired on UPN/CW from 2004 to 2007 and starred actress Kristin Bell. When *Mars* was ultimately canceled, the show's fervent fanbase took to the internet to express their disappointment. The large swelling of support inspired Thomas to write a full-length script which he hoped would convince the powers that be at Warner Brothers to put up the funding in support of a feature film. They declined.

The project sat in limbo until March of 2013 when Thomas and Bell decided to take the project to Kickstarter, believing fully that the passion to see the *Mars* characters on screen still ran deep with the fans. They set up some creative donation incentives (for $8K you got to name a character in the movie. For $10K you got to *be in* the movie). They enlisted fellow *Mars* actors Enrico Colantoni, Ryan Hansen and Jason Dohring to appear in a video promoting the campaign. Then they launched. Their goal? Everyone put their pinkie finger to their lips like Dr. Evil . . .

$2 milllllionnnnn dollars.

They reached it in ten hours.

In the end, they had set a record for the most backers on a single Kickstarter project with 91,585 donors who pledged $5,702,153.

There were some who were outraged by the fact that those working within the system would use a medium that was clearly invented and designed for the cash poor, struggling independent film artist (although that was certainly never stated by anyone running a platform). The flip side to that argument, voiced by the stars themselves and others coming to their defense, was that there was no other option. They reminded anyone who would listen that the studio that owned the property wasn't interested in funding the film. Further, Thomas and Bell couldn't finance the movie on their own, but believed enough in the project and in the support from the fans of the series to commit their time to launching, supporting and nurturing the campaign. Eventually the news cycle surrounding this story died down and peace was somewhat restored.

Sensing safer tides, more and more celebrities jumped into the crowdfunding ocean. Spike Lee (Kickstarter: $1.2M goal, $1.4M raised for his feature film *Da Sweet Love of Jesus*), Shaquille O'Neal (Indiegogo: $450K goal, $459K raise for his video game *Shaq-Fu: A Legend Reborn*), Don Cheadle (Indiegogo: $325K goal, $345K raised for his feature film *Miles Ahead*), Whoopi Goldberg (Kickstarter: $65K goal, $74K raised for her documentary, *I Got Something to Tell You*), Ed Begley, Jr. (Kickstarter: $25K goal, $29K raised for his webseries, *On Begley Street*), and even legendary *Ren and Stimpy* animator, John Kricfalusi (Kickstarter: $110K goal, $137K raised for his cartoon series *Cans Without Labels*) got in on the act and ran hugely successful campaigns. Other high profile stars such as James Franco (Indiegogo: $500K goal, $326K raised for his feature *Palo Alto Stories*) also tried their hand at crowdfunding their projects, but came up short.[2]

But it was Braff who, despite not being first or even the highest profile celebrity raising funds through rewards-based crowdfunding, would become the poster child and whipping boy of the "Celebrities Abusing the System" mob. Braff kicked off his campaign for *Wish I Was Here* on April 24th, 2013 with a target goal of $2M. From the get go, Braff made a few things well known: One, outside of the potential crowdfunding raise, he was investing his own funds into the movie. Two, he was counting on foreign pre-sales (selling the right to distribute the film in different territories before the film is completed) to round out the budget (estimated at the time to be about $5–$6M). Three, one of the benefits of choosing the crowdfunding route to supplement the budget was to retain complete creative control.

The outrage was quick, vocal and vast. Here was a rich, privileged celebrity taking real estate and supporter dollars away from the starving film artist who truly needed the assistance. Here was someone who could (some thought) easily (it's never easy) find traditional financing and support. The torches were lit and the villagers were at the gate. But in a vote of confidence for the wise Irish dramatist Brendan Behan, who said, "There's no such thing as bad publicity except for your own funeral," the supporters—46,520 of them—fought back by opening up their wallets. In the end, *Wish I Was Here* raised $3.1 million, a little more than 150% of the set original goal.

But that didn't quell the debate.

Neither did the fact that the film was selected for the 2014 Sundance Film Festival, adding more fuel to the "privileged" fire. Now, not only was Braff

stealing supporter dollars from the starving film artist, he was stealing prime festival space as well.

"I was completely taken aback by the criticism," Braff said at the Zurich Film Festival.

> I was expecting a conversation because it's a fascinating and new model. But I felt the criticism was unfair and uninformed. It was frustrating having the debate with people who didn't have all the analytics and facts. I knew we were driving new people to Kickstarter who then invested in other projects, for example.

> The onus was on me to explain why someone like me couldn't get a film made in the traditional way [Braff continued].

> This was not an attempt to make a lot of money. I was a little shocked my quest got lost in the Kickstarter conversation.

> If you gave ten dollars to our film, it didn't mean another film wouldn't get funded. By contributing a certain amount, people felt part of the film. Crowdfunding can be a very emotional medium.[3]

By raising the idea that the high profile nature of his campaign actually informed and educated people who previously had no knowledge of the presence or mechanics of crowdfunding platforms, Braff was able to silence some of his harshest critics. But not all. Even today, the argument rages on, with some celebrities admittedly terrified of risking their brand and/or their good will with the general public by launching a campaign.

So who's right and who's wrong in this argument? Before I answer that question, let me highlight a few, lower profile film crowdfunding success stories involving non-celebrities to add some color to the conversation.

Worst Enemy

Lake Bell was a little known actress back in 2010 when she decided to follow her dreams of becoming a writer/director. Reluctant to lean on her contacts in the industry and hoping to gain support from the general public for her short film, she launched the Kickstarter campaign for *Worst Enemy* with a modest goal of $8,000. She worked her campaign tirelessly and without

cashing in on whatever celebrity she had at the time. She surpassed her goal by $625 and went about making her film. Later that year, she entered the short at Sundance and was accepted. The film was extremely well received and reviewed. Three years later, she was back at Sundance with her feature film, *In a World*, which not only went on to become a critical success and an indie darling, but also won Bell the Waldo Salt Screenwriting Award.[4]

Dear White People

Writer/Director/Producer Justin Simien had nothing but short films on his resume, and none in five years, before hooking up with producers Lena Waithe, Ann Le and Angel Lopez to launch the $25,000 Indiegogo campaign for *Dear White People*. Campaign tagline: A satire about being a black face in a very white place. With active, engaging and motivating updates and content, the campaign surpassed its goal by over $16,000. In 2014, the film played at the Sundance Film Festival, winning Simien the US Dramatic Special Jury Award for Breakthrough Talent. On January 29th, 2015, Indiegogo sent out a press release stating that *Dear White People* had broken the box office record for a crowdfunded film with a take of $4.4M to date, not so ironically besting the previous record holder, Zach *!#$@! Braff's, *Wish I Was Here*.[5]

A Girl Walks Home Alone at Night

Described by Writer/Director/Producer Ana Lily Amirpour as the "First Iranian vampire western," *A Girl Walks Home Alone at Night* originally began as a short, winning Best Short Film at the Noor Iranian Film Festival. Amirpour, along with producers Sina Sayyah and Justin Begnaud, launched an Indiegogo campaign seeking $55,000 with the intent of extending the material into a feature.[6] I mean, come on, who wouldn't want to see a black and white vampire movie in Farsi with English subtitles and with Southern California doubling for an Iranian ghost-town called Bad City? I mean, who wouldn't be on board with that? (For the record, I was, and in a big way.)

Clearing their set goal by just a couple of thousand dollars, the film was completed in February of 2013 and premiered at the 2014 Sundance Film Festival, where it had tremendous buzz. It was also the opening night selection at the MoMA for the New Directors/New Films Festival Presented by the Lincoln Center in New York. All of this led to Kino Lorber and Vice Media getting involved in the distribution and promotion of the film with Vice Creative Director Eddy Moretti calling Amirpour "the next Tarantino."[7] As a result, Amirpour almost immediately landed financing for her

sophomore film, *The Bad Batch*. The film premiered at the 2016 Toronto Film Festival.

These are three films that made it into Sundance on their own volition, helmed by relative unknowns—Bell, a first time director, and first time feature directors Simien and Amirpour. None of these films had major star attachments or power player producers, nor was a traditional funding avenue an option. Yet, due to meticulously run campaigns, they all made their crowdfunding goals and went on to realize successes which launched each of their careers.

Research

WHERE DOES THAT LEAVE US?

So let's go back to those questions I posed earlier. Have celebrity crowdfunding campaigns helped the starving artist filmmaker by raising recognition of rewards-based crowdfunding, thereby effectively increasing the pool of available funds? Or have celebrity crowdfunding campaigns taken money, significant money, away from the pool and devalued the already jammed real estate of crowdfunding platforms accepting film campaigns?

As my terrific publisher, editors and I were performing the focus studies referenced throughout this book, the issue of celebrity crowdfunding was raised often as a subset within the subject of crowdfunding as a whole. This was on your minds. You had passionate opinions about it. Some of you brushed it off, saying, in the spirit of our friend Brendan Behan, no publicity is bad publicity—the more eyes the better. But many more of you weren't buying that notion. A couple even mentioned that until celebrities were banned from the major crowdfunding platforms, it was worthless to even think about launching a campaign on any of them—too competitive, the playing field uneven. One of you even went so far as to include an extremely colorful, beautifully textured takedown of Zach Braff which inspired the title of this section—you're a hell of a writer, by the way.

So needless to say, because it matters so much to you, it matters much to me. And because of that fact, I've given this a ton of thought. Certainly, I can appreciate both sides of the argument. So much so, I found myself having *Sybil*-like discussions in my head, occasionally muttering to myself, much to the concern of friends and co-workers.

But then an interesting thing happened. As part of my research for this book, I began watching crowdfunded and crowdsourced films. A ton of them. I watched

some from unknown, on the rise and celebrity filmmakers alike. I watched the three films I mentioned above. I went back and looked at the nuances of their campaigns, all of which are archived online in case you'd ever like to do some reconnaissance yourself. Suddenly, it all came clear. I had my answer.

It doesn't matter.

It's just another excuse.

It certainly didn't matter for the three filmmakers highlighted above. Watch their films. See the confidence. Look back at the campaigns. See the plan.

In the "A Brief History of Crowdsourcing" section above, I posed the question of whether a lower barrier of entry to making a film and, therefore, more people flocking to film crowdsourcing platforms to fund their projects is a good thing or bad. Well, pragmatically, any new money channel for financing films is surely going to bring in the haves and the have-nots, but guess what? Your job remains the same.

Be original. Put your unique voice and vision on display.

Identify the crowd. Engage the crowd. Move the crowd.

Control what you can control.

Let go of what you can't.

That's how you rise above.

NOTES

1 www.seedandspark.com
2 https://www.kickstarter.com/projects/1869987317/wish-i-was-here-1
3 http://www.fashionnstyle.com/articles/26529/20140929/zach-braff-shocked-by-controversial-kickstarter-campaign-backlash-wish-i-was-here-actor-refuses-to-crowdfund-future-movies.htm
4 https://www.kickstarter.com/projects/teamg/worst-enemy-short-film-dir-lake-bell
5 https://www.indiegogo.com/projects/dear-white-people#/
6 https://www.indiegogo.com/projects/a-girl-walks-home-alone-at-night-feature-film
7 http://www.nwffest.com/festival-2017/featured-guest-ana-lily-amirpour

13

A Guy Walks Into a Bar and Asks Everyone to Donate $1,000 to His Crowdfunding Campaign

OK, so we've reviewed a brief history of crowdfunding, the different types of crowdfunding, an overview of how a campaign works, a variety of platforms and how they operate and some success stories. And, hopefully, we've pushed you past your desire to seek out and destroy Zach @$*!@ Braff. Good. We're ready to move on and discuss the ins and outs of running a successful crowdfunding campaign and, more specifically, how you can use crowdsourcing as a means toward significantly increasing your odds of running a successful campaign. For within every crowdfunding campaign, there is an element of crowdsourcing. Make no mistake, there are a ton of other factors that can make or break a campaign. But if you understand who your target audience is, how to create a compelling story around your project and how to deliver that story in an involving way *before* you even think about launching a campaign, you'll only need a sensible plan of execution to see considerable results.

Sounds easy, right? Then why do so many projects fail? By the end of this chapter, I truly believe you'll understand the many reasons why. But to get

things rolling, let's look at one critical mistake which, in reality, is more of a mindset problem than an actual execution issue. Namely . . .

YOU THINK CROWDFUNDING IS ABOUT MONEY WHEN IT'S REALLY ABOUT RELATIONSHIPS

What's that you say, RB? I'm looking to get dough, bones, cheddar, Benjis, clams, lettuce. Perhaps you haven't heard . . . It takes cash to make a movie. If I want a relationship, I'll buy a dog, thank you very much.

My answer? Get on with your bad self. You're clearing the field for those with a proper mindset.

In the early days of crowdfunding, Slava Rubin, the co-founder of Indiegogo, said, "The world is shifting from a world of transactions to a world of relationships." Those words were absolutely true then and ever more so today. Think about it from this perspective: By all accounts, people are busier than ever (or at least many claim to be). We're all chasing that ever-elusive mistress named Free Time. We're sleeping less and working more. We're endlessly and relentlessly tethered to our electronic devices, going so far as to keep our smartphones by our pillow lest we miss an interesting email in the middle of the night. We're being offered and consuming more media than ever before. We haven't seen our closest friends in eons. For the third straight week we forgot to call Mom. In fact, *all* of our relationships are suffering.

We're tired. We're weary. We're distracted. We're seriously considering hitting up that cool electronics trade show in Vegas in an effort to secure a couple of clones.

We wonder how we make it from day to day sometimes.

There's a simple answer.

Because we have interests. We have goals. We're motivated to accomplish and achieve.

Stay with me on this . . . I swear there's a point.

My grandmother had a saying that a woman who married a man strictly for his money "couldn't see past the dollar signs in her eyes." The same could be

said for many people running a crowdfunding campaign. They see the end—the pot of gold at the end of the rainbow—but they haven't mapped out a path or considered the complications and barriers they may face to travel over said rainbow. Even more shortsighted, they haven't even considered the prospect that with proper planning and engagement, they can enlist a crowd so passionate and dedicated that it will carry them on their shoulders up and over that rainbow and to that pot of gold.

Some of the reasons for this shortsightedness were illustrated in the social media chapters and in other sections of this book: Narcissism, hubris, ego, and simply a lack of self-education on how things operate. But the most common issue is that many people running a crowdfunding campaign see potential supporters as simply a means to the end, recognizable only by the number of greenbacks they choose to donate to the campaign. Much like my grandmother's opinion of the woman who marries just for money, the love, if there is any, is conditional.

For someone running a crowdfunding campaign, this line of thinking is a killer mistake. The love should be unconditional and it should be flowing mostly from your side of the computer screen.

Earlier, I said that we all have interests. We all have goals. We're all motivated to accomplish and achieve.

The shortsighted crowdfunding campaigner only recognizes his or her interests, his or her goals for launching a project, and his or her personal motivation to accomplish and achieve should the campaign be funded and the project move forward.

The smart and aware crowdfunding campaigner recognizes that the *supporter* of his or her campaign has interests—interests that have aligned themselves with either the project or the person (or people) campaigning. The smart and aware campaigner recognizes that the supporter is a living, breathing human being with goals, one of which may be to altruistically support projects he or she feels worthy of his or her hard earned dollars. The smart and aware campaigner recognizes that the supporter is a person motivated to accomplish and achieve something—in this case, supporting an artist he or she has connected with on some level. Finally, the smart and aware campaigner recognizes that the supporter has his or her own dreams and aspirations but is taking time away from them to assist those of the campaigner.

In short, the smart and aware crowdfunding campaigner doesn't see the supporter as a fat piggy bank, but as someone to nurture and build a relationship with. He or she realizes that they are indebted to the supporter and will do everything in their power, day in and day out, to not only show appreciation by staying in communication, but by delivering on all promises. He or she realizes that the onus of support *is on them.*

In recognizing all these things, the smart and aware campaigner understands that there is no significant, sustained financial support without significant and sustained relationships.

Got it? Good. Now let's go be smart, aware and run a successful crowdfunding campaign.

PRE-LAUNCH

When speaking on the subject of crowdfunding at various conferences, I always ask the following question: When do you believe a crowdfunding campaign begins? I would estimate that 90% of those who answer state that a campaign begins the second you hit the "Launch" button for your campaign page, effectively making it live for all to see. Many times I'll hear that a campaign doesn't begin until that first dollar is donated. At one recent event, I posed this question and a gruff gentleman barked at me that a campaign "doesn't begin until it ends."

Not wanting to waste the next 59 minutes and 20 seconds of the talk looking for reason within that folksy wisdom, I politely moved on. But if anyone has a clue as to what the hell that means, feel free to hit me up on Stage 32.

The experts in the field, those who run or work for crowdfunding platforms or those who have many successful campaigns under their belts, all have their theories as to when a campaign really starts. John T. Trigonis, Campaign Strategist for Film at Indiegogo and author of the terrific and highly recommended *Crowdfunding for Filmmakers: The Way to a Successful Film Campaign*, says:

> Realistically, I tell people that a crowdfunding campaign begins long before you click the "Launch" button on a campaign and send out your first emails. There are tons of things to consider: Planning out the

campaign, of course, but also strategizing, delegating responsibilities, putting together a calendar and planning ahead on how to handle the inevitable lull every campaign goes through. But really, crowdfunding begins with crowd*finding*, or, in other words, crowdsourcing. For that reason alone, I recommend all my campaigners begin their relationship building and outreach months in advance, spending time on blogs, websites, social media and any other places they've identified as places where working their way into the community will be mutually beneficial. These efforts are intended to prove to those likely to support the project that the campaigner truly sees them as something much more than a dollar sign which, of course, will serve them well once the campaign goes live.

Some sage advice from John. Some of what he speaks we've seen put into practice in the case studies we've highlighted thus far. But for the purposes of this section, let's focus on one point: John suggests starting a campaign months before hitting the "Launch" button. He's certainly not in the minority on that notion. In doing my research for this book, I never had one person who has either worked for a social media platform or has run a successful campaign state that a pre-campaign should last less than two months before actually going live.

It might not surprise you to learn that I have my own opinion on this subject and, well, since it's my book, I'm gonna express it.

A crowdfunding campaign begins three to six months before you hit the "Launch" button. Here's why:

1 Running a Crowdfunding Campaign Is a Full Time Job

I know it's numbered and in bold type, but I'll repeat it again anyway. *Running a crowdfunding campaign is a full time job.*

Don't want to take my word for it? Timon Birkhofer, producer of the first documentary ever on the crowdfunding revolution, *Capital C*, which itself was crowdfunded successfully to the tune of $84,298, has this to say on the subject:

> In doing our research for the film, we explored a wide number and variety of campaigns. There were common mistakes, but the number one reason for a campaign's failure was simply that the people running the campaign

would launch the project on a random crowdfunding platform (without much, if any, research) and then lean back and wait for the money to magically appear. This will not happen, not at all. Crowdfunding is full time work, a job in and about itself. It should be treated with the same respect and sincerity as you would treat any other way of raising funds.

Pre-launch campaign research

Your pre-launch campaign is going to require a ton of research. What campaigns similar to yours have worked? What innovative perks did they offer? What media did they present to their followers? How often did they post? Is there contact information for those who have run certain successful campaigns available so you can discuss what went right and wrong during their campaign? These questions and many more will need to be researched and answered to your satisfaction before moving forward.

Additionally, there will be researching efforts regarding the crowdsourcing aspect of the campaign. Who is your audience? Where are they located? Are there bloggers or journalists working in the space? Are there entities and/or organizations (online and offline) that might have a common interest regarding the subject matter of your project you can reach out to? What social media platforms do you need to be on to reach them? Are you familiar with how these networks operate, or will there be research involved here as well?

Have this all under control? Ready to get a couple of hours of rest? Fugghedaboutit! You haven't even begun to think about what media you're going to produce to entice and attract your potential supporters. Is it going to be photos? Video files? Audio files? How many? How often are you going to post?

But wait, there's more . . . There will be posts and comments from your supporters to answer and address—a constant stream of information to be provided for a hungry, motivated and passionate crowd. Remember, the internet doesn't sleep! The doors are open 24–7. And, wait, is that someone bashing you, your talents and your project? He or she needs to be dealt with, too.

Hey, stay awake. You still need to set perks. Giving away various promotional products with the movie logo? Gotta get those designed and printed. And wait a second, are those your only perks? You better brew yourself another cup of coffee. It's time to dig down and get more creative and innovative.

What's that you say? I'm sorry, you sound dazed. It's a lot of work for one person? Very true. Listen, filmmaking is hard work. So is running a

crowdfunding campaign. Filmmaking is also a collaborative process. So is (or certainly should be) running a crowdfunding campaign. To that end . . .

2 You Need a Team

If you do your research on successful film crowdfunding campaign, no matter what the subject matter, whether it's a short, a documentary or a feature, there is almost always one common denominator: The campaign was run by an organized team who rotated responsibilities. Even only a two person team cuts the workload and time responsibility in half. Imagine if you could find four people to buy in? Six? Ten?

Building a team should be fun and exciting. It should create a bigger groundswell for what you're doing and enhance the crowdsourcing aspect of the campaign simply by virtue of having more voices singing the sweet tune of the project reaching a greater potential audience in the process. But remember, the bigger the team, the more organization that's required. You don't necessarily want too many "voices" on the actual campaign page posting and commenting. In the instance of having too many people, split up the responsibilities. On an eight person team, for example, maybe two people handle the communication on the actual campaign page, two handle the social media outreach, two people handle the bloggers and reporters and two people handle the producing of all media to be shared with potential supporters. But the key word is "communication." Make sure, no matter how the responsibilities are divvied up, that the team still communicates on a daily basis. A crowdfunding campaign is a living, breathing thing with ebbs and flows and a personality unto itself. That means the entire team needs to talk to one another and stay flexible if a change in strategy is needed midstream.

A team united for the common good of the project will bring to your campaign energy and a diversity of ideas. It will almost guarantee that things never get stale. But remember, a poorly picked team can cause dissension and sabotage the campaign from within. Choose your campaign brethren wisely.

3 Building an Audience Takes Time *and* Can *Evolve* Over Time

As we've discussed a few times in this book, the "Build it and they will come" crowdfunding strategy rarely, if ever, is successful. And as you've seen in the various case studies which had a crowdfunding component throughout this book, building an audience was paramount to not only the success of the

campaign, but to the overall success of the project upon being distributed. But building an audience, one which is fully engaged and compelled to act on behalf of either you or the subject/mission of the project (or both), takes a huge investment of time and creativity.

Significant social media followings do not happen overnight (unless you purchase followers/likes, which we've already identified as an "empty calorie" approach). Researching and identifying bloggers, journalists, organizations and the like which can help your cause takes time. And, once you've identified them, contacting, communicating and convincing them to take the journey with you (or not) can take weeks or months. Crowdsourcing is more about groundswell than viral. And a groundswell happens over time.

Further still, you may discover as you move along that your targets shift ever so slightly either based on audience response or due to new elements within the project—script changes, new locales and the like. Or you may find yourself targeting a new audience entirely. These discoveries can be as easily made in the pre-launch campaign as they might be during the campaign or post-campaign initiatives.

Award winning director, producer and media strategist Jon Reiss (who you might also remember from being on my crowdsourcing panel at AFM) says:

> I think it's obviously very helpful to have a sense of your audience at inception. But I also think that often there are many underserved niche communities that filmmakers who want to get a jump on having a successfully engaged project before moving forward should consider. This requires drilling down a bit more. For projects that are not targeted to a specific niche, often a filmmaker will discover that their knowledge and conception of their audience might change over time and they should embrace this need to be flexible. Filmmakers should be open to discovering more audiences and getting specific about their audience as the process of the film evolves. This even and, in certain instances, especially includes after they start to screen the project in various stages.
>
> I would caution filmmakers against starting engagement if they have not thought through how they are going to sustain that engagement through the end of distribution. I would recommend starting when you are sure you will be able to sustain that engagement.

So you see, it's vitally important that you build in the time to truly identify as many audiences as possible, plan how you are going to approach these audiences so that they will remain engaged for the long term, and have a collective team mindset of flexibility and open-mindedness.

We've talked many, many times already about finding ways to set yourself apart from the competition and rise above the noise. Allowing yourself a three to six month window to plan, perfect and execute a pre-launch strategy will give you an enormous advantage, I promise you.

SETTING UP AND RUNNING THE CAMPAIGN

So you've done your research on all of the above and are now ready to move forward in the planning of the campaign. Here are a few things you should pay special attention to:

Message/Mission of the Project

This is your chance to explain to the world what the project is about. It's not the time to tell people how awesome you are or how your aunt said you were destined to be a filmmaker when you were 4. No, no, no. This is a time to be humble, gracious and descriptive. Remember, this is about relationships, not money, right? Make your opening relatable on a human level. Let the person reading your message/mission feel the emotion of the person who wrote the words, as opposed to just seeing a block of black text against a white background.

Remember, you are trying to create an all-important positive first impression for the campaign. Be conversational, informative and inviting. The tone should either match your personality or, if clearly defined, the personality of the project. Don't be afraid to be humorous, self-deprecating, fun, serious, wild or adventurous—whatever it takes to get the point of your message/mission across in a clear, concise manner.

Leave hubris, ego and any other chest-pounding behavior at the door. You are asking people to not only support you, but to take the journey with you. Make it about "us," not about "me." Be inviting and, wherever and whenever possible, inclusive.

A Personal Statement (If Applicable)

Yeah, I know. I just said not to make it about you. I'm sticking by it. But what I am telling you is that it's OK to let people understand your (or the team's) connection to the project and why it's important to you to have the opportunity to tell this story. If your pre-launch plan has been executed as well as possible, you will have cultivated a like-minded and interested audience. If you deliver your personal statement in a selfless, relatable fashion, your relationship with the people who have followed you this far can only grow.

Perks

Let's forget about the t-shirts, hats, key chains, buttons and other chotskies for a second. Based on everything we've discussed so far in this book, what do you suppose is the greatest reward you can give your backers? I'll give you a hint—it's not material. Give up?

It's you.

It's the personal, special connection you make with your supporters.

It's the relationship.

That simple.

Sure, there are some people who may go from nay to yay because you're offering a simply too-cool-for-school perk. But a majority of your backers are going to jump into the fray with you because of who you are and/or the message of the project. Most likely both. Still, this is not a license to be boring. Your perks should be as well thought out and creative as the rest of your campaign. Everyone offers t-shirts. Hell, you can put this book down right now, head down to the local auto-mall and come back with ten of them. Let me take this one step further . . . When was the last time you felt a connection to a t-shirt handed to you at a convention (not your lucky t-shirt, heaven forbid), game or film promotion? How about a key chain? Or a button?

Let's go a little more *real world*. What's the difference between buying an autographed book from your favorite author on eBay and meeting your favorite author face-to-face and having him sign and personalize a note to you? The connection. The interaction. The opportunity to express gratitude.

This philosophy applies to your perks. Want to offer DVDs of the movie for a $25 donation? Make sure every single one is signed and personalized by you and other cast and crew. Looking to solicit higher dollar amounts? How about 15 minute Skype sessions with the cast and crew member of the supporter's choice? Naming a character after a backer? A role as an extra? A speaking role?

Be creative. Be inclusive. Be authentic.

And whatever you do, don't attempt to fleece your potential contributors. I saw one campaign recently which was offering a "perk" of a $10 Amazon gift certificate for a $50 contribution. Needless to say, they weren't within a million miles of their goal with only days remaining.

Spelling and Grammar

Let's pause right here. You've now planned and written out the message/mission of the project, a personal statement and all the language associated with the perks. Give them another very close read. Then give it another. Then pass it on to each and every member of the team. Then pass it on to one or two people not associated with the project or the campaign crew. Does everything make sense? Is everything spelled correctly? Is the grammar tight?

Now, I know what you're thinking . . . I'm a filmmaker, not an English Lit major. The mission, your humble nature, the perks and, of course, your talents will win the day and override any spelling or grammar errors.

Not so.

Remember, we're trying to rise above the noise here. Any mistake, big or small, is a distraction. And with so much competition, the last thing you want is any visitor to your page to be distracted and move on.

Says Timon,

> You *must* take your time refining, tightening and polishing your campaign page *before* you launch it. You would be amazed at how many people put up a sloppy, error filled page. Chances are that people will only click on your campaign once, and if you can't convince them right away, they will leave the page and do something else. So eliminate

typos, make sure your grammar and syntax are on point and that all your social media links lead to where they are intended to go.

Setting Your Goal

Another factor that can sink your campaign before it starts is setting an unrealistic goal. Like many factors with a crowdfunding campaign, there's a psychological aspect to not only setting a goal, but how that goal will be perceived by others. Set a goal too low and your potential backers may view you as someone who is unable to budget correctly and, fairly or not, incapable of seeing the project through to the finish line. Set it too high and your potential backers may feel as if you are trying to take advantage of them or, even worse, that you might be looking to line your pockets as opposed to putting the funds toward the project.

Our friend John from Indiegogo says:

> The biggest mistake campaigners make is setting too high a goal. Most people think they can raise a million dollars, but what they don't realize is that it's hard enough raising twenty thousand. Crowdfunding is one part psychology and one part physics. You need to be realistic in your goals or people will see right through.

Let's let that sink in for a second. If crowdfunding is one part psychology and one part physics (we've previously called it momentum), then it only stands to reason that the physics part can't kick in if your potential contributors don't buy into the psychology. So in theory, if it's apparent to your potential contributors that you've set your goal entirely too high, you have already stunted your momentum. You have sent the signal that the campaign is doomed to failure and have effectively sent your audience off to find something worthy of their interests and hard earned dollars.

So, before you set your goal be sure you have gone through the project with a fine tooth comb. Do you need every character or can some be combined or eliminated all together? Ask the same questions about locations and crew. Then ask yourself what period of the project you are looking to cover. Are you looking to raise enough money for all aspects of the project's life or just some? Is this a development to production to post-production to film festival submission to distribution raise? Or are you just looking for money to get you through the shoot and planning another raise for post and distribution later?

No matter how you answer these questions, nothing matters more than complete honesty. Pomposity and pretentiousness need to be checked at the door. If the film in question is a short or even a full-length feature with a small cast and crew to be shot at only a few locations, you and your team should be able to figure this out on your own. But for more complex shoots, a line producer should be employed. However, and this can't be overstated, without a realistic worldview as to the overall budget of your film, you are putting yourself in peril before you ask for dollar one.

Once you've figured out your budget, here are some other costs to consider:

▶ Building a website

▶ Costs associated with producing/shipping your perks (including packaging materials and adding shipping costs for international supporters)

▶ Crowdfunding platform fees

▶ Costs for producers, editors, designers to create media for distribution during the campaign (if applicable)

▶ Marketing or advertising costs (if applicable)

~~At this point, you should have a fairly solid number in mind as to what you feel you'll need to raise. Ask yourself again: Am I being honest with myself? Is this number too high? Can I find more cuts? Am I being too precious about the material?~~

And perhaps the biggest question of them all: Do I have the support to raise this amount?

How do you know, you ask? Well, there's one solid way to find out.

Outreach to Friends and Family

Your first line of defense, or perhaps better put, offense, when gauging whether you have overshot on your prospective goal is by polling friends and family. What's that you say? Of course your friends and family are going to support whatever you do. Well, that may be the case, but that's not the question at hand. The question isn't whether they will support you;

it's how much are they willing to contribute to the campaign in support of you.

Let's back up a second. We've discussed how psychology plays a huge part in the momentum of a crowdfunding campaign. And, in some of the previous case studies, we've proven that meticulously planning when certain targets are contacted in regard to donating to a project can give your campaign the perception of constant interest. What we haven't discussed is the absolute fact that the first seven days of your campaign are without question the most important seven days of your entire campaign.

There have been numerous studies speaking to the importance of the first week of a crowdfunding campaign. It's been well documented that campaigns that reach 15% of their goal in the first week have approximately an 82% chance of success. Raise that initial week number to 30% of the raise and the success rate soars to 98%. This is just one more reason why a pre-campaign strategy is a must. It's also the reason why I refer to the first week of a crowdfunding campaign as Friends and Family Week.

Let's say you've looked over all the facets of your project: Number of locations, availability of talent, total shooting days, crew costs, post-production expenses, film festival submission fees, etc. You've been realistic and honest with yourself and, if applicable, your partners. You have come to the conclusion that your raise is going to be $30,000 all in.

Terrific. You now have a starting point from which to launch. Not your actual campaign, mind you, but the part of your pre-campaign where you approach your friends and family to see if you can raise $9,000. Why $9,000, you ask? Well, in the previous paragraph, I stated that studies have shown that if you can raise 30% of your total raise in the first week, your success rate is 98%. 30% of $30,000 is $9,000. So there's your goal within a goal.

This is where the psychology comes into play. For the last many (at least three to six) months, you've already begun crowdsourcing on social media, to bloggers and through offline efforts. You have already identified and engaged these people. They're fans. They're supporters of the project in every way except with their wallets. You've won their respect. Now you have to prove you can deliver. The best way to show you can deliver is to present momentum, or what Mr. Trigonis called "physics."

Says John,

> The physics is about getting a very solid start between days one and seven. Doing so will build up the proper momentum the campaign will need to sustain itself through however long the campaign runs. This is why the host committee, a base core of contributors which usually consists of family and friends who are ready to contribute on day one of the campaign is so important to help seed the campaign. At this point, psychology comes into play. Not only have you proven to the potential supporters you've recruited during the pre-campaign that the project has momentum, but random people who simply are browsing your chosen crowdfunding platform for support will also see the project as "hot." People love to be associated with a project that has serious momentum. That psychology will trump that generated by even the most amazing perks.

At this point I'd like to pause while you underline, carve into your workstation or prick your finger and write in blood the word "psychology." Done? Good. Because guess what? As it relates to the first seven days, or the Friends and Family week, there's a psychology within the psychology. I'll pause while you shake your book or Kindle violently and mutter unprintable things about me. It's OK. I've heard them all before. I can take it. I feel confident I can turn you in my favor.

Let's go back to our $30,000 raise and, more specifically, the $9,000 goal within the goal (our first week goal) we determined you needed to give yourself somewhere around a 98% chance of reaching your goal. You've made your calls, sent emails to long lost acquaintances and watched the Food Channel for a week so you could invite your immediate family members to charm them for a somewhat edible meal. (Helpful hint: You can overcome any culinary inadequacies with copious amounts of Barolo.) You have determined that you have enough support to raise the $9,000 in question. Fantastic. But your work is not done.

Why? Say it with me. Psychology.

What you do not want to have happen is for all your friends and family supporters to donate on day one. While it may seem impressive on the surface that $9,000 in pledges appear on the campaign page hours after launch, it also might appear a bit shady. For those with a higher threshold for cynicism in

Ask John about this

your realm, their threshold will surely be breached when they see your dona-
tions go from $9,000 on day one to next to nil for days two through seven.

In addition to thanking your friends and family profusely and shamelessly
for supporting your vision and dream, you must assign them a day and time
to donate. This can be done with an email (and a gentle reminder email if
necessary) specifying the time you would prefer them to go through with
the transaction.

What you're looking to do here is create the impression of constant traction
and momentum. There *is* going to be a lull at some point in the campaign. It's
inevitable. When it happens mid-campaign it's something that, if all else has
been executed correctly, can be overcome. But when it happens in the first
seven days, it's almost always insurmountable. By day seven you want to give the
impression that the campaign is not only going to hit its goal, but fly through it.

Now, not everyone who promises to donate is going to follow through and
some may miss their assigned days entirely. That's OK. My advice is to make
sure that those you can depend upon most are assigned days one, six and
seven. Here's my reasoning:

By firing out of the starting blocks on day one, you're sending the message
that you've built up a wealth of support for the campaign and that there were
supporters simply waiting for the lights to be turned on. This is a great first
impression. For those who have supported a crowdfunding campaign before,
they will recognize the instant backing as a sign of a competent team and a
project with heat. For those who haven't supported a crowdfunding cam-
paign before, they'll be drawn to a project that is getting immediate attention.

Days six and seven represent a huge psychological milestone as well. Your
campaign has been live just about a week. There is already the impression
that your most ardent fans were waiting at the ready for the campaign to
go live so they could offer their support. But there will inevitably be those
sitting by the sideline to see if you (and your team) can sustain the action.
In short, does this campaign have legs? Is this project worthy of my cash?

Showing an uptick at the end of week one will quell a ton of doubt.

But there's another reason why days six and seven are vitally important.
You have spent months cultivating relationships online with like-minded

individuals, people who relate to the material, bloggers, journalists and those you believed would support the cause. You've done the same with your offline efforts.

You've identified.

You've engaged.

Now it's time to ask them to move. And that happens leading into week two.

Crowd Outreach

Actually, the outreach to your crowd, asking them to move happens before week two . . . partially. Let me explain.

From day one, your intention on cultivating these relationships was to at some point go for the "Ask" of supporting your campaign either by spreading the word, donating to the project or both. However, the initial support, if you have created an inviting and engaging environment, should be organic. You shouldn't have to ask. If you've connected with your intended audience, people should be sharing your content and communicating with others that you are someone they need to have in their orbit. As we've discussed earlier, there are plenty of metrics which will serve as indicators of your success, be it a greater social media following or simply a growing contact list.

Now you find yourself in a position where you have seemingly executed on all levels. You've built your team, you have content to carry you through the campaign, you've checked your ego at the door, your perks are attractive, you've been honest about how much you need for the raise and you've determined that your family and friend support is such that it will carry you through the first seven days looking strong.

Now it's time to set a launch date. Now it's time to go in for the "Ask."

What you are asking for is support in the way of spreading the word of the campaign, donating to the campaign or both.

If you've executed on all levels, or even most, the crowd will move for you with pleasure.

Now let's come back around to my week two comment at the end of the last section. You have your dependable family and friend supporters submitting their contributions on days one, six and seven. You have created the appearance of momentum. Inevitably, you will be in contact with those from your crowd who are looking to support the campaign. These usually have been your most ardent fans since the beginning. Assign them a day as well. Ask them to begin donating on day eight and carry through to day fourteen. Keep that momentum going.

Clearly I'm not saying you can control all contributors. And, frankly, any money on any day is welcomed. But, if you can control some of the flow, you can control the psychology and you can find yourself heading into week three in terrific shape. At that point you can circle back to those who seemed on the fence, perhaps ask a blogger or two to push a little harder on your behalf, or utilize the uniqueness of those in your crowd in unique ways. When you have momentum, the possibilities open up. Everyone wants to be a part. When you don't have momentum, the crowd thins out.

Again, you've spent months growing the crowd, soliciting support, engaging, supporting. Outside of the day you hit your goal, moving the crowd will be the most satisfying moments of the campaign. Feel the wind at your back, turn your face to the sun and enjoy the ride.

THE CAMPAIGN IS LIVE!

Congratulations! The campaign is now a living, breathing thing. And because you've followed everything laid out in this book thus far, you're off to a stellar start. Time to just sit back and watch the money roll in, right?

Wrong. Time to work harder than ever.

But RB, you just said to feel the wind at my back and turn my face to the sun!

I wanted to give you a moment.

Moment over.

As I mentioned above, the campaign is now a living, breathing thing. That means it has to be fed, watered and nurtured. It needs constant attention. There can be no lapses.

As your campaign gains momentum, the need to pay attention and supply information to your supporters becomes greater than ever. Their thirst for information, progress updates and to be engaged will rise proportionately in relation to how close you are to your goal. The more it looks like the project will become a reality, the more they want to feel rewarded for backing you.

You're already armed yourself with an arsenal of videos and other content to be presented during the campaign. You have your team in place with their assigned days to respond to comments and queries on the campaign page.

Give them more. Give them you.

Be out there. Be present. Ask more questions. Be even *more* engaging.

Says Timon,

> A lot of people are not only supporting crowdfunding campaigns in order to receive a product at the end, but to become part of the creative process, of something that goes beyond money. By engaging an audience that already voted with their wallets, you are giving them another opportunity to get involved. And to be honest, not a single person on this planet, and certainly not everyone on your team, can know everything. So why not query and listen to the people who are most passionate about your project? Even once you started the campaign, the opportunities remain endless. You could ask them to submit ideas for the movie poster or the official film t-shirt, for example. No matter what you ask, however, you need to be extremely specific about what you are asking from the crowd. If you ask open questions, you will not only cause confusion, but will also get a variety of answers which will then take a huge amount of time and resources to sort through. Asking precise questions will give you the results you want and can either carry the momentum of a surging campaign or rejuvenate one that has hit a wall.

In short, don't sleep on your audience. Give them a reason to feel enthused and in the mix at all times. If the project appears as if it has the momentum, begin talking about it as if you've already hit the goal. Talk about plans for the film. Share ideas you have for the shoot. Discuss your vision. I don't think at this point in the book I need to remind you that you should be doing this minus ego and from an angle of communication and solicitation rather that pontification. Then again, I just reminded you.

Remember, you're still trying to win new supporters throughout the campaign. Further still, you want those who are already supporting you to sing about the merits of your project and campaign even louder. But there's another strategy at play as well.

Up until this point, although your personality has assuredly helped you form these terrific relationships that have led to you getting this far, the emphasis has been on the project. And that's OK. But as you get closer to the finish line you should unleash your personality, talent and vision that much more. The ultimate proving ground will be your film delivering on the promises you set forth in the cultivating and campaigning. But until then, inspire confidence that your supporters have backed the right horse.

YOU DID IT!

OK, so I have one more reason that I want you to make sure your personality shines through, but I wanted to save it for this section. But first, cheers paisan or paisana, you've executed tremendously and have run a successful campaign. You should be enormously proud! You have inspired a crowd of complete strangers (excluding your friends and family) to support you in the pursuit of your dreams. If that doesn't put your faith in mankind and inspire the living hell out of you to create the best film possible, nothing will.

You've thanked everyone who donated personally, either by email (where possible) or through the campaign page. You've sent out or provided information on delivery of your perks in a timely fashion. You've waved and saluted to the crowd like Charles Lindbergh before hopping into the *Spirit of St. Louis* before heading off to France. It's time to leave the crowd behind and go make that film of yours. You'll touch base with everyone in a year when the film is ready to be distributed, playing at Film Festival X or available online, right?

Wrong.

Your work here is not done.

Nobody likes to feel abandoned. No one likes to feel taken advantage of. No one wants to feel loved and left. Further still, we live in a time where the amount of media vying for our attention has never been greater.

So remember this:

Ignore the crowd, lose the crowd.

Your supporters are going to understand that you have a film to shoot. They're going to understand that you and your team might not be able to provide as many updates a day, or even every few days, as you were during the campaign. But, in a world of camera phones, apps and instantly postable (perhaps not a word, but one that will now become vogue) videos, they won't be understanding if you go dark for long.

Photos from on set, rehearsals, the cast getting made up, the crew setting the scene. Quick videos of the cast and crew speaking to why the project is important to them, of you providing status updates or any other behind the scenes peeks. Any and all of these, or just about anything in type, takes only a few seconds to execute, but can create months or years in good will.

Which brings me back to you upping the exposure of your personality and vision as the campaign gains steam. When you launch a crowdfunding campaign for the first time, you are an unknown entity to the crowd. You will be engaging them more on the merits of the project—the subject matter, the cause, the purpose—than you likely will be on your own merits, unless you are a known personality or famous in some way. So, yes, while you will be getting them to buy in on you as an expert, a provider of quality content, a communicator and so on, you will initially be seeking out people who connect to the material. In theory, you are initially cultivating a crowd of supporters for their connection to the content first and to you second.

Now here's the cool part. If you execute, if you stay connected, if you deliver on your promises, that order will reverse itself. The crowd will follow you wherever you go *regardless of the content*. The audience doesn't just become a fan of the project, they become a fan of you. And that is infinitely more powerful.

Says Jon Reiss,

> I think it's vitally important for filmmakers to stop thinking in a project to project mode, but to see themselves as an artist who will continually engage with their audiences, depending their relationship to those audiences, with the goal of bringing those audiences with them throughout their career.

I have a friend who is a filmmaker. If I gave you his real name, he'd assassinate me simply because he's a humble guy and likes to gain notoriety on his own accord. So, let's call him Frankie because I have some Sinatra playing in the background while I'm typing this.

Frankie decided that he wanted to make a short. A very smart guy, a voracious consumer of content, a believer in self-education, Frankie admittedly had struggles in live social settings. He wasn't terrific at initiating a conversation, but if you got him into the flow, his natural penchant for engagement and storytelling shined through. People hung on his every word and were simply blown away by his breadth of knowledge. Plus, they loved his inclusive and inquisitive nature. He didn't talk *at* people, he talked *with* people.

Frankie decided that one way to break himself out of his shell was to become active on social media. He targeted people with similar interests: Film, directing, cinematography, producing, to name a few. He wrote his own blogs, shared content that interested him and was gracious to his followers and commenters by promoting their work and just making sure that all correspondence received a response. Over time, Frankie had developed a nice following and his confidence in communicating with people online continued to grow. Slowly but surely, this confidence began to seep into his offline life as well. He began taking his networking to the streets. He formed a filmmaking group, a reading group and a film discussion group.

So when the urge hit Frankie to finally step behind the camera, he had confidence that he would be able to identify and reach multiple target groups he believed would be interested in the film. At this point, due to his enormously positive results on social media, Frankie had become such a true believer in the power of community he decided to forego the idea of a traditional financing raise and try crowdfunding.

Now this was in the very early days of film crowdfunding. The knowledge base and the pool of available supporters then was nothing like it is today. But Frankie had faith. And he had vision. Although he already had a small following of disciples who liked him, he knew he was an unproven commodity as a filmmaker. So he took the emphasis off him and on the subject matter of the film itself. What that subject matter was is inconsequential to the story. The point is Frankie knew there were multiple audiences who would

be attracted to the subject matter and he believed he could not only reach them, but could engage and solicit their support.

Frankie set a budget of $7,000, which was a fairly high goal in those early days of crowdfunding, especially for a short that also didn't have the myriad of distribution choices available to short filmmakers today. But again, Frankie believed he could deliver both the message of the movie and what he planned to do with the film once it was completed.

Ultimately, Frankie raised over $13,000. Nearly double the goal. More importantly, he delivered on every promise. The perks were delivered in a timely fashion. Updates came daily, sometimes twice, three times a day. And when the film was completed, it was such a solid effort, it not only gained entry to numerous festivals and found a home on multiple distribution channels online, but bloggers and other film related site owners asked if they could show the film as well.

Frankie went to work on his next short film. This one was to be a bit more ambitious. The raise was to be $20,000. On the first short, Frankie used the friends and family approach for week one. With this film, Frankie again turned to friends and family, but he also turned to those who supported him the first time around. The feedback was overwhelming. Many wrote back and said that they didn't care about the content, they just wanted to support him, the filmmaker, the communicator, the guy who delivers on his promises. They had first become fans of the film. They now were fans of *him*.

So now, with his friends and family and a legion of supporters in pocket, Frankie was able to crowdsource the audience he believed would be a fit for this short. It took him five days to reach his $20,000 goal. At the end, he cleared over $50,000 and was able to make the film look like a million.

Since then Frankie has secured the raise for two other films through crowdfunding. One was a $75,000 feature film raise. He hit the goal on that one in 13 days. His latest is a $150,000 feature. That one hit the set target in 17 days.

Frankie was able to turn a small group of people who believed in the content and mission of his first short into a legion of supporters and fans who would follow him into fire. That's true power. That's building a career. And all of it is in your control.

The moral? Win every single day, but never lose sight of tomorrow.

OH NO! YOU DIDN'T DO IT!

So you followed all the steps outlined throughout this book and, in particular, this chapter, and you still didn't hit your goal. That's OK. It's not about the fall, but how we get up, right? Now is not the time to curse the darkness. To the contrary, it's time to light a candle. It's time to evaluate where things might have gone awry. Let's go through the checklist below and see if we can discover the issue.

1 Social Currency (Online)

Look back at the history of your social media campaign. Did you spend enough time cultivating the relationships that could have led to a stronger response? Did you gain a significant amount of followers, likes and new people into your network or social circle? Were people truly engaged by you, your voice and the message of your mission? Could your posts and other communications been massaged to be less spammy? Did you ask questions? Was the content you disseminated responded to and shared?

The evaluation of your social media strategy should be meticulous and brutal. Do a complete autopsy and be absolutely truthful with yourself.

1a Social Currency (Offline)

Did you effectively connect and stay connected with the people, groups, organizations and companies you targeted offline? Did you give them the same attention you gave your online supporters? Many times it's easy to get wrapped up in the instant response gratification that comes with running an online campaign. As a result, it's not uncommon for the people and groups that you targeted and connected with offline to get short shrift in the communication outreach during the campaign. Review your calendar and call logs and see if too much time had passed between contacting and updating.

2 Your Team

Did you stay consistently and effectively connected to your supporters? Did everyone contribute in an equal manner? Did everyone meet their assignments and produce the information and materials to keep your supporters truly engaged? Did the team stay in constant communication and remain flexible to combat the various swings of momentum and tenor changes

which occurred during the course of the campaign? If so, did they make those adjustments in a timely fashion?

Go back through the schedule and see who was responsible for what and see if there is any correlation between effort (or lack thereof) and when the campaign took a bad turn. Perhaps someone either didn't carry their weight or was placed in a position for which they were not qualified.

3 Your Content

Were your updates truly engaging or were they mostly static broadcast messages? Was the media you provided compelling or simply mailed in? Did you truly make every effort to keep things fresh? Did you re ive the response you anticipated and, if not, did you adjust?

Many crowdfunding campaigns drop the ball when it c s to their media updates. Review everything you posted and shared an e honest in your assessment whether it hit the intended target.

4 Your Campaign Page

Was your campaign video well thought out, concise and welcoming? Was the messaging inclusive? Was the mission and vision of the film clear? Did you give people a reason to come back by communicating and keeping things updated?

Can you assess truthfully whether you would have donated to the campaign yourself?

5 Your Perks

Were most of your donations leveraged toward one tier group due to the perk that was offered? Did you stay on top of your perks throughout the campaign to make sure you didn't have any "dead tiers"? When the campaign hit a lull, did you introduce new perks or perhaps make the initial perks more attractive?

6 Your Goal

This last one is perhaps the toughest on this list to evaluate. Obviously, poor execution of any of the above elements could leave you far short of what is

actually a realistic goal for your project. So let's assume that you handled your Friends and Family Week in perfect fashion and your supporters rose to the occasion in week two. If you still fell 25% or more short of your goal, it's very possible that you overshot or at the very least caused a disconnect between what you set as a goal and what was projected through the messaging of your campaign page.

If you fell more than 25% short of your goal, it may certainly be a sign of setting the bar too high. But, assuming that you handled those first couple of weeks correctly, it's more likely that you have some holes which will be uncovered by running through the checklist above and by evaluating the psychology and momentum of the campaign. Where did things slow down? Where was the disconnect? Did you crash on takeoff or did something happen to the engine of the campaign during flight?

Remember, not every campaign is successful the first time around. But that doesn't mean you can't launch again and in fairly quick fashion. If you've handled yourself with integrity, if you are forthright with your supporters and if you reveal why you feel the campaign fell short and prove that you have figured out how to adjust, you'll be amazed how many will line up alongside you again. Communication humility and transparency go a long way.

BRINGING IT ALL HOME

Although most platforms are reluctant to give up failure statistics, I read a report recently that estimated that 57% of film campaigns fail. Discouraged? Don't be. Here's two examples why.

Recently, on Twitter, I was tweeted at (very purposefully selected word) by a woman who demanded I take a look at her crowdfunding campaign. I did some quick investigating and uncovered the following:

▶ She had just joined Twitter that morning.

▶ This was her first contact with me.

▶ She hadn't bothered to follow me.

▶ She had launched her campaign an hour earlier.

▶ She had raised zero dollars.

▶ She was only tweeting to users with a high follower count.

▶ She was spamming those accounts with the same static message.

▶ She had followed the maximum amount of followers Twitter allows in a day.

We've talked about never getting a second chance at a first impression. But how about making nine bad first impressions with one tweet?

A staggering accomplishment, no? Unfortunately, the Guinness Book of World Records has yet to recognize such feats of social media futility. We can only hope that one day we live in such a world.

As I dug further, I noticed that she did manage to get 51 followers from those with an "automatic follow back" policy, but none of the people who she had spammed bothered to respond. I was inclined to just block her and move on. Instead, I posted the following string of tweets directly to her:

> Tweet 1: "Hi there. Social media is about cultivating relationships and not spamming. Also, it's always better to ask than demand"

> Tweet 2: "Also, with so much competition, you will not get a crowdfunding campaign funded by having only 50 followers and spamming strangers"

> Tweet 3: "If I could help, please read this article: (link)"

The link was to a popular article I had written on Medium titled *5 Ways You Are Using Twitter Incorrectly to Promote Your Crowdfunding Campaign*. If you're interested, you can read it here: https://medium.com/@Stage32online/5-ways-you-are-using-twitter-incorrectly-to-promote-your-films-crowdfunding-campaign-246e4a84c137

Her response after receiving all this information?

"Not if they're the right 50 followers."

I was tempted to tell her that if she had the *right* 50 followers she wouldn't need a crowdfunding campaign or to spam strangers, she could just raise the financing privately.

But I digress.

Let's move on to the second example.

I received another tweet a day before writing this chapter that read:

"Hey @RBwalksintoabar HELP MY CAMPAIGN. Only hours left! Need your help!"

Again, this wasn't a follower of mine nor anyone who I had crossed paths with previously. Still, curious as to how close this person was to crossing the finish line on said campaign, I clicked through. First I saw the goal—$78,000. Then I saw the time remaining—1 hour, 23 minutes. Then I saw the amount raised thus far—$783.

So I cut him a check for $77,217.

I'm joking, of course.

Having read these two chapters on crowdfunding and, in a broader sense, the information in this book so far, would you agree that you now have a much better chance at running a successful crowdfunding campaign than the two people I outlined above?

That was a rhetorical question.

So back to the 57% failure statistic and statistics in general.

> Life is not just a series of calculations and a sum total of statistics. It's about experience, it's about participation, it is something more complex and more interesting than what is obvious.
>
> **—Daniel Libeskind**

> Statistics are no substitute for judgment.
>
> **—Henry Clay**

Statistics are used much like a drunk uses a lamppost; for support, not illumination

—**Vin Scully**

Don't get caught up in the noise. Don't get rattled by the din. Don't be fooled by the sheer amount of competition. And don't worry about the statistics. Knowledge and execution will provide you with the only statistic that matters—your singular success.

Go forth.

14

Case Study #3

Mile ... Mile & a Half

In the two case studies presented thus far, we reviewed and dissected film crowdsourcing efforts related to a narrative short and a narrative feature. But what about the documentary format? Do the same rules apply?

Through the years, I have had many talks with creatives who believe that sourcing a crowd for a documentary feature presents a most difficult, if not impossible, task. The prevailing theory is that audiences for documentaries are smaller than those for narrative features. A smaller pool represents a smaller crowd. And a smaller crowd means less people to move in support.

This is, of course, backward thinking. Remember, ultimately, we're trying to identify, engage and move a crowd of people interested in the *subject* of our film or aspects related to the themes within. Documentaries are often referred to as human-interest stories. This means ... there are humans interested! And that means there are individuals to identify and enlist toward forming a crowd.

In other words, we're not worrying about whether an audience will show for our film because we're *bringing a passionate, supportive and interested audience with us.*

The creatives involved with the hit documentary *Mile . . . Mile and a Half* understood this strategy all too well. They identified their core audience, and through creative and innovative crowdsourcing engaged and moved them with alacrity. But then they discovered they might have just sold themselves a bit short as more people, groups and organizations proved anxious to join their mission and, ultimately, their movement.

I'm going to leave it there, lest I ruin any part of this incredible and inspiring tale.

This is the story of *Mile . . . Mile and a Half.*

ORIGIN STORY

The genesis of *Mile . . . Mile & A Half* came from a group of friends working together in the entertainment industry who collectively aspired (and conspired) to hike California's John Muir Trail, a 211-mile long trail in the Sierra Mountain Range of California stretching from Yosemite Valley to Mount Whitney. A majority of the trail is not accessible by car and those hiking the length of the expanse will pass through some of the most highly regarded and scenic of America's parks including Yosemite, John Muir and Ansel Adams Wildernesses (the trail was one of Adams' favorite places to shoot), Kings Canyon and Sequoia National Parks. Along the way one will experience a variety of peaks—some 13,000 and 14,000 feet high, thousands of lakes and a multitude of canyons and granite cliffs. The ecology along the trail is complex and diverse and, at times, the weather can be quite unpredictable. It's not uncommon to experience snow-covered peaks even in August. Those who have traversed the length of this world famous trail—approximately 1,500 set out to do so each year—describe it as a transformative experience.

As an avid hiker and California native, Jason Fitzpatrick had long dreamed about hiking this trail and capturing the scenery in a High Definition medium (a format that hadn't gained much attention at that time). Unfortunately for him, he couldn't find others enthusiastic about making the journey. Ric & Jen Serena moved to California in 2004 and, soon after, they met Jason. With a mutual love of exercise, the outdoors and photography, the three began backpacking together and began preliminary discussions on the possibility of hiking the trail in its entirety. Over time, they drew the interest and, eventually, the inclusion of other like-minded creative people, including Durand

Trench, Paul Bessenbacher, Zee Hatley, Bernard Chadwick and others. This led to the creation of The Muir Project, which is the collaborative that would eventually go on to create *Mile . . . Mile & A Half.*

Conceptualizing the idea came easily, though following through on the concept proved much more difficult. As the years passed, the group continued talking about hiking the trail in its entirety and bringing their HD cameras (and other high tech equipment) along. Year after year, the team committed to the journey, but every time the plan got rolling, something—be it work, children or prior commitments in one form or another—forced them to put it off. Finally, in 2011, all schedules meshed. The trip and plans to film the journey were a go.

One benefit to the delay was that by 2011, the HD revolution was in full swing. Camera technology had advanced beyond even the filmmakers' expectations. It was now possible to shoot high quality images on a DSLR. This would prove to be a blessing. Because of the camera size, each hiker was able to bring a camera without being bogged down. The downside to having waited so long was that the HD boom was in full swing and the demand for HD content was over-saturated. This tempered the excitement of the team. As they were about to set out on their trek, they couldn't help but wonder what type of creative project they were capturing content for. Realizing the potential of the experience in front of them, they squashed any negative thoughts.

"We set our minds on capturing the experience and whether it ended up being an art exhibit or a short film of scenic beauty we weren't sure. Ultimately, our goal was to complete the trail and enjoy the experience," Fitzpatrick said.

After setting up all their food depots, as well as a weekend test trip to get their gear dialed in, the team set out for their official run of hiking the John Muir Trail on July 10th of 2011.

Said Trench,

> We could go into detail about our actual journey, but it's probably better to just watch the film, as it's a really accurate representation. It was an amazing experience, and in mid-August, after settling back into our daily lives for a few weeks, we began to comb through our footage.

PREPPING THE CROWDSOURCING CAMPAIGN

Not long after they completed the trail and with what the team felt was the most compelling shots from the each hiker's footage, Ric Serena created a two-minute video titled *Almost There*, which was edited to the music of Opus Orange, a Los Angeles based band consisting of friends of the group who donated the song for the cause. Two members from the band, Paul Bessenbacher and Bernard Chadwick, had hiked the last week of the trail with the team and were inspired by the beauty. The team shared this scenic "music video" with friends and family as well as other people they felt might be moved and inspired by the content. There was an immediate and organic viral reaction to the video and a groundswell of support in the form of shares via email, social media and blog posts. In what was a very shrewd and prescient move, the team bookmarked all the bloggers and Facebook companies who shared the video. These first steps represented a crucial moment in the film's eventual success. The team had established an audience, albeit a small and very niche one at this point, but certainly one with which they could share ongoing information and future updates.

Serena said,

> There's no doubt in any of our minds that the initial step of sharing our material with not only people close to us, but people we felt shared a common interest in hiking, health and photography, played a huge overall part in the success of the film.

A few months later, after having reviewed more than 30 hours of extraordinary footage captured during the trek, the team realized they had the makings of a feature length documentary. Along the way they discovered something unexpected; the footage of the actual team members, including their challenges along the hike, their interactions with one another, their feelings and emotions along the way and their reactions to the beauty of the trail, made for interesting and absorbing theater. They all agreed that pivoting away from simply showing the beauty of the ecology and injecting a human factor into the documentary represented the best path to building a broader audience.

"It was somewhat surprising, as the footage of *us* was never really meant to be a part of the project, rather it was more for behind-the-scenes pieces and our own memories," Fitzpatrick said.

While Ric and Jason began putting together the film, Jen began creating all of the visual brand design for the Muir Project as well as taking leadership of creating and launching the project's website. The aesthetic that she created would play a large part in the success of the film. She created professional artwork for the film's posters and other key art (site banners and logos), which added legitimacy to the project. One load of the website's landing page screamed that this was a project of the highest quality. Additionally, since both Ric & Jason came from the promo world, they knew exactly what to cut together to create trailers and featurettes that would draw people in and inspire interest.

With the website in good order and an arsenal of content at their disposal, the team took to social media and chat boards, identifying and then reaching out to a targeted group of bloggers. They also reached out to those bloggers who had helped to spread the viewership of their first video release. The Ask was simple—since they had enjoyed and connected with the earlier material, would they be willing to share the new content and any other updates the team provided? This is a critical part of the tale. Because the team had taken their time in their planning, chose the correct targets and cultivated a relationship with the bloggers on their target list, the reception from their now growing crowd to carrying the message forth and sharing the new content was overwhelmingly positive.

Also around this time, the team formed a partnership with the extremely talented artists at Angry Bear, a full service design agency. Being hikers and outdoorsman themselves, the principals of Angry Bear were so inspired by the mission of the team they volunteered their time to make the website even better. The result was a visually beautiful, informative, media rich and easy to navigate site. Paired with the key art, teaser videos and occasional blogs written by various members of the team, the slickly designed website helped tremendously to connect with the now growing audience and establish the project's credibility.

Now completely certain in their conclusion that there was enough content to release a feature length documentary, the team collectively decided to send the project to an outside editor who could give an unbiased look at the project. In early 2012, editor Edward Chin was working on cutting the film in New York, when the team realized they couldn't afford to finance the entire film themselves. While they were fortunate enough to have Osprey Packs, a company specializing in outdoor gear and accessories, express interest in sponsoring

the product after the initial viral success of the *Almost There* video, even their lowest budget estimates were far more than they had raised through the sponsorship route. The team felt strongly that everyone who worked on the film (specifically those who didn't get to experience the joy of the hike—the editor, colorist, musical engineers, sound editors and mixers, illustrators, motion graphics artists and others) needed to be paid appropriately. Additionally, there were other expenses looming in regard to preparing the film for release, including dubbing, quality control, international subtitles, lawyers, Errors & Omissions insurance, title clearances and DVD/Blu-Ray considerations.

With that in mind, and with the collective desire to see the project through to the end, the team decided to try crowdfunding. Smartly, they examined their choices, researched all the various platforms, and debated the pros and cons of each. After a few days, Kickstarter emerged as the winner. Ric Serena explains why:

1 The most obvious reason for the choice was that the platform had a high profile and an impeccable reputation. We believed it would give us the best option and audience reach to assist in raising the funds and getting the film out the door.

2 We believed it would be a great way to show that there was a viable audience for the film. We knew we would be approaching sponsors and distributors, and this campaign would prove we had an audience. This allowed us (and forced us) to really concentrate on targeting and building an audience that would appreciate the film.

3 Finally, we chose Kickstarter (over other crowd funding platforms) because we thought its notoriety would allow us to raise our lofty goal, and as crazy as it sounds, we liked the "all or nothing approach." (RB Note: Kickstarter has since changed their terms to allow those running a campaign to keep any funds raised.)

Serena adds,

> We started planning for the Kickstarter campaign launch about two months in advance, planning how we'd promote the campaign each day. Also, well before the campaign was launched, we let family and friends know about our crowdfunding plans. Further, we reached out to our list of friendly, supportive bloggers and those who had championed

our cause by sharing the *Almost There* video on Facebook and let them know about our strategy and our campaign release date in hopes that they would promote it right out of the gate.

CROWDFUNDING (AND MORE CROWDSOURCING)

The Kickstarter campaign for *Mile . . . Mile & A Half* was launched on August 28th, 2012. The goal was set for a $78,100 raise. That figure was determined by line budgeting the costs for post-production of the film, the fees of running a campaign and the costs of fulfilling the premiums.

With a clear strategy in mind as to how they were going to run their campaign, the team presented their case for support on the project's dedicated Kickstarter page as follows:

What's the Movie About?

It's about hiking . . . a lot of hiking. Just kidding, here's the synopsis: On July 10th, 2011, a group of friends (who are multimedia artists in their day jobs) set out to hike the John Muir Trail and record their experiences. Two hundred and nineteen miles in 25 days. Join them on the adventure of a lifetime: Facing epic snow conditions, recording the wild and pure alpine beauty of the mountains and creating lasting friendships with the eclectic team of musicians, painters, teachers and other adventure-seekers they meet along the way. Come laugh, limp, sing and—of course—walk with us.

How You Can Help?

We've done it all on our own so far, from getting the film to a nearly-finished cut, to producing promo pieces to build awareness about our project and much more; however, major expenses are looming and we can't absorb any more out-of-pocket costs. We need your help to get the film finished, into festivals and out to the world. Ultimately, we want this film in theaters and in the homes of people like you who love a good, fun adventure. Your Kickstarter support shows you care about this project and that there's a community interested in a film about hiking our amazing wilderness and creating art wherever you are. So we ask you to pledge your support (and pick up some fun rewards) and pass on our project with your adventure-seeking, fun-loving friends.

Where Is Your Hard Earned Cash Going?

The campaign funds are not going to anyone you see on screen (our hope is to recoup our investments during distribution.) This money is going to pay very discounted rates to a host of professionals who didn't get to join us for the 219 miles, but are helping us complete the film. **Thanks to these amazing people who believe in our project, what could easily be a $250,000 post-production budget is being achieved for $78,100.** And for that, we are incredibly proud and grateful.

From there they broke down how the $78,100 was to be spent. Smart. Shows that there is nothing to hide. That no one is profiting from the contributions. But that's just one facet of what's brilliant about this short, three paragraph section. Let's look at some keywords and phrases:

▶ Group of friends: **Relatable**.

▶ Two hundred and nineteen miles in 25 days: **Inspiring**.

▶ Adventure of a lifetime: **Cool. Who doesn't want to go on an adventure?**

▶ Come laugh, limp, sing and—of course—walk with us: **Cute. Fun. Inviting.**

We can't absorb any more out of pocket costs: **Honest. Suggests that those running the campaign have invested their hard earned money into a project they believe in.**

. . . in the homes of people like you, who love a good, fun adventure: **Direct. Connecting.**

Your Kickstarter support shows you care about this project, and that there's a community interested in a film about hiking our amazing wilderness and creating art wherever you are: **Personal investment that goes beyond money. An investment in your lifestyle.**

. . . pass on our project with your adventure-seeking, fun-loving friends: **Community.**

The campaign funds are not going to anyone you see on screen: **Transparency.**

Thanks to these amazing people who believe in our project: **Selfless contributions.**

And for that, we are incredibly proud and grateful: **Humility. Unadulterated appreciation.**

It never ceases to amaze how many filmmakers screw up the information section of their film's crowdfunding project page by posting egotistical rants or providing useless, and sometimes baseless, information. It's a poisonous approach. *One that repels instead of invites.*

Here you have engagement on a micro and macro level. An extremely well thought out approach that invites you in, wraps an arm around your shoulder and whispers in your ear, "You're one of us and we appreciate you." For the person who sits in the target category (or categories, in this case) of this campaign, how can you not feel spoken to? How can you not want to lend support? How can you not want to go carry the message? (The end result of the campaign renders these questions to the realm of the hypothetical.)

In addition to their well actualized and realized campaign page, the team created a terrific strategy to promote the progress of the film and the Kickstarter campaign on Facebook, which they had decided would be their primary social media platform for disseminating information. It's important to note that for many managers of crowdfunding campaigns, this is where the wheels can come off the wagon. Too often, the posts made on social media in support of a crowdfunding campaign come across as too much of a hard sell. This can make you look needy at best, desperate at worst. The key is to commit to posting quality and engaging material, information and media on a regular basis. Remember, you are trying to raise interest and get people to not only believe in your mission, but carry the message of it forward.

Fortunately the *Mile* team was aware of the pitfalls and created a winning balance that paid dividends along the way. Each day, without exception, the team would make two to three posts with content they believed would interest their fanbase along with a single post regarding the film or the Kickstarter campaign. Think of it as a niche audience newsfeed sponsored by a film; information brought to you by this inspiring team who happened to be making a film looking for financial support.

In addition to making posts speaking to such things as new hiking gear on the market, the team posed questions to their fans as well such as asking

them to list their favorite hike or their favorite time of day to hit the trail. To keep things even more interactive and community based, they came up with creative ideas such as running a Sierra Cup Diet (http://themuirproject.com/sierra-cup-diet/) where hikers had to come up with a daily meal plan for breakfast, lunch and dinner that could fit inside a hiker's cup. They received dozens upon dozens of photos from fans showing what they had fit in their cup, and they made it a point to post as many as possible. Again, this is engagement at its finest—fun, interactive and competitive.

All of these efforts paid off handsomely. On September 28th, 2012, the campaign closed with $85,405 raised thanks to 814 backers. Remarkable.

Says Ric Serena,

> One of the unexpected by-products of our Kickstarter experience was how much of an awareness campaign it turned out to be. A week into our campaign, REI, one of the top outdoor gear and apparel outfitters, got wind of our project and posted a challenge to their social media audiences: "If we can get 5,000 likes on a photo, we'll give $5,000 to the Kickstarter campaign." Within 2 hours, the post had exceeded all expectations. We were floored. Suddenly, our campaign had traction and others were inspired to spread and carry the word independently of us. In addition, we held live events at REI and Adventure 16 outdoor equipment retail stores where we screened exclusive content, talked to audience members about our experience, and invited Opus Orange to play acoustic sets. It was a great way to reach, communicate with and engage an audience on a personal level (something that's very difficult to do over social media). By the end of our campaign, we had reached an enormous audience who were excited about the prospect of the film and were anxious to spread the word. This also translated into us procuring email addresses from people who wanted to continue getting updates on the film. It's a list that continues to grow and serves as a great tool for spreading the word about our milestone updates with the film."

POST-PRODUCTION AND BEYOND

Soon after the completion of the Kickstarter campaign, the team locked the cut of the film and began moving into the finishing stages. Paul and Bernard worked tirelessly on the score while Durand, David Barnaby and Ethan Beigel spent long hours creating the sound design and working on

the mix. Simultaneously, Bruce Goodman at Hot Pixel was coloring the film. On October 20th, 2012, the team held a private friends and family screening of the completed film, *Mile . . . Mile & A Half*. They watched the faces of their audience, gauging their reactions to key scenes. By the time the credits rolled, they knew that had something special.

Over the next few months, the team followed in the footsteps of many independent filmmakers, braving the film festival submission process. Kia Kiso, a co-producer on the film and the person responsible for handling all distribution and legal aspects associated with the project headed up the film festival strategy. Says Kiso,

> I wasn't sure this was going to be a film that would get accepted to Sundance, win, get a big distribution deal and we would all fly home with lots of money. So, I asked the team to bring in a great festival consultant, Thomas Ethan Harris, to give us his take. He determined the movie was not quite what festivals were looking to program—either a social issue doc or a film with high drama. Even if we did, he said festivals program first to alumni and celebrities so there are few remaining spots left for newcomers. Also, he gave us a dose of reality that most people do not see much cash at the end of festival sale. So, because our film didn't have any prostitutes dying in gutters and we didn't have any festival connections the whole team knew we should take a different route. Talking with the consultant gave us a healthy reality check that the road to releasing this film would be a lot longer and would take more effort. He suggested a few great festivals to focus on.

> Then, I sat the team down and asked them a series of questions. The two main ones were, "What is our goal with this film?" I knew that we would come to crossroads where we had to make a decision and everyone needed to be on the same page. In looking at some choices, like money, awards or exposure we chose exposure. Because there was an additional goal to make more films like this, even be paid by sponsors to do similar projects, exposure was the highest priority. That ended up guiding quite a few decisions that we had to make later on. Secondly, I asked, "Who is our niche audience—where do they live, work, shop; what do they read, watch, listen to; what is their age, sex, income, education level, etc.?" With that question, we created a list of psychographic profiles of over 30 types of people who might enjoy the film. Then we selected the top two or three that we understood most and we focused on just catering

to just them throughout all of our marketing and publicity. We could have gone after the "active retiree" or the "overworked cubicle rat" but that would have diluted our efforts. You cannot reach everyone. You have to be selective; you need to drill down narrowly and as deep as possible. Once we had our answers, we began to submit to festivals on our target list. By focusing on certain festivals, we saved a lot of money, energy and time in the long run. A small number of them accepted us but I had the confidence we could forge our own path because of the audience we already proved we had.

Adds Fitzpatrick, "It's important to note that a filmmaker should not take this process personally. Festivals have their own agenda, and it doesn't always fit with your film."

Just because they had submitted the film, it didn't mean the team was resting on their laurels. They continued to control what they could control. So, while they were waiting to get some good news from the festival circuit, they identified, engaged and eventually partnered with the American Hiking Society, a large, national, nonprofit organization with a shared interest. The team also made this move so they would be prepared with a 501c3 option if an interested sponsor wanted a write off. They donated a percentage of the sponsorship money as event fundraising to the organization and, in turn, the American Hiking Association spread the word to their members about the film (which they had seen and loved). They had created yet another win-win situation, and secured another huge champion of the message and mission in the process.

On June 1st, 2013 (coinciding with the American Hiking Society's National Trails Day) *Mile . . . Mile & A Half* premiered at the Dances With Films Festival in Los Angeles. With an already large base of champions (at this point the *Mile* Facebook page had 4,600 fans), it was easy to move those supporters to show up for the film's debut. In fact, the 160 tickets available for the premiere sold out so quickly that the festival, in an unprecedented move, added a simultaneous screening in another theater. That showing sold out in even less time than the first.

Reaction to the film was overwhelmingly positive, with the film winning the Audience Award for Best Documentary. Further, over 30% of the audience from both showings stood in line for over 45 minutes to buy a DVD or Blu-Ray copy. This ratio held true at other festival screenings and when the team independently took the film on tour.

We were spoiled by how well run this festival was, and by the success of the premiere [says Ric Serena]. To receive the Audience Award for Best Documentary and walk out of the theater to a line that stretched the length of the lobby of people waiting to buy a DVD of the film. This was a huge affirmation for us.

Says Fitzpatrick,

> These were people who believed in our film before it was complete, so their approval was crucial to us. The response was great, and we were recharged to move forward with getting the film out there. We instantly began shipping out DVDs and Blu-Rays of the film to our Kickstarter backers.

An added bonus to all this positive momentum was that sales agents and distributors were beginning to take notice. At the same festival, Kiso met the VP of Acquisitions and the Senior Director of Business Development for Gravitas, who was in charge of handling documentary acquisitions for the company. But Kiso found there were other suitors interested in the film as well. A high class problem.

After researching all the companies who were interested in the film and getting feedback from other filmmakers, the team signed with Gravitas to serve as their sales agent for domestic Video On Demand. Other film festivals began inviting *Mile . . . Mile & A Half* to screen, and over the summer of 2013 the team did their own "four wall" tour as well, screening the film in various cities across the country where they knew their fanbase was the largest. For many of these screenings, Opus Orange performed live before or after the film, adding an extra element to the affairs and casting a potentially wider net audience-wise. The team sold DVDs and Blu-Rays at the live events, which helped fund their travel expenses and offset the day-to-day costs of screening the documentary. They also successfully crowdsourced screenings through Tugg (www.tugg.com).

Says Fitzpatrick,

> It's a great service that enables people to bring your film to their town through crowdsourcing. They have deals with many of the large theater companies, and a minimum ticket threshold is set that covers the fees for the theaters, filmmakers, the local sponsor and Tugg's percentage.

If that threshold is met, then the screening happens. If not, nobody is charged. Sales over the threshold are split based upon percentages agreed to in advance. It's also a great service as they handle all of the deliverables to the theaters. They also have great tools to help sponsors use the screenings for fundraisers. Overall, it's one more terrific tool available to the independent filmmaker to get their content seen.

In the meantime, Kiso worked closely with Gravitas. She says,

> Gravitas trusted how well we knew our audience. We knew a fall launch on Video On Demand (VOD) would be best. Hikers would be coming in from their summer journeys but they would be longing for the trail. Ultimately it was decided that the film be released in September of 2013 on iTunes, Amazon and other major Transactional and Cable VOD platforms.

Once the film was in pre-sale phase, the team again reached out to their now growing list of bloggers, social media and other supporters in advance, asking them to spread the word about the film's release date. They urged their audience to add the film to their wish list in hopes that when the film was released, it would break strong from the starting gate. They asked their fans who had seen the film in person or via directly purchased DVD or Blu-Ray to also put the film into their iTunes wish list and to rate and review it. On the date the film transitioned from pre-sales to being available for viewing, the crowd had already responded by posting over 100 5-star reviews, a significant number for a documentary that did not have a traditional theatrical release backed by a healthy prints and advertising spend. Says Kiso,

> Gravitas was flabbergasted and called to ask who our impressive PR/marketing firm was. We had to laugh when we told them that it was just us. They were really impressed and asked if we would consider partnering with them for our International VOD. They even paid for all the subtitling costs up front for us. From the beginning we collaborated with them, we gave them updates on what we were doing, even calling them when we won other awards. They were always looking for a way to increase our exposure on the platforms.

Ric Serena was quick to recognize the power of the crowd:

> The greatest advantage we had at that point were the thousands of people who'd seen the film at screenings, festivals or from their Kickstarter

reward. Because those audiences were talking about the film, others were anxiously awaiting the opportunity to see it for themselves. We came out strong for a small, independent documentary, ultimately reaching #5 on the iTunes documentary charts. In the spring of 2014 the film was released on Netflix, garnering over 120,000 viewer rankings with a 4.1 star average.

During the summer of 2013, Kiso shopped the film to and fielded interest from sales agents and distributors.

Having Gravitas on board, our amazing fan reviews and purchasing numbers made it super easy for me to pitch this film and gather other more interest and offers. Thankfully, we were able to be a bit choosier than other filmmakers typically are. We signed with FilmOption as our broadcast sales agent because they were very familiar with sports and nature documentaries. Through them, we signed a deal to air on National Geographic US. The deal for international broadcast is pending.

Really, it was a snowball effect. We started with a beautifully shot film about a subject that a large niche audience could relate to and get excited about. We gathered their support, both enthusiastic and financial, during the Kickstarter campaign. We talked a festival into premiering us and we proved to them we could sell out *twice*. We won the Best Audience Award because people loved our film and we simply outnumbered all the other film's audience members. We met the perfect VOD sales agent at the festival who helped us attract all the other partners we needed to distribute on the other platforms. We maximized our audience's love for our film so we could shoot up the iTunes charts, and that strategy ultimately helped us reach international audiences. And so on! We received the exposure we hoped for and then some. We now expect to be profitable two years ahead of our projected schedule. For a documentary, let alone any movie, that is huge! But none of this would have been possible without the crowd believing in us and carrying our mission and message to the masses.

Adds Ric Serena,

This has been, and continues to be, a labor of love for us. For the most part, the people you see in the film are the same ones that carried this film through post-production, screenings and distribution. We're the same ones that package a DVD when it's ordered and we still answer all of our email correspondence. As wonderful as the success of our film has

been, we all agree that the best part of this experience has been the amazing support and the response we have gotten from the people who watch it. Whether it's people who have been inspired to hike the John Muir Trail or a different adventure, or people who have disabilities or troubles who've felt they were able to join the journey, the fact that they continue to reach out to us has been an amazing and touching experience.

CODA

On the surface, it would seem as if *Mile . . . Mile & A Half* had nothing but smooth seas on its journey from concept to distribution. And for the most part it did, thanks to the incredible planning and precision execution of the team. But that doesn't mean they didn't learn a few lessons along the way, particularly on the crowdfunding side of things. Below, Jen Serena, who played a huge part in the development and execution of the crowdsourcing and crowdfunding campaigns, shares four Dos and Don'ts from her experience and four bonus tips for good measure.

Advice on What to Do From Jen Serena

1 Do Your Research

First, in the platform you choose. And once that's decided, second, learn *all* the rules about that platform. With our Kickstarter campaign, we had wanted to donate some funds raised to a charity, but that's not allowed. We had also built a fun calendar with giveaways. Alas, giveaways are not allowed either. Violating these rules could lead to having your campaign delisted. It would be a shame for you to do all that work, including the months of preplanning, if you're doing things right, only to have your project removed due to a lack of research.

Also, research other successful projects and if you see something in the execution that fits the sensibilities of your campaign—be it in their rewards, uploaded media, how they interact or why their updates get a positive reaction from fans—mirror it.

Finally, research through Google and seek out articles and tips, not only for your pre-campaign strategy, but what has worked for people *during* the campaign. You never know when you might discover another nugget of information that'll make your life a little easier after the launch.

2 Do Keep a Calendar

Keeping a calendar will keep you on track during the preplanning and during the campaign. It will also greatly help you with listing who is responsible for uploading media and posting updates and responses to the fanbase on any given date.

Make sure your calendar includes everything you'll need *before* the campaign starts. Will you show samples of the rewards? Do you need anything else ready to go before you launch? Which days are you going to introduce new content or information about the project?

Every day, without fail, we scheduled everything from updates to "Thank Yous" to everything happening with the team and the project. This helped us to remain on top of the campaign, give the appearance of constant activity and keep our fans (and us) motivated. Perception plays a big part when crowdsourcing.

3 Do Make a Budget

You have gone through the trouble of creating a budget for your project. You need to spend the same effort designing one for your crowdfunding campaign as well, particularly where your rewards structure is concerned. Sure, it's difficult to guess which rewards will get the most play, but knowing the out-of-pocket costs and your profit for each is very important. Finally, don't forget to calculate Kickstarter fees, Amazon's processing fees and fees for packaging and sending rewards.

In our case, for example, we chose to set $15 as the first level for which we would mail, and that was for an item that would fit in a #10 envelope and keep down our costs.

Remember to bake all these fees and expenses into your budget or else you may find yourself coming up short of funds during shooting or in post-production.

4 Do Thank People and Keep Them Informed

We were nervous that people would tire of our updates. (We posted every 2–3 days.) But we also made sure that our posts really had something to say—revealing new info, additional footage and sneak peeks, thanks and

calls to action—they weren't just a call for money, but designed to further the sense of community.

THANK EVERYONE. Let me repeat that. Thank *everyone*. We took turns every single night thanking our new backers. We didn't want anyone to feel that we were taking their support for granted. And, on an even more base human level, we believed it to be the nice and proper thing to do. But the truth is, with the focus on making sure we were executing at a high level and that all the updates, reminders and posts were being handled every day, *we* needed that time to remember that people were supporting us through pledging their hard earned money to be part of our project. Thanking them for doing so was incredibly uplifting and rewarding.

Now some don'ts learned along the way . . .

Advice on What Not to Do From Jen Serena

1 Don't Give Up

There were times when we wondered "Is this really worth it?" and suffered from insecure "We're not going to make it!" thoughts. Early in our campaign, we were pacing way ahead of goal, but as we entered the last five days, we were disheartened to find ourselves still short by around $8,000. Talk about tense! But true to the research we had done on other successful campaigns, as well as statistics we had reviewed, tons of pledges came in right at the end and we exceeded our goal by nearly $8,000.

There will be naysayers. No matter how wonderful you are to your supporters and how altruistic you intend to be, someone will say your project sucks and that they could do it better. Some may even call out your campaign as being full of lies. It really hit us hard when it happened to us on one blog, and even though we had such incredible responses hundreds of times over, that one piece nagged at us. How can't it when you know that you are coming from an honest place? We chose to stay positive and not engage the person. Then something amazing happened. A number of our supporters and backers came to our defense. They were so moved by our mission, they provided a voice for us. All comments that followed were overwhelmingly positive, and we won even more new fans. In the end, all we could do was make sure that we are honest and

true to the project, our followers and ourselves. We knew the rest would take care of itself.

2 Don't Set Your Goal Too High

Our initial goal was closer to $100,000. And although we'll be spending the difference between what we raised and (even more than) that amount before it's all said and done, we decided to go bare bones to give ourselves better odds of hitting our goal, finishing the film and showing a success. We also knew we had a film that wasn't high drama and had no celebrities attached. Best to keep the budget realistic and attainable without sacrificing your vision. Just be honest about how much you truly need. Don't price yourself out.

3 Don't Keep the Conversation Strictly on Your Crowdfunding Page

We posted more than six times a day on Facebook. We kept up our own web blog, wrote numerous guest blog posts and fielded interviews from bloggers. We tweeted and pinned on Pinterest. We held live events and sent newsletters out to followers. We made friends with companies with high followers on various social media platforms so we could do cross-promotions. (Making friends is much easier than you think, as so many companies are hungry for content—especially on social media.) And this community of supporters is still part of our project today. We may not be in contact with them as often as we were during our campaign, but we still do reach out whenever we have a milestone event with the film and the response is always favorable.

4 Don't Go It Alone

Because we had five of us working on the project, we were able to constantly have a rotating lineup of voices telling our story, updating the community and, ultimately, asking for support. Trust me, you *will* want help with this. From coming up with fun rewards that actually provide revenue, to updates, to thanking the supporters and fans, to conversations on other platforms and, ultimately, reward fulfillment—having a team you can rely on makes all the difference in the world. Enlist people on your filmmaking team or, if that proves impossible, others who are willing to donate their time to the cause.

And here's four more bonus tips I learned along the way . . .

Bonus Tips

*1 It Takes a Village. Or, More to the Point, You Need to
Already Have a Village In Place*

Yes, more people will find your project than your initial target group, but don't count on that being the majority. The actual backers coming in straight from Kickstarter were less than 4%. Through our crowdsourcing efforts, we brought the rest there.

2 You Will Become a Crazy Person. And That's OK.

Hello, Crazy Person. I hate to inform you, but this will probably be you the second you hit "Launch" on your campaign. You *will* be checking your progress every second like some sort of addict, praying that people are backing the project. And, if things are progressing well, you *will* begin wondering just how much beyond the set goal your final number will be, all the while inventing grand schemes of how you can thank people for helping you raise $1 million. And yes, you *will* probably also haunt Kicktraq (www.kicktraq. com)—which never helped determine how well we were doing. It just gave us another distraction with which we could agonize about the campaign and give us bipolar waves of emotion alternately that we'd make it above and beyond goal or fail miserably, depending upon the updated feed.

*3 You Can Change Things After the Campaign Has Started. But Not
Everything.*

A Kickstarter staff member suggested we lower the prices for our gifts, and we did. This created a whole new set of tiers. It also caused quite a bit of confusion, especially for those viewing the campaign page after we had set the new tiers. A person who had already donated a certain amount of money which was now eligible to be moved into the new tier and earn the gift associated with that new tier had to log in and do this manually. We couldn't move them to the new tier. Not everyone moved, which meant some of the old tiers remained. Thus the confusion. We spent countless hours explaining the situation.

So while you can adjust where necessary, the point I made about doing your research and planning properly remains. The less you have to change once you launch, the better.

4 That Money Goes Fast!

We handily spent $77k (the amount we received from our $85k raise after Kickstarter and Amazon took their cut) on everything we detailed in the campaign's overview. So much money, and yet it didn't even cover our initial investments. That's not a complaint. We knew going in what we were raising the money for. So what's my point? Make sure *you* believe in your project! Somewhere along the way you may have to come out of pocket. We were prepared to do so. We believed so much in what we were doing and what we hoped to achieve. It was a true test of the Labor of Love theory. So believe in what you are doing. Have conviction to spare. If you don't, how can anyone else?

15

Case Study #4

Stage 32

To wrap things up, if you'd indulge me, I'd like to present a case study near and dear to my heart. For you see, my dear Padawan, crowdsourcing has been in my blood for some time. I tell you this story not only to bring our journey full circle and share more about how I used crowdsourcing tenets and strategies to launch my last two businesses and to reach this point in my professional career, but to illustrate some lessons I've learned along the way.

In November of 2009, I attended the American Film Market (AFM) in Santa Monica with the hope of attracting interest in a crime-drama film I was planning on producing. This was a project that had been around the block a few times before I came on board. Early on, the plan was to film it as a $4 million dollar indie but, over time, the script got passed around town and interest started to grow on both the talent and business sides of the industry. At one juncture, the budget had swelled to $30 million with Richard Gere and Julianne Moore verbally attached and interest from a major studio. Scheduling and other logistical conflicts ultimately killed that deal.

By the time I became involved (about six months before AFM), the project lay dormant for almost two years. Within a couple of months, we had interest from a former A-lister whose star had fallen and was looking to revive his career. But we had little else. No financing, no supporting stars. In short,

outside of a good script with a cool concept and a "Yeah, I remember him" actor, we were well aware we were heading into the conference with a weak hand.

Undeterred and with a current of ambitious electricity coursing through me I hoped would compensate for the "lightness" of our pitch, I soldiered on. I had been to AFM before, but purely for the educational opportunities, attending panels and seminars. I had not been up in the halls where the studios, production companies, sales agents, distributors and the like set up shop in the cleared out Loews Hotel guestrooms and suites where the pitching and, for the fortunate, the wheeling and dealing commenced. So while I wasn't entirely optimistic (as it turned out correctly so) about our prospects, I was excited for the learning experience.

If you're not familiar with AFM, in addition to its numerous screenings, seminars and networking opportunities, it's one of the largest and most prestigious film markets in the world. It's an eight-day, balls out, white knuckle experience for those hoping to sell, finance, acquire and secure distribution for films. Participants, including acquisition and development executives, agents, attorneys, directors, distributors, festival directors, financiers, film commissioners, producers, writers and other industry executives come from all over the world (more than 70 countries, according to AFM's Wikipedia page https://en.wikipedia.org/wiki/American_Film_Market). For those looking to make a deal, hopes and dreams are packaged in briefcases, manila folders and flash drives. Those prepared to listen to pitches sit like kings on the throne. The whole thing is a scene and a half. Nervous energy, oversized (and often unearned) egos, hubris, white lies and tall tales seemingly make up the architecture of every conversation. In the day to day, the film business is full of hype and unrealistic proclamations. During AFM, with a nod to *Spinal Tap*, illusion and delusion are turned up to 11.

So here I was, ready to be a sponge, anxious to soak it all in. Every morning, I would enter the lobby of the Loews and breathe in the scent of optimism. For at 8:30 am, everyone is well pressed and manicured, bright-eyed, bushytailed, vigorous and ready for the attack. You can practically see the thought bubbles over heads—*Me, on the cover of* Variety. *How 'ya like me now, Ma?*

Pushing my way through the crowds, I'd head to the lobby bar. (Really? Is that what you think of me? *For coffee*.) There, one would find the serious crowd, some deep in thought, some already in a flop-sweat running through

their pitch. One would also find others nervously waiting for the bell to ring, looking for someone to talk to, a relatable calming soul brother or sister. I wanted to be that calming soul. I wanted to hear stories. Where did they come from? What were they looking to accomplish? What would happen if they failed?

It was the answers I received from that last question that sparked the Ah-Ha moment leading to the embryonic idea that would evolve into Stage 32. Before I go forward with that story, however, allow me to take you back in time.

THE *RAZOR* YEARS

RAZOR Magazine was a national men's lifestyle publication which I founded in 2000 and published until 2006. In the years prior to *RAZOR*'s launch, the print industry was thriving and the men's space was one of the fastest growing sectors not only in circulation, but in new titles introduced per year. I was doing a ton of business traveling during this period and in spite of the plethora of men's titles facing me every time I entered an airport newsstand, I found myself reaching for the same old business, sports and fitness rags. There was simply nothing in the men's space that I connected with or which appealed to me in a relatable way.

The Big Kahuna at the time was *Maxim*—a UK import boasting a remarkable circulation of 2.5 million at its peak and a simple editorial edict and philosophy of "Beer and Babes." *Maxim* had become a phenomenon spurring spinoffs and a plethora of imitators. With its quick hits on gear and cheap fashion, McNugget style journalism and multiple bikini spreads, if one didn't stop to gawk at the photos, you could make it from cover to cover of any of these interchangeable mags in 15 minutes. Not ideal for an eight hour plane ride.

Make no mistake, I'm not slamming *Maxim*'s model or business. Quite the opposite. As it relates to the subject at hand, they were a crowdsourcing machine. They knew (with precision) their audience, brand and message. Almost staggeringly so. They were not only able to engage their readership with high frequency by keeping the editorial on point with the message of the brand, but they were able to mobilize their audience to carry that message forth with relative ease. It was OK to be a *Maxim* guy. It meant you were the frat guy and the frat guy loved beer and babes. There are a ton of colleges in America and Maxim crowdsourced its audience to hold parties in just

about every college town imaginable. Further, they crowdsourced ideas for extensions of the brand by taking suggestions from their readership—a smart, inclusive and collaborative approach.

Even though I was barely beyond my college years and no one would ever confuse me with someone who didn't like to party, or start one for that matter, I just didn't find Maxim's editorial engaging. It just wasn't my thing. It was, by their own admission, sophomoric, and, by my assessment, repetitive and boring.

I liked long form journalism. I liked progressive fashion. I liked travel. I liked politics (as a spectator sport). And I liked women who looked, um, old enough to operate heavy machinery.

Now I know what you're thinking: What about *GQ*? Well, in the opinion of many, including me, *GQ* (although, certainly not the only magazine in the space guilty of this) had bowed to the success of *Maxim*, dumbing down their editorial, compromising their fashion standards and in many ways abandoning their core audience in the hope to take some of the so-called laddie mag's share. The *GQ* covers of the late 1990s featured A-list actors and world-class athletes in $3,000 suits. The editorial was upwardly mobile, fashion forward and tailored to those driven by, or who had attained a certain level of, financial success. By the early '00s, the covers reflected a surrender of sorts, featuring such celebrities as a barely legal Lindsey Lohan in a cut tank top, thumbs in her panties, standing in front of a table covered with cherries and berries next to a headline that read "Lindsay Lohan Isn't Teasing."

When it comes to summer fruit, who does?

Deep thoughts.

Anyway, I believed I had identified a need in the space and set out to fill it. I put together a skeleton crew and together we spent eight months developing a strategy. Although we didn't know it at the time, it was a crowdsourcing strategy. Who was our reader? How do we reach them? How do we find out exactly what they are looking for? How do we engage and mobilize them?

We employed a couple of polling companies. Without diving into all of the minutiae, we narrowed our demographic field and asked a variety of questions general to the men's space, but specific to our message. We concluded

there was an audience for the material we were hoping to serve. But the responses also helped mold our creative direction. We were asking the potential reader what they would like to see and read, essentially and effectively crowdsourcing our content.

To crystalize the branding, I locked in on this main talking point: "*Razor* is the magazine for when you're done with your *Maxim* years, but not ready for your *Esquire* years." (*Esquire's* editorial skewed to an older demographic.) I felt that not only clearly defined the gap we were looking to fill, but also suggested what kind of reader we were looking for—namely the guy looking to grow up, but not ready to grow old. We ran this idea by some focus groups and the response was overwhelmingly positive. The mission now was deliverability of said message.

THE LAUNCH AND BEYOND

Now keep in mind, this was the early '00s. Social media was more hobby than instrument, oriented more in recreation than business. Friendster was beginning to fade. MySpace was now the dominant player, but by this point had gained a reputation as a place to hook up or work out mommy issues. Still, there was no denying the reach of the platform. So, as a test, a member of our editorial team posted some early concept artwork and posts about the mission of the magazine. Within four weeks, we had 173 responses. About 20 were in the "How cool!" arena. The other 150 or so were of the "Can you send me pics of chicks in bikinis?" variety more associated to the (dominant for the space) *Maxim* "Beer and Babes" mentality.

We needed to find a better way to get our message across. A more direct approach.

We took to the streets.

First, we held a number of launch parties—decidedly cool affairs in upscale lounges and clubs—in cities where we had secured distribution, such as New York, Toronto, San Francisco, Chicago, Las Vegas and Los Angeles. We didn't have much working capital, so we had to be resourceful. Crowdsourcing style. They offer the space, we provide the crowds, all the events—details and photos—published in the magazine and on our website.

In many cases we were joined by trendy fashion companies and independent liquor labels who we had sold on our message and wanted a seat on the train—everything fresh, new and on the cutting edge. We brought in DJs who were on the rise to set the mood and who wanted to be identified with the brand. Around each event, we had giant posters of our house ads featuring models dressed to the nines in action shots—business meetings, airport lounges, nightclubs, cars, dating—"Who's the *RAZOR* man? You."

At the end of each of these events, the attendees were handed a copy of the magazine. Inside the cover was a note from me describing my vision, the mission of the magazine and a few requests, the "Ask": If they liked the product and identified themselves the target consumer, would they please help us launch and be part of the movement by . . .

1 Spreading the word in any way possible—online or offline.

2 Purchasing a subscription.

3 Purchasing at least one subscription for someone else as a gift.

You'll notice that the "Ask" offered inclusion. A chance, some might argue a responsibility, to be a part of this thing we were trying to create. To be able to say "I was there at the beginning." Ownership. Pride.

The print run for our first issue was a modest 17,000. We had circulation at about 200 newsstands in 12 cities. By year three, our readership was a more robust 500,000, and we were on newsstands in every state in the US and throughout Canada. We never spent a dime on advertising. We had stayed the course. We continued to ask the crowd to carry the message and that crowd had expanded exponentially. More voices. More power. An army of boots on the ground.

From a business standpoint, we kept things lean. This allowed us to realize a profit on many individual issues. Still, in spite of winning accounts that made our competitors stand up and take notice such as the re-launch of the Pontiac GTO (complete with a huge *RAZOR* party at the Kentucky Derby with the hotrod front and center), not to mention our swelling circulation/sales numbers, we were still having a hard time getting meetings. And the press was doing us no favors, either, barely recognizing some incredible achievements such as being one of only two magazines of fifteen at the time

in the men's space to show double digit year over year circulation growth, according to the Audit Bureau of Circulation, and at one point surpassing the sales of both *GQ* and *Esquire*.

But I have a saying: Force them to not ignore you. So I went at it even harder. I brought in writers such as Mark Cuban, James Carville, Mike Lupica, Paul Haggis, and one of my writing heroes, David Mamet (who I had to call at 1am New York time to kindly explain that the first draft of his piece sucked—a call which took years off my life and required three Jack Daniels' worth of courage to make). I hired one of the top stylists in the game and he brought along all his modeling and photography contacts. I did some recon and found a few style and fashion editors unhappy at their current positions and brought them into the fold. Finally, I started an "Are you a RAZOR man?" campaign, where I featured testimonials and video from our readers on our website.

The efforts paid off. Within months, our content was getting covered in both print and on television. Our fashion spreads were being covered by top journalists and media outlets. The new editors brought fresh ideas to the table. Our readers clamored to be featured in print or on the site speaking to why they embraced the *RAZOR* lifestyle.

Hell, even I was suddenly in demand. I was asked to appear on Fox News, CNBC, MSNBC and the CBS Morning Show. The entertainment news show *Extra* came to my home and did a five minute feature where they called me "the next Hugh Hefner." I was featured in *People* magazine's 25 Hottest Bachelors issue (next to Keanu Reeves . . . whoa!) which led to me being interviewed for and then asked to be the subject of NBC's *The Bachelor*—a gig I had to turn down due to the requirement of being sequestered for four months, a *slight* problem for someone publishing a monthly magazine.

Best of all, the advertising world came calling. Most importantly, the *fashion* advertising world came calling. The Holy Grail. An industry with a lemming mentality if there ever was one. Pull one or two fish in, watch the rest of the school head-butt the side of the boat begging to come on board.

As a result of all this coverage, publicity and, not to be underestimated, the crowd continuing to swell and carry forth the message of our brand, our readership was now over a million per issue. We were sitting pretty, or so it seemed.

It was early fall in New York and my sales team and I had nestled into a mid-town hotel for three days of prep ahead of our calls with the fashion industry bigs. Our goal was to secure no less than 40 pages for our spring fashion issue. Many magazines can turn an annual profit just on the spring and fall fashion editions, and with our subscription, newsstand numbers and buzz at an all time high, we had some serious wind in our sails.

So for 72 straight hours, minus a few here and there for sleep, in hotel rooms, lobbies, conference spaces, restaurants, bars and while riding the subway, the team worked on the message and the pitch. We grilled each other in every setting imaginable—panels, one on ones, role reversals, you name it. Our confidence was soaring. We had moved and mobilized the consumer audience; we were going to do the same with the advertising community. Every successful business has a tipping point they can point to and we all were convinced this was going to be ours. And sure enough we did tip.

Right on our asses.

On the surface, the meetings could not have gone more spectacularly. Even the most stoic and egotistical couldn't help but praise our accomplishments. There were wide eyes and slacked jaws when I explained our plans for the following year. Some expressed outright giddiness at the prospect of working with us. There were promises of RFPs (requests for proposal) and partnership explorations. The worst we would hear was that we were still young and had much to prove, but even in those cases there was the lingering promise of "testing the waters." We floated out of each encounter more encouraged and emboldened than the last.

The final meeting of our week occurred in the offices of a very well known fashion brand. The buyer for the company was a big, impeccably dressed, elegant, teddy bear of a guy. A true gentleman and an industry legend who had been at his job for 35 years. I purposely scheduled him last for a couple of reasons. One, I wanted to have nowhere to be afterward so I wouldn't feel rushed. Two, I hoped that by meeting with him at the end of the day, I could convince him to grab a drink afterward and pick his extremely experienced brain.

Again, the meeting couldn't have gone more swimmingly. His opening salvo: "I've seen a lot of things in this business, but I can't remember a more exciting and innovative title hitting the space in the last 20 years. Bravo." He

proceeded to praise our hires, our editorial and our fashion sense. In turn, he openly questioned the direction of other magazines in the category— "Their editorial is forcing us out." If this trend continued, he mused, he could see *RAZOR* becoming the men's fashion leader. My team and I floated from the meeting.

The love fest continued afterward at a local bar, where over numerous martinis this gentleman regaled us with stories of the so-called golden years of magazine publishing; the characters, the parties, the scene. He was a raconteur extraordinaire. I could have listened to him all night. And I did. Long after my sales team had gone home, exhausted but still riding a high. Finally, about 1am, he was ready to call it a night and he gave me a huge hug and a kiss on both cheeks. I thanked him for his time, his candor and his generosity and I told him I was looking forward to seeing those RFPs and working with him. He could call me directly any time. Then, quite suddenly, his smile disappeared.

"RB, I want you to know that I meant every word I said. Every single word. The product is superior. What you're doing is spectacular. And the inroads you've made in such a short period of time is nothing short of amazing. But it's not about what you have or what you've done, it's about what you don't have. I may not like what the other titles are doing, but I have to buy them because we buy across other titles the publisher produces. If I pull one, I lose all leverage. You're a single title. A *new* single title. I simply can't pull from them to give to you. And in spite of what anyone else told you during these meetings, I think you'll find it to be the same across the board. I only tell you this to be honest and because I see your passion."

"But what about the message, the vision?"

"I believe in both! As a reader, you have a fan for life. As a buyer, for now, my hands are tied." Then, one last bit of encouragement. "But don't give up! The climate is always changing. In a few years who knows where we'll be sitting!"

The wind was now out of my sails and whistling hallow in my ears. We had done such a tremendous job identifying and moving the crowd and adjusting the product to their wants, we were more popular than ever. But more readers meant more copies published and more copies published meant

 higher expenses and higher expenses meant we needed ad dollars. And there, my friends, was the rub.

We battled for two more years, even capturing a nice chunk of the spirits market, which helped us stay afloat and give us staggered, lingering hope. And while we were able to pull one fashion fish in here and there, the rest of the school were more than happy to swim in safer, less turbulent waters. When I went calling on the aforementioned buyer again for the last time he was in sour spirits. His print ad budget had been cut in half, the titles he had protected no longer receiving his business. The other half had gone to an internet buyer who was shooting in the dark, spending the company's money arbitrarily.

Each of the last ten issues we published outsold the last. Our final edition had a readership of over 1.5 million and our ABC Audit numbers for the half-year were our best ever. In our time in publication and the two years that followed, 27 titles that entered or existed in the men's space shuttered.

COOL STORY, RB, BUT WHAT DOES IT HAVE TO DO WITH ANYTHING?

Patience, grasshopper.

So what were the takeaways from *RAZOR*? Well, for starters, although the word crowdsourcing hadn't been coined yet, I had effectively put the basic tenets into practice by learning how to identify, communicate with and mobilize a crowd *offline*. This was an important lesson.

 I also learned that it is much more difficult to move two crowds as opposed to one, and finding that balance is tough. Yes, there were certain things that were out of our control. We couldn't have predicted the tragedy of 9/11, which effectively shut down the advertising world for almost 18 months. We couldn't control the fact that being a single title publisher would have little bearing on some and place us at a major disadvantage with others. Even the things we prepared heavily for, such as content moving away from print and online, didn't turn out quite as we, or anyone else for that matter, expected. We were of the belief that premium content would be desired and accepted by the consumer as the norm and that advertisers would support the plat-form. It's a battle that's still being fought by premium content providers today.

Ultimately, we had to move the consumer to action and the advertising community to action for the entire operation to work. One proved easier than the other. The consumer loved the message and was willing to abandon the status quo. The buyer loved the message but wouldn't risk abandoning the status quo until finally forced by a seismic change in where people consumed their content.

This is one of the reasons why I believe online film distributors have been largely unsuccessful at worst, uniquely challenged at best. It's easy to crowd-source filmmakers. Everyone wants their film to be seen and find an audience. But with so much free content out there, not to mention a variety of subscription based models for premium content, how do you crowdsource and motivate the film-going audience, the consumer, to not only consume your content, but pay to do so? It's a tough dilemma . . . The dust is still in the air.

But, ultimately, to end this section on a high note, I learned that identifying a need, identifying who would benefit from that need and then filling that need brought results. Big results. And that the power of one could charge the power of the infinite.

And on that note, let me take you back to . . .

THE BAR AT THE LOEWS

Back to the bright-eyed and bushy-tailed. At the bar of the Loews in the morning, optimism hangs like a refreshing dewy mist in the air. In speaking to those about to make the trek up the stairs from the lobby to the magical, mystical catacombs that are the Loews hotel hallways, the reality of how difficult this business can be to penetrate, never mind sustain any sort of momentum, has been pushed to the deepest recesses of the mind. Each person or team feels that they are holding a winning ticket—a project that is going to resonate with *someone* and, if they're lucky, a few someones all but eager to bid against one another. Confidence is high, bordering on cocky.

"See that guy over there?" a producer from London asks me. I look to find a Tom Ford lookalike, suit, stubble, sheen of aftershave, laughing uproariously on his cell phone, confidence oozing from every pore. I nod in the affirmative.

"He's peddling a zombie, werewolf horror. Poor bastard. Lamb to slaughter."

In mere minutes the London producer will take his first meeting. He's pushing a rom-com with a B-List actress attached. He admits she's not the most bankable name in the book, but he says the script will "knock the entire genre on its ass." With that, he takes off, taking the steps from the lobby two at a time, like he's left Base Camp for the peak of Everest in a t-shirt, shorts and sandals, oblivious to the challenges that lay ahead.

Late afternoon at the Loews bar is an entirely different experience. The dewy, misty air replaced by a humid, oppressive ceiling that never moves, only thickens. Those descending the stairs don't walk to the bar, they trudge to it. They are bright-eyed and bushy-tailed no longer. No, sir. They now resemble clubbed seals.

I sidle over to two gentlemen, both giving million-mile stares into their vodka tonics. They're a screenwriter and a director from Australia and have brought to the fest a completed family holiday film looking for distribution. They took 13 meetings today. As if summoning the energy from the tips of his toes, one offers a less than convincing, "We did receive one solid 'Maybe.'" I ask them why they've traveled half way around the globe when there are so many ways to reach distributors through online channels or simply from networking with other filmmakers and receiving recommendations.

"Like we're going to find a distributor through Facebook," one scoffs.

"We don't have a network," the other says. "We have us and the people we met today." He paused and added, "Which means we have us."

"And we just don't know enough on the subject. We need help."

"Plus to do it on our own costs money. Our entire expense budget was allotted for this conference."

Later, I get into a conversation with two men and a woman from Japan. The first gentleman is a director. The other gentleman and lady are a producing team. They have come to push a high concept, high budget Japanese fantasy trilogy. The idea is not based on source material. It's entirely their own. They have taken seven meetings on the day.

The male half of the producing team wears a dynamite suit and is still sweating a half hour after his last meeting. He stands slightly folded at the waist as if he's still fighting off the effects of a punch to the solar plexus and dots at his head with a handkerchief while gulping his $11 beer. "They don't get us," he says. "Too expensive, not big enough, too strange, not odd enough. Nobody knows what they want." Welcome to Hollywood, I think.

The director, his face red with heat, is more irate. "This isn't comic book bullshit," he says in perfect English. "This is the new thing, the next thing. This is attainable fantasy."

I'm not exactly sure what he means by that, but I'm sold on his passion. Still, I ask them what they will do if they can't sell their concept.

The female producer doesn't hesitate. With half resolve and half vengeance, she spits, "We will come back every year until we convince them."

"What about the rest of the year? The rest of the *globe*? Movies aren't only being financed and made in L.A., you know. Have you thought about the UK? Canada?"

She glares at me in a way that makes me extremely glad looks can't kill. "You have contacts there? Because we do not."

Finally, I strike up a conversation with a 37-year-old actress turned producer. She has over 25 credits to her name, some on films you've heard of, many you have not. But she has been working on independent film sets for over 17 years. She's here with a short she produced, looking to find someone to assist with her efforts of turning the film into a full-length feature. She has taken ten meetings. When I ask her how it went, she pounces.

"'Who are you? What have you done? What movies have you been in? Have you produced before? What makes you think you can produce? Sure, leave a screener.' That's what I heard all day. Nobody even watched the damn thing. They're all so concerned about everything but the fucking product."

"Why bring it here?" I ask. "You must have contacts from all the various films you've worked on. People that can help you."

"Yeah, I've worked a lot, but you go in, do your scenes and leave. I mean, I've been on some close knit sets where everyone genuinely liked each other and got along. You stay in touch for a while via email, but then everyone fades away. You're left with your core group."

"There has to be a way to stay in touch with these people."

"What? Like Facebook?"

"I guess."

"Are you on Facebook?"

"No."

"May I ask why?"

"As a creative, I just don't see the point."

"And that's my point."

Touché.

And thus the embryonic idea that would become Stage 32 was born. There had to be a way to make the world a bit smaller for those pursuing a career in film, television and theater. Further, as someone who believes life is a never ending educational process and who makes it a point to learn at least five new things every day, I wanted to bring education to the masses.

THE LESSONS LEARNED FROM *RAZOR*— BUILDING STAGE 32

The first phase of Stage 32 was pushed live early in the second quarter of 2011. At no point did I deceive myself into believing that I had come up with a concept so revolutionary that people would flock to and embrace the idea like manna from the gods. I, of course, had identified who my potential audience was. That wasn't an issue. What I needed was a powerful, relatable message that would take away the numerous questions and pushback I anticipated, the biggest of which (I believed) would be convincing people

that this platform could and should replace their broader social media platforms when it came to their film, television or theater pursuits. Having spoken with some of my industry friends, and, as mentioned, other frustrated creatives along the way, plus my vast experience working with a variety of startups throughout my business career, I knew that finding first adapters who would be not only willing, but excited to try out a new platform would be easy. Getting them to instantly understand the mission, subscribe to the mission and carry the word of that mission forth, well, that wouldn't be so easy. After all, even though the feedback was overwhelming that the broader social networks weren't producing professional results for many, I couldn't discount the comfort and familiarity aspect of the equation. Even when things aren't working, people abhor change, choosing comfort over the fear of the unknown. It's why we stay in bad relationships. It's why we stay in jobs that don't challenge or excite us. It's human nature.

With these facts preying on my mind, I was extremely cognizant of the fact that I had but one bullet in the gun. Execution was going to be everything. I decided to take a step back.

I took a week to sift through my *RAZOR* launch notes. On the surface, this may seem like a questionable move. But if there was one things that stuck with me about *RAZOR* in the dispiriting aftermath of closing down operations, it was all the letters and emails I received from disappointed subscribers and readers of the magazine; those who had championed our cause and carried the message. I particularly remembered one email from a devoted reader who had bought nearly 100 gift subscriptions throughout our run. I decided to write him and ask him if he would be willing to take a moment and express why he had been such a champion of the brand and the mission.

> I was on board from the beginning. Your editorial statement, the material, the lifestyle embodied within the pages all spoke to me. But more importantly, *you* spoke to me. Your approach was one of inclusion, of speaking to as opposed to speaking at. I wanted to be a *RAZOR* guy and I wanted to help build that community and spread that mindset.

So moved and inspired was I by this response, I eagerly reviewed some of the early plans we had implemented to recruit, inspire and move disciples of the *RAZOR* brand. It was an enlightening exercise. In business, at times, whether you have success or failure, time erodes the tenets of the foundation

you constructed in the early days. Revisiting these unvarnished, enthusiastic plans and strategies put even more wind in my sails and gave me more perspective on the initiative I was about to launch. But I didn't stop there. The good side is always the easiest to look back on. But for complete truth, you must review the bad as well. I took a long hard look at our missteps and why those particular ideas didn't take root. Now that I had the whole truth, I had clarity.

At the end of the week, I was invigorated, and I was sure of one thing: The membership and direction of Stage 32 needed to be crowdsourced. I needed true believers. I needed champions. I needed people to carry the message.

As soon as I felt we had enough built out that could serve as proof of concept, and also enough features and resources which would invite and promote activity throughout the site, I put together an email. I introduced Stage 32, my reasoning for starting the site and my desire to help all creatives increase their odds of recognizing their dreams through targeted networking and other future initiatives. I attached a mission statement (still available on the site today at www.stage32.com/content/our-mission). I ended the letter with this:

> I have chosen you to receive this invitation to be a first adapter because you are not only one of the most passionate creative minds in my circle, but I deeply respect your opinion. Some of you may answer my request to test out Stage 32 with cynicism. That's OK. All I ask is that you experience and utilize the site with as open a mind as possible. Well, that's not entirely true. I also ask this: If you like what you see from Stage 32, if you can gaze into the horizon and see the land I am hopeful to conquer, and if you can get behind the mission of what I've set out to achieve, I ask you to please invite at least 5 fellow creatives to assist me in building this community. Needless to say, the more creatives inhabiting Stage 32, the more opportunity that will exist. Conversely, if you don't like what you see, I ask you to please send me at least 3 reasons why. I cannot and will not pretend to believe that I have covered every angle, but those I have led me to this point and the need for your help. I'm asking you to help carry me forward, be it with positive or constructive feedback. I thank you in advance.

letter to supporters to know your supporters.

I targeted and then sent the letter to 100 industry colleagues and friends. Within three weeks and with barely little prodding, I had 100 responses. That alone blew me away. But what really knocked my butt to the canvas was that 97

not only loved the concept (*and* sent extremely solid suggestions and improvement ideas), but all 97 invited at least five fellow creative colleagues to the site. The three dissenters made valid arguments, pointing out a few items I hadn't thought of previously, and agreed to have another look down the road (all three eventually became members). Not only did I implement their changes, but I made multiple adjustments to the existing design and features based on the suggestions of others. Basically, I let the members crowdsource the direction of the site, which in the early days of any startup is a smart strategy, especially when the suggestions are coming from your target audience. These first adapters were thrilled to see their ideas taken seriously. This gave them ownership and made them even more excited to carry the message forth.

By September of 2011, and with no other outside publicity, advertising or marketing, simply by virtue of these first adapters and, in turn, their invitees preaching the gospel of Stage 32 , we had over 7,000 members in the community. We were now ready to come out of beta and the preplanning stage and launch the site. Almost.

I had connected with my peers; people who knew me. People who, although nothing is a given, more than likely felt a responsibility to at least respond to me. Now, I faced an entirely different challenge—connecting with creatives who didn't know me from the next guy on the street, or, more appropriately, the next dude with an idea for an online platform. How could I get them to see that as it related to Stage 32, I was simply one of them? That I was coming at them as an actor, screenwriter, producer, voice actor before an entrepreneur and businessman? How can I make them understand my intentions were pure and evolved from an honest place? How could I take away the "What's the catch?" cynicism that seemed to dominate the focus group reports I had read online regarding internet startups? How could I make them fully and completely understand and embrace the vision, mission and brand?

I looked at the challenges over and over, up and down, in and out, analyzing all the potential reverb I might receive. Eventually, I took out a pad and wrote the following down:

1 Site will be and will always remain free. Somewhere down the line we will produce premium online educational opportunities at an affordable price.

2 Site will be a friendly, welcoming environment where debate is invited, but where abuse (and trolling) will not be tolerated. We will promote

a nurturing, positive domain at all times. The challenges creatives face are hard enough. This site will be about support, collaboration and self-lessness as much as it is about networking.

3 I will stand in front of the brand (the face) as a screenwriter, producer, actor and voice actor. It must be known that I am no different than any other member. I too am working to advance my creative career and create opportunities. We are all in this together.

4 To that end, everyone who joins will receive a welcome post from me—including the information listed in #3, plus our mission, our brand philosophy and the fact that Stage 32 is simply a blank canvas—must supply the brush and the paint. And they should paint freely.

5 We will continue to ask all members to help support the movement by inviting at least five fellow creatives. Ownership in building the community is a must (but also has to be earned). "This is a network built for you, built *by* you."

With these directives in hand, I felt the time was right to move us out of beta. In mid-September, 2011, we opened the doors to all film, television and theater creatives.

I now had a reason to be active on other social media platforms, still not as an individual, but as an ambassador and spokesperson for the brand. I immediately set up our Stage 32 Twitter (www.twitter.com/stage32) and Facebook accounts (www.facebook.com/stage32) and set out to follow and like film, television and theater creatives from every discipline regardless of their level of accomplishment. I made sure my posts were engaging and intriguing by asking questions and welcoming suggestions as opposed to simply broadcasting. I invited people to join the site and offer feedback. I gave anyone who wanted it a voice, a platform to be heard; something that was enormously appreciated by most. Who doesn't like their opinions to carry weight? When, and only when, I received a positive response, I asked that person to carry the message by retweeting, sharing my posts or simply by sending invites through our site's invitation system via email or Facebook.

By the end of our first month out of beta, our membership had nearly doubled. I made every attempt to stay in contact with the user base regarding tweaks and fixes to the system, new resources and features we were

introducing, and plans for the future. When something positive happened to someone in the community, whether it had to do with a connection made on the site or not, I turned the spotlight on the member and the accomplishment. I made everything about the community, offering support and positive reinforcement where applicable. Challengers and cynics were disarmed simply by pointing to the numerous success stories and already incredible and productive interactions occurring within the walls of the site. My biggest asset, I believe, was my conviction in the mission. I truly believed in what we were doing and had found a way to transfer my excitement and energy to the members of the community. I received dozens of emails speaking to my passion and thanking me for taking on such an endeavor. These notes did not serve to fuel my ego—I knew we had a long road to travel—but they did serve as fuel that we were on to something and that we were filling a need.

After a few months of building personal relationships and good will and, of course, displaying proof of concept through the aforementioned success stories and an overwhelmingly positive and supportive environment, I went for the big "Ask." I asked members of the community to blog, contact journalists on our behalf, reach out to people of influence both in the studio and independent film world, contact their instructors and professors and find their own innovative ways to spread the word of Stage 32. I was asking our members to essentially put their reputations on the line. You can't make that "Ask" if you haven't forged a sincere relationship that benefits both parties. I felt we had delivered on our promise. Now it was time to see if others felt the same way.

[handwritten margin note: When to go for the Ask]

In the end, over thirty members blogged on our behalf. A few dozen more reached out to other influential bloggers and journalists, resulting in another 20 or so blog entries and articles being written about Stage 32. I was suddenly inundated with messages from teachers, industry veterans and award winning talent, now all members of the community, many of them offering their services to help benefit the cause. The network grew to over 50,000 people. We were barely six months old.

To this day, we still utilize all the same principles and methods to help identify, attract, engage, inspire, motivate and move the crowd. As I type this, Stage 32 is now over 500,000 members strong with creatives from every country on the planet. Tens of thousands of jobs have been secured and every day we receive letters from those not only thanking us for helping them facilitate their dreams, but asking us what they can do to help spread

the word. By keeping things positive, giving members ownership and a voice in our direction, and by delivering on our promises, we've created what I believe is the single most positive and progressive network in the world. This statement may seem like hyperbole, but I'd point to the fact that we've only had to kick three people off the network for abusive behavior in four years, and the fact that our members police the platform on our behalf. That speaks to the culture we set out to create in our early days. A culture that was embraced, supported and policed by our members.

Further still, the members of the community are not only willing to help spread the message of Stage 32 to other film, television and theater creatives, but in other ways as well. They will recommend me for a podcast, webcast or television show. They will point journalists our way. They will tell our story to people of influence in the business world.

As a result of their efforts and those of my passionate staff, we've had hundreds of pieces of media coverage, including articles in and on *Forbes, Variety, The Hollywood Reporter, Entrepreneur, Indiewire, The Wrap, The Huffington Post,* and *Yahoo! Entertainment,* to name a few. I've been fortunate enough to have been featured on the covers of *Indie Source* and Robert McKee's *STORY* magazine. Additionally, I've been a guest on nearly 80 podcasts, 30 webcasts and numerous television and radio shows. Lastly, I've spoken at conferences and colleges all over the world on a plethora of topics, including social media, crowdfunding, crowdsourcing, business, entrepreneurship, acting, screenwriting, producing, film finance and the film business at large.

I can say with certainty that none of this would have started, nor would the snowball effect which led to these successes have happened, without embracing, enabling and unleashing the power of crowdsourcing.

16

My "Ask"

We have reached that point in our journey where I now am going to call upon you to do me, as Don Corleone, David Mamet or my old bookie (don't ask) might say, a service. It's time for me to present my "Ask."

As I said from the beginning, quite nakedly and transparently, my goal in this fun and exciting trip was to crowdsource you, my dear Padawan and fellow creative in arms. Following our basic definition of crowdsourcing, my overall aim was to identify, engage and move you.

Now there's a distinct possibility that you actually did some of my work for me. If you came to this book never having heard of me before and simply by virtue of having a curiosity and interest in the subject of crowdsourcing (and as a result, purchasing this book), you have identified yourself to me! And for that I am grateful.

But it's also likely that you may have been part of a crowd I identified either through Stage 32, other social media channels or perhaps a plethora of various offline and online initiatives. If I engaged you in some way to believe enough in me to purchase this book, I thank you for the trust and the leap of faith. It's certainly not lost on me that you spent your hard earned money to take this ride with me, but equally, if not more importantly, it's not lost on

me the *investment of time* you put in to reading my words. And that is very special to me. And certainly not something I take for granted.

This book is over 200 pages and 100,000 words long. It is the result of over two years of research, interviews, outlining and writing. It involved a number of rewrites and an incredible amount of changes and editing on the fly just due to the fact of how quickly technology moves and the aspects (but not the definition!) of film crowdsourcing change.

I mention all this not for sympathy, empathy or any other "thy." I tell you this because I want you to know that I left nothing on the table in my responsibility to deliver you the material you will need to crowdsource your film from concept to completion and beyond, and to give you a significant competitive advantage in an increasingly competitive marketplace. I feel extremely confident you now have all the tools to go forth and prosper.

Therefore, I hope that I engaged you and kept you interested and involved every step of the way. And, I hope that you will continue to feel engaged and connected to the material between these covers moving forward. While the landscape might change in the film crowdsourcing world (and my contract calls for updated editions!), the basic tenets of everything we've explored along the way will always remain the same. Use those tenets as an anchor. When you feel lost, or if you feel your campaign is running aground, come back to them. Remember what my aim was throughout this book, and embrace this idea when things get rocky:

Simplify.

Further, I hope you were engaged not only by my words, but by the varied case studies presented throughout. These filmmakers and producers are not only innovators and great thinkers, they're trailblazers. As you set forth on your film crowdsourcing campaigns, be sure to revisit those chapters. There is much to learn from those who explored before.

And now it's time for my "Ask."

Trusting that you've enjoyed this journey and found it to be beneficial, I would be most appreciative if you would pay it forward and share the existence and benefits of this book with your friends, cast and crew, classmates or other fellow creative peers. You can do this through your various social

media channels by making a post speaking to what you liked or gained by reading the book. If you'd like to get visual, take a picture of the book with your dog, cat, baby or next to your favorite bottle of wine or scotch! (Yes, be that person!) If you're so inclined, shoot a video speaking to the glorious benefits of owning a copy! It's OK!

If you have a blog, please write a (nice . . . I'm just sayin') review or run a small excerpt. If you're a journalist, I'd be most grateful if you'd consider interviewing me or publishing an article. When you're on set or with your screenwriting group, at an acting class or attending a conference or festival—hell, any live setting where you're around other creatives, please let your peers know this tome exists.

You can also give copies of this book as a gift! Seriously, there's no law against this! I looked it up! It may even be tax deductible! (Not actual legal advice.)

So, please, and in (not so) short, share the love and spread the word where you can. There is no greater honor for an author than to know that his or her work is enjoyed by the reader. And, as we've learned, your word of mouth support will carry much more weight than me shouting from the rooftops.

But I have one more "Ask" as well.

Really, RB?

Really, my dear grasshopper.

As you know, there's this site called Amazon that's kind of on the rise. My sources tell me they're probably going to make it big. Anyway, they allow people to review the books they sell on their site regardless of where it was purchased. So whether you bought this tome through them, another online source, a book store, at a conference, at a seminar or even if you received it for free, I ask that you please take a few minutes and, if you've gotten all I hope you did out of reading my words, leave a positive review. This will, of course, help with sales, but as you know, this ain't about getting rich (or with all respect to 50 Cent, dying trying). It's about helping people. It's about getting the word out. It's about paying it forward. I hope I've engaged you enough to ask you to move for me.

And that's it . . . That's my "Ask."

And I thank you in advance.

Come visit me at Richardbotto.com.

Also feel free to follow me on Twitter and Instagram at @RBWalksintoabar.

And if you're not a member of Stage 32 (www.stage32.com), I encourage you to join and enjoy all the benefits the platform has to offer. Be sure to say hello when you do!

Index

Note: *Italic* page numbers indicate graphs and boxed text.